Pictures I Had to Take Joel Grey

Introduction by Duane Michals

 powerHouse Books New York, NY

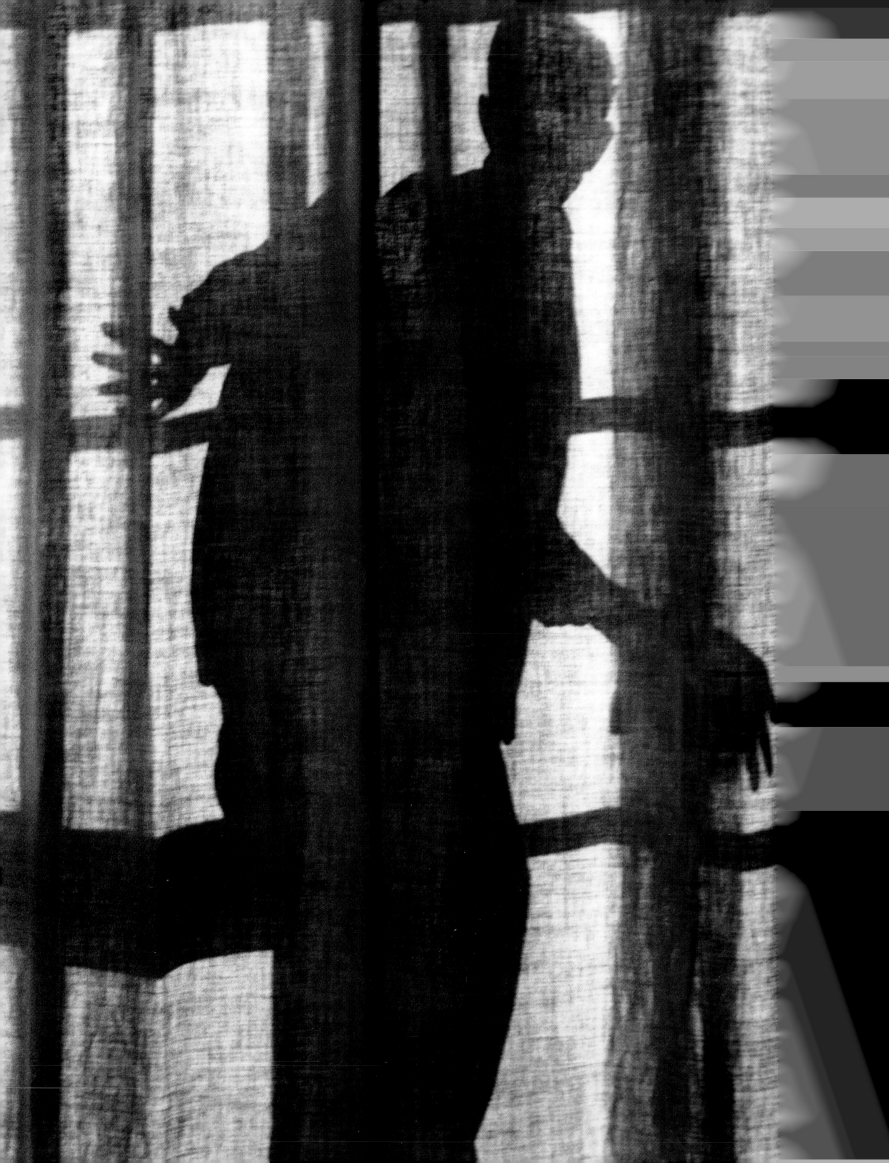

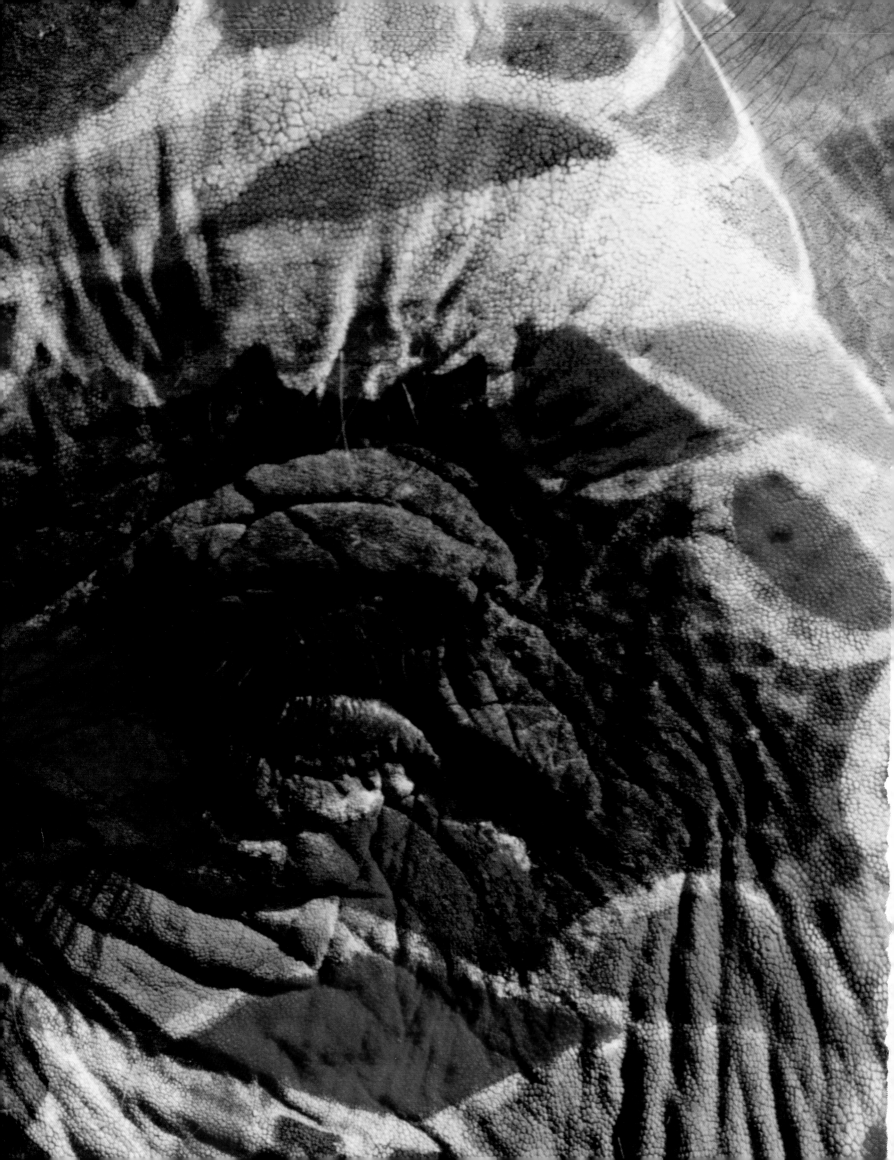

JOEL GREY, Photographer

Actors are shamans. With sleight of hand they magically metamorphose into someone else. They shrink or appear larger than life. Their eyes squint; the voice rasps or bellows. Age descends upon their shoulders. Every gesture is studied, and an atmosphere of another presence is brought into focus by their intense observation. They vanish as a trompe l'oeil.

Photographers are shamans. With sleight of hand, their camera obscuras stop time. For one-sixtieth of a second, a sliver of a fleeting moment is extracted from the cavalcade of time as a specimen on film. In the constant bombardment of sensory assault we experience, the photographer observes a gesture, a dance of light on the façade of appearances, a faded color. He absorbs what he sees into a moment of recognition. And with the alchemy of silver and other chemicals, the photograph becomes a trompe l'oeil.

One should not be surprised to discover that Joel Grey, that great actor, is also a wonderful photographer. It is in the nature of the creative personality to experience reality with a heightened consciousness, an askew view of being. They see into the serendipitous relationships of time and place, then extract a presence that is invisible to the non-poet. The residue of these observations is distilled into their art. All of these are the talents conspicuous to Mr. Grey.

Joel Grey had to take these photographs because he is a visual voluptuary addicted to the subtle pleasures of light, color, and form. He can be mesmerized by the reflected glimmering sheen of plastic, the ponderous power of ancient stones at Machu Picchu, as well as the graceful arc of a tulip. Grey's vision is always intimate, even when he photographs panoramic scenes. Many of his photographs strike me as sets, backdrops for drama. From train stations devoid of travelers to crowded Indian streets, there is an air of anticipation, a suspense that something is happening or is just about to happen.

His photographs are a Baedeker to the joys of the world's wondrous sights. There is a consistent sensibility and an elegant simplicity in evidence. Grey is not a dilettante or photographic poseur. He could have taken the easy route of photographing his celebrity chums that most star snap-shooters travel. He didn't, because he must express his child-like awe of the treasures of our paradise's earthly delights. He shares with us his amazement that the less-attentive have overlooked.

Grey is an authentic photographer because he responds to the moment without any preconceived photographic theories that tell him what to see. His heart takes his pictures.

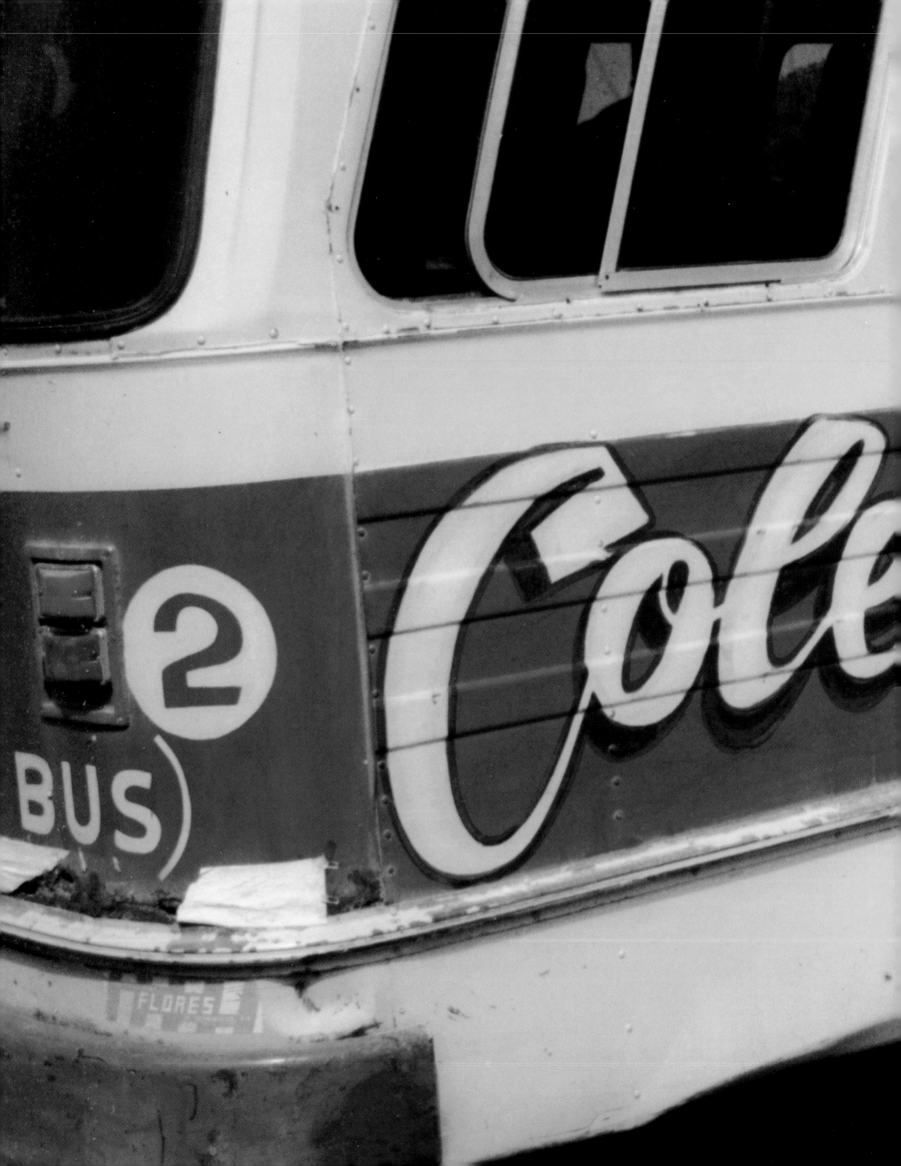

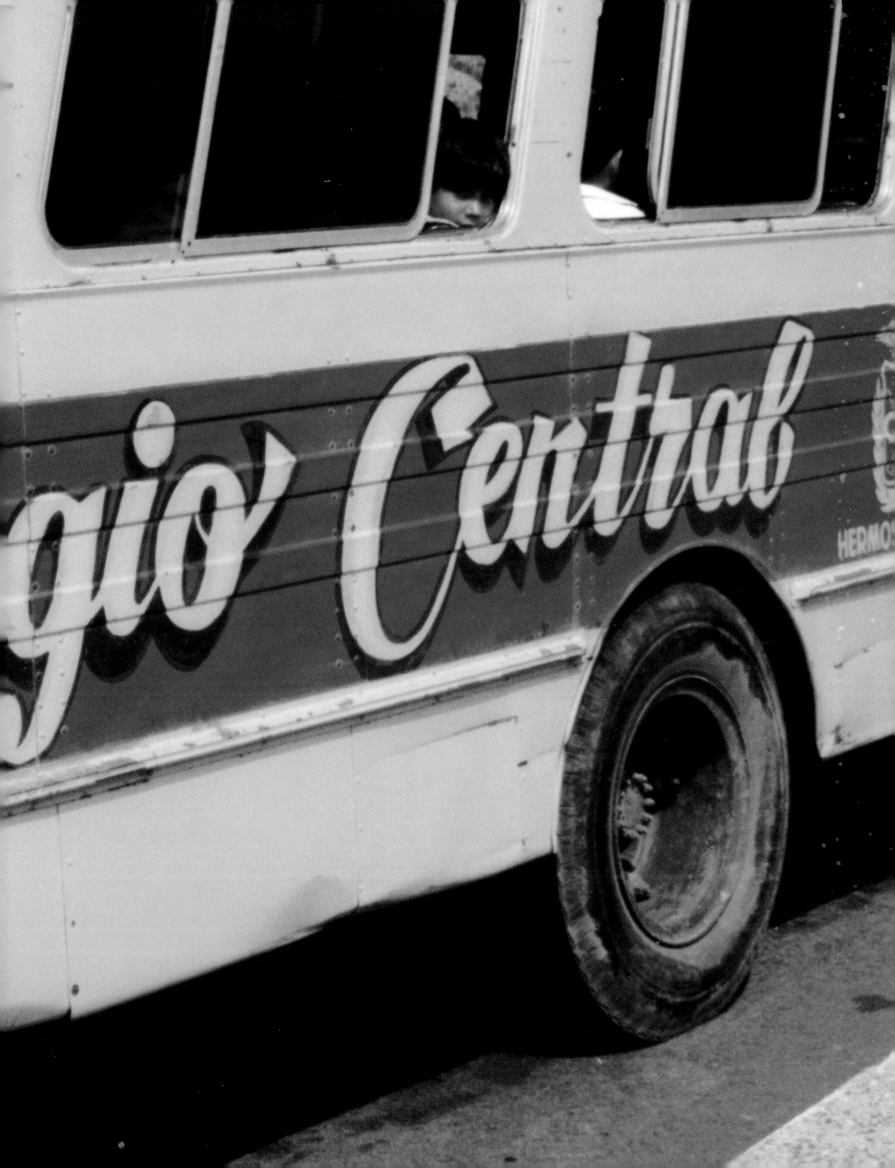

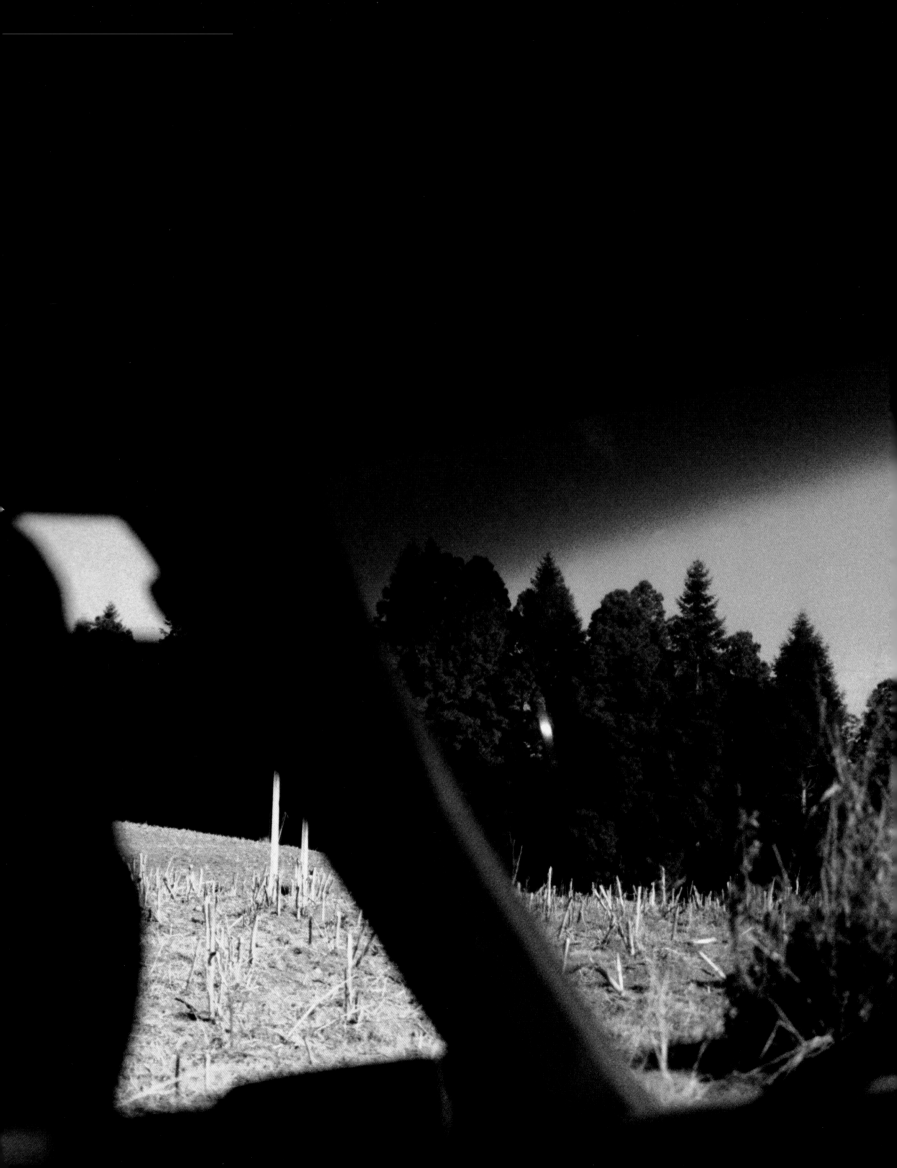

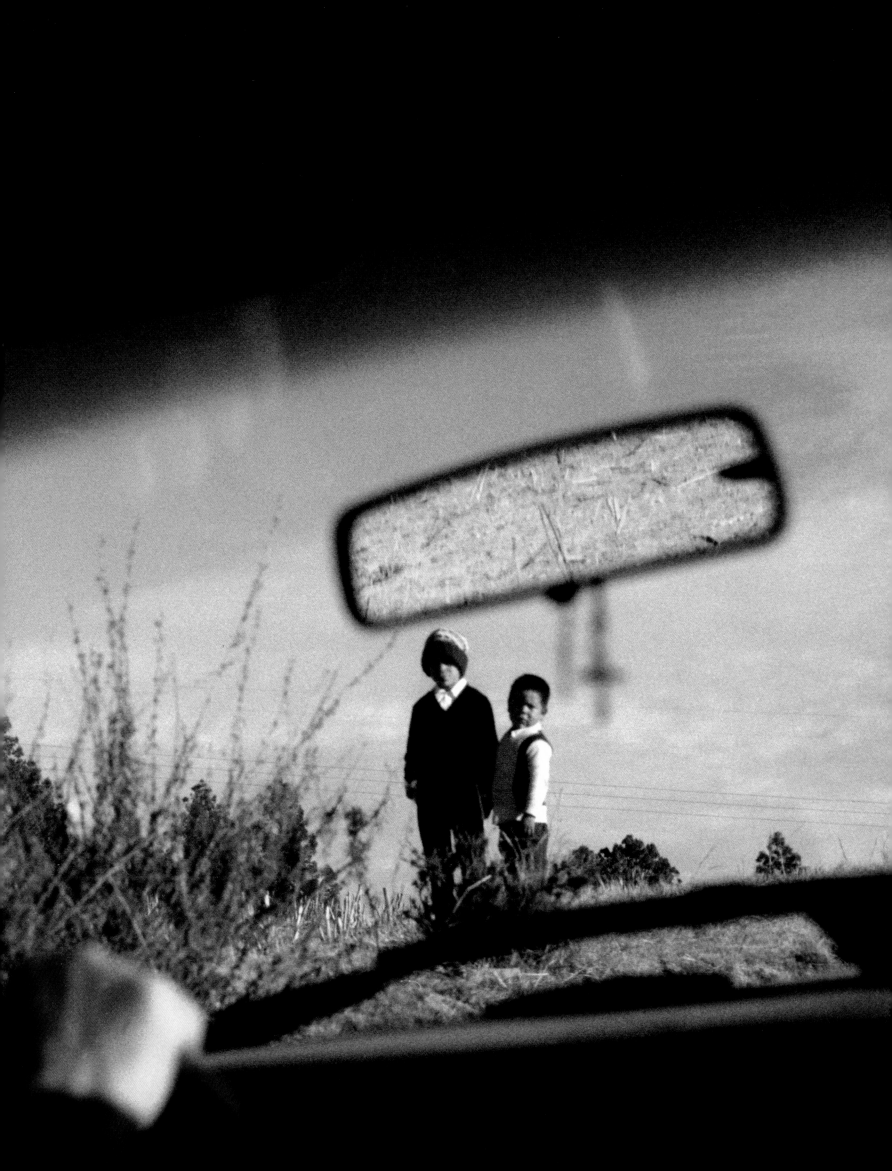

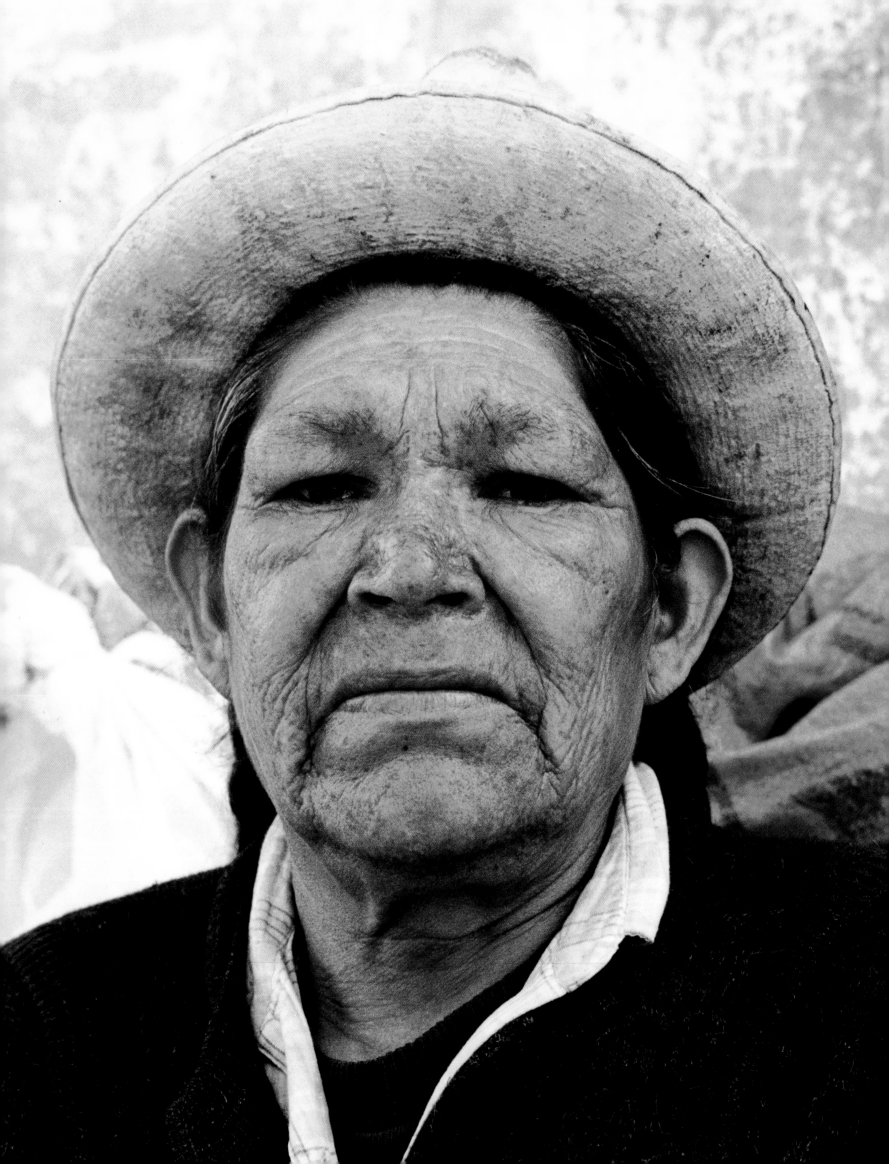

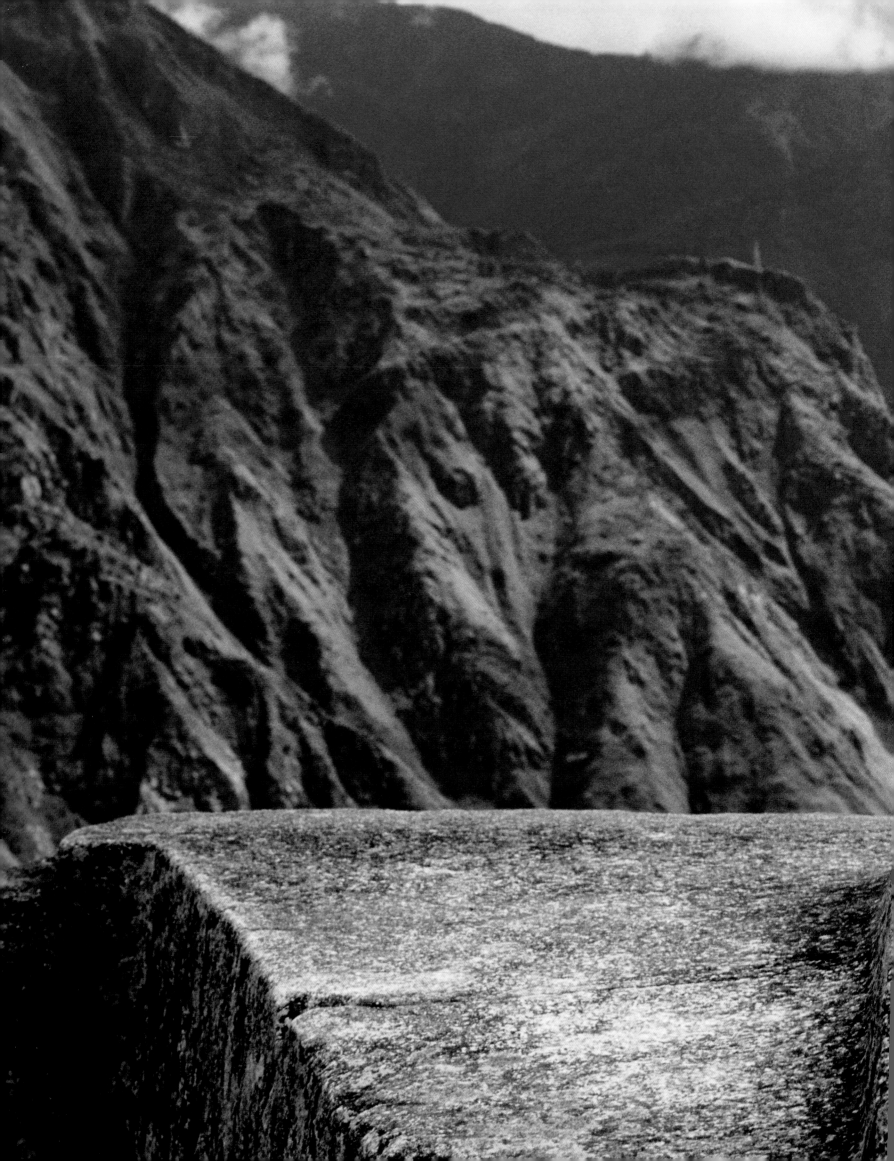

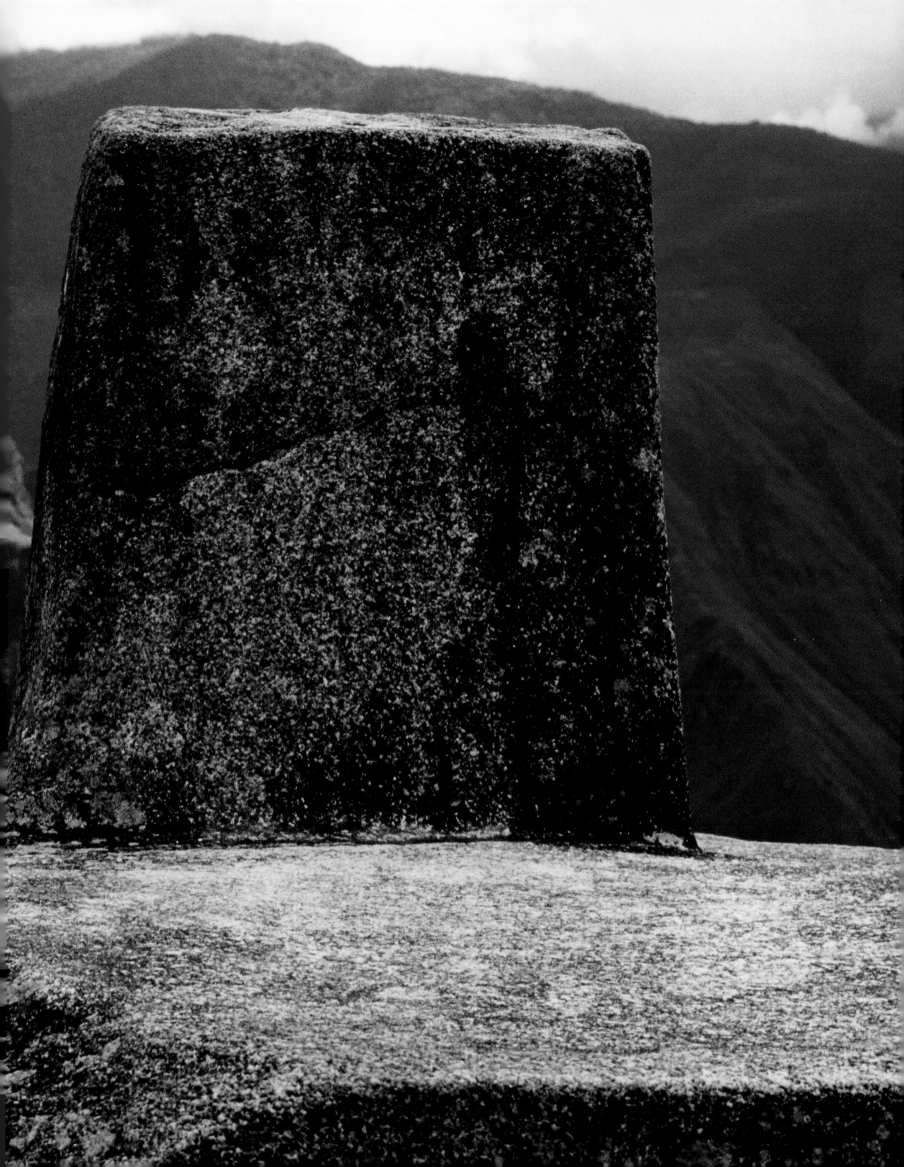

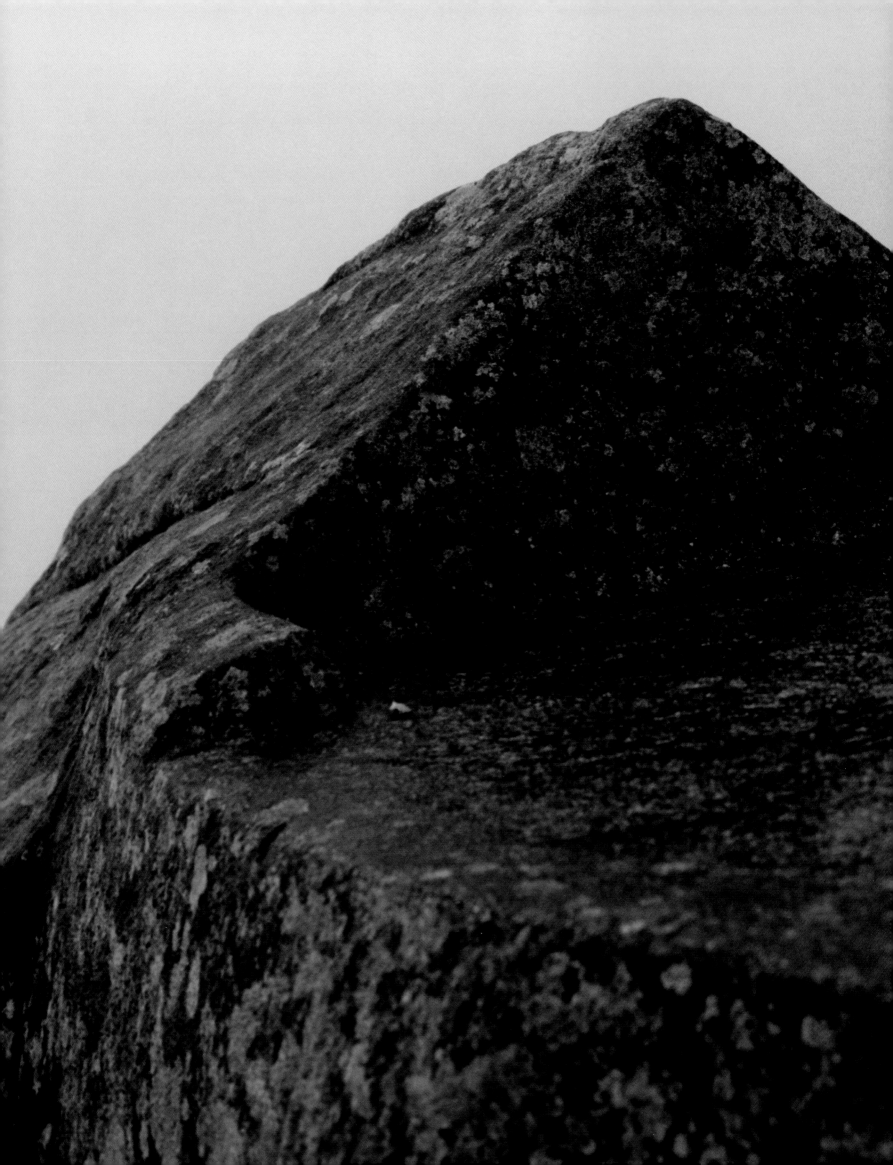

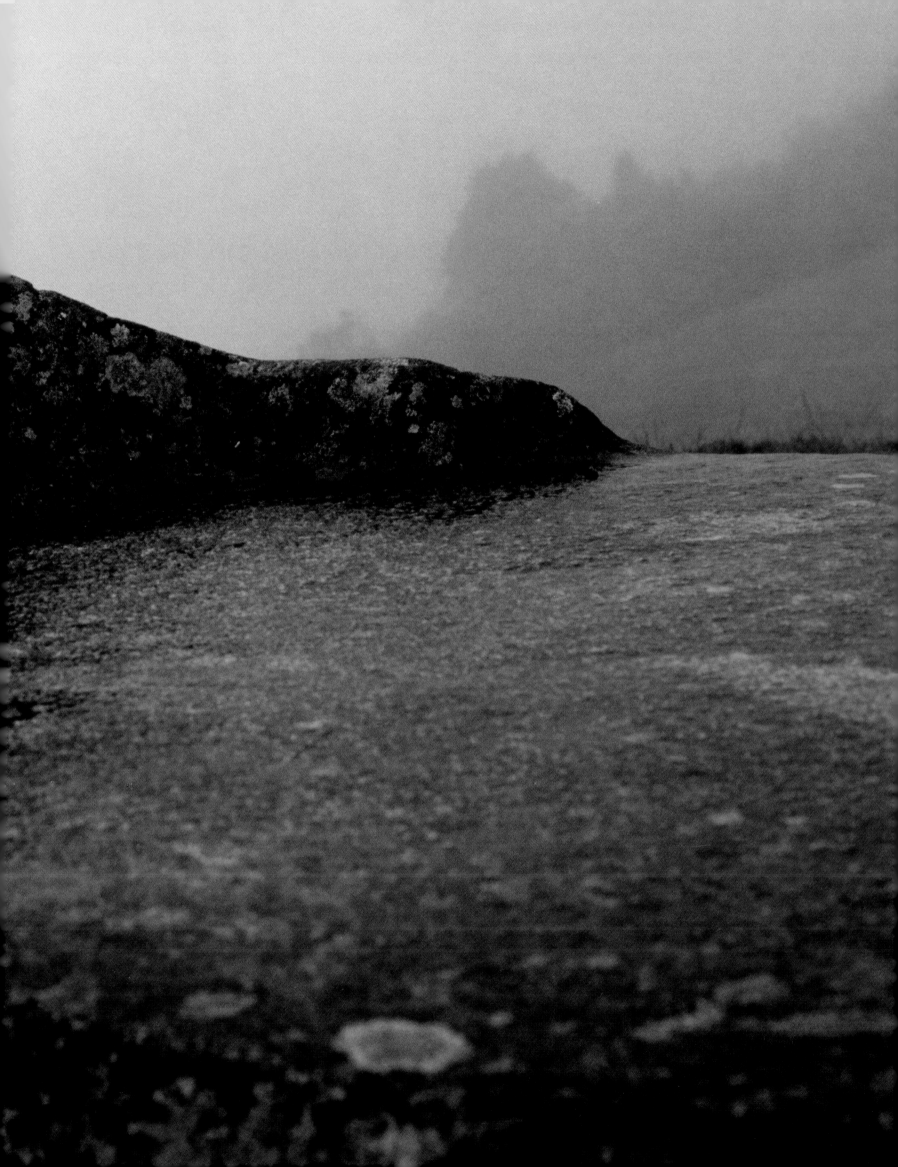

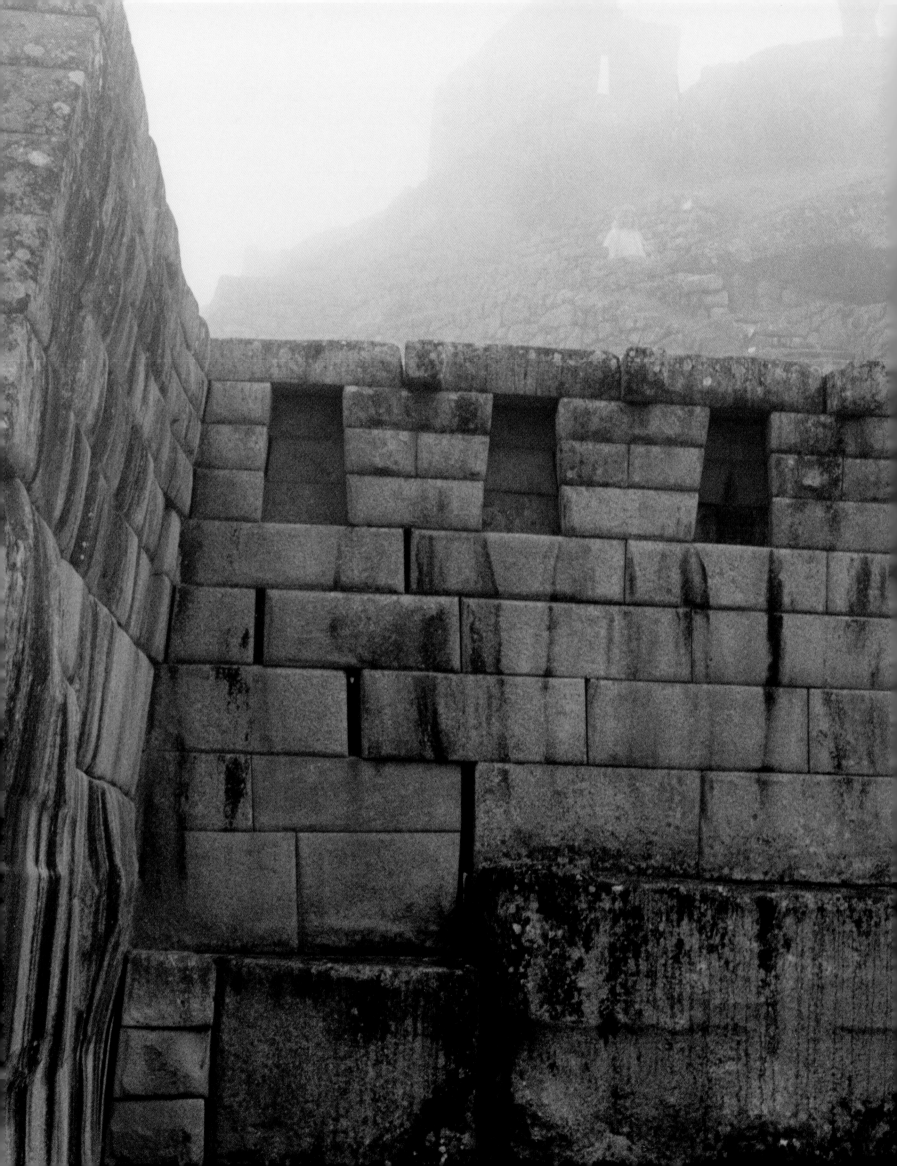

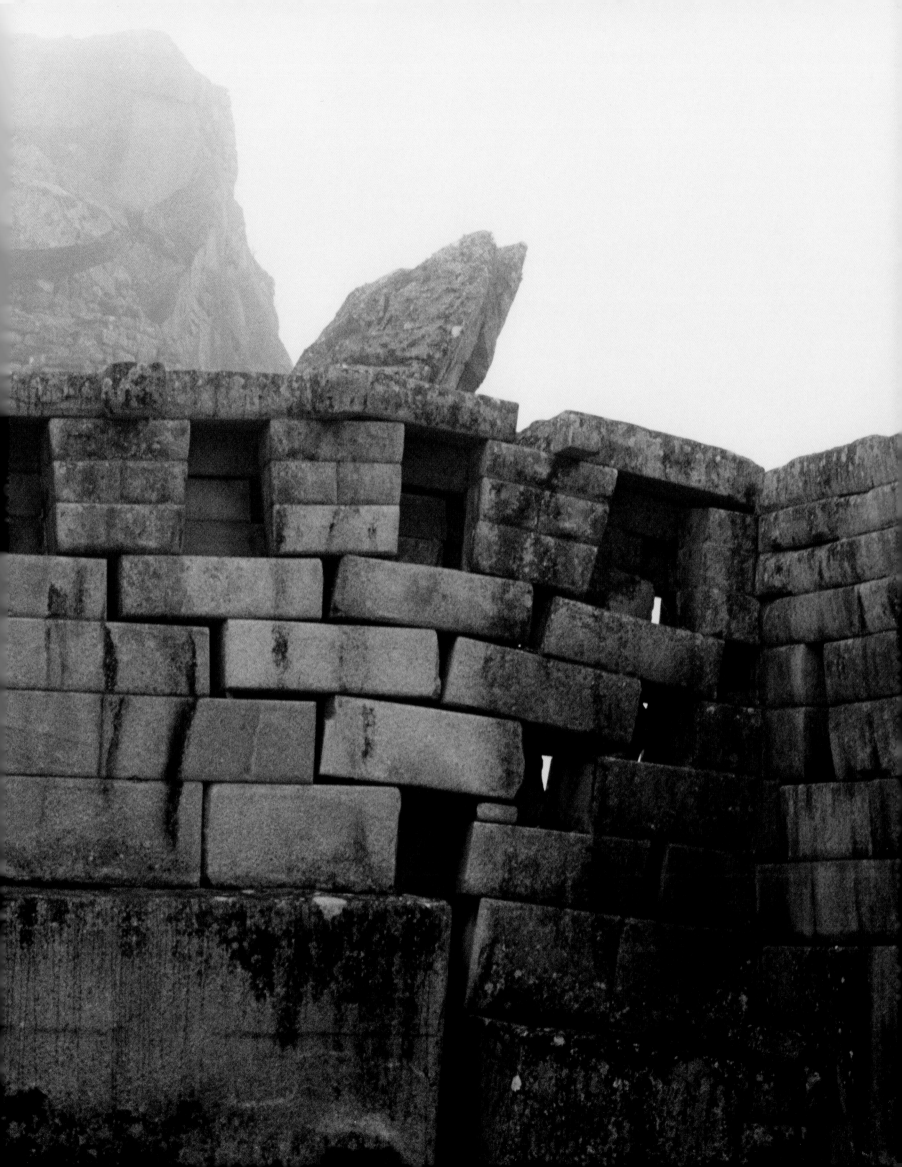

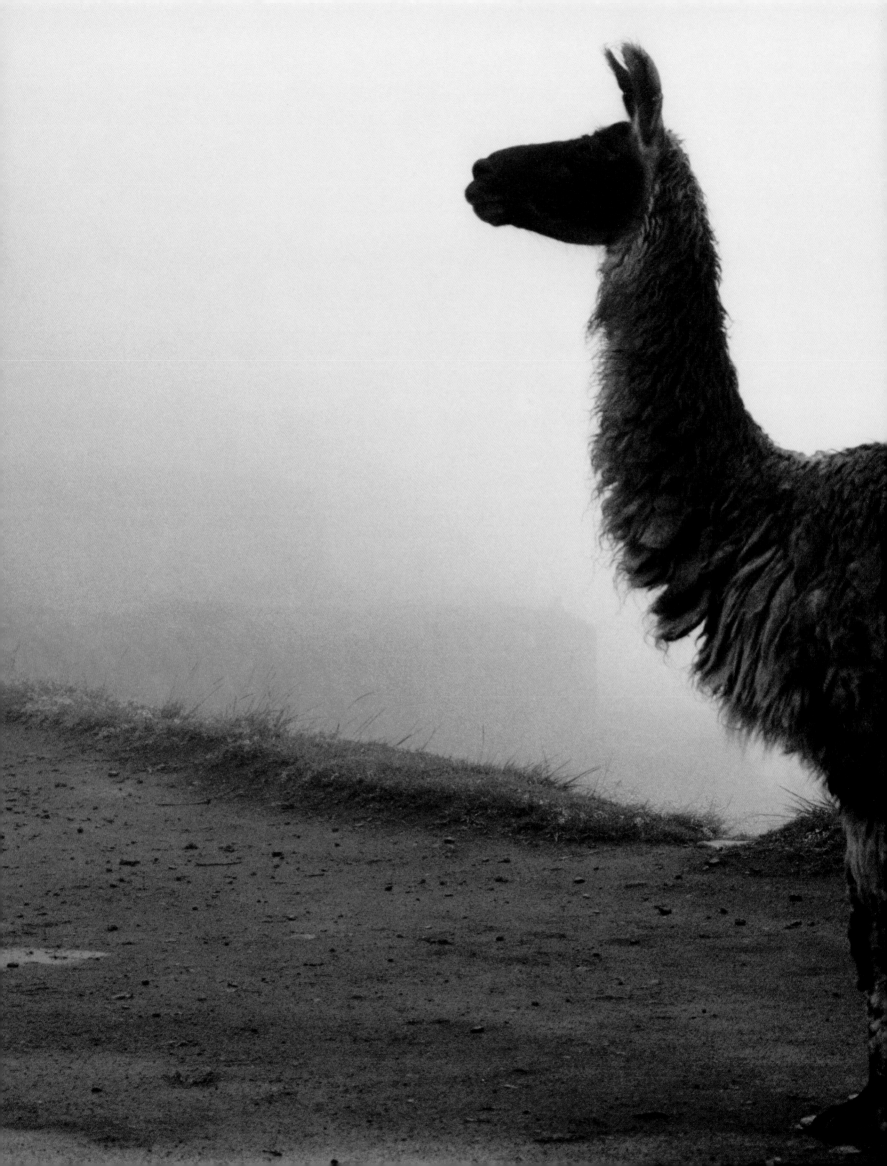

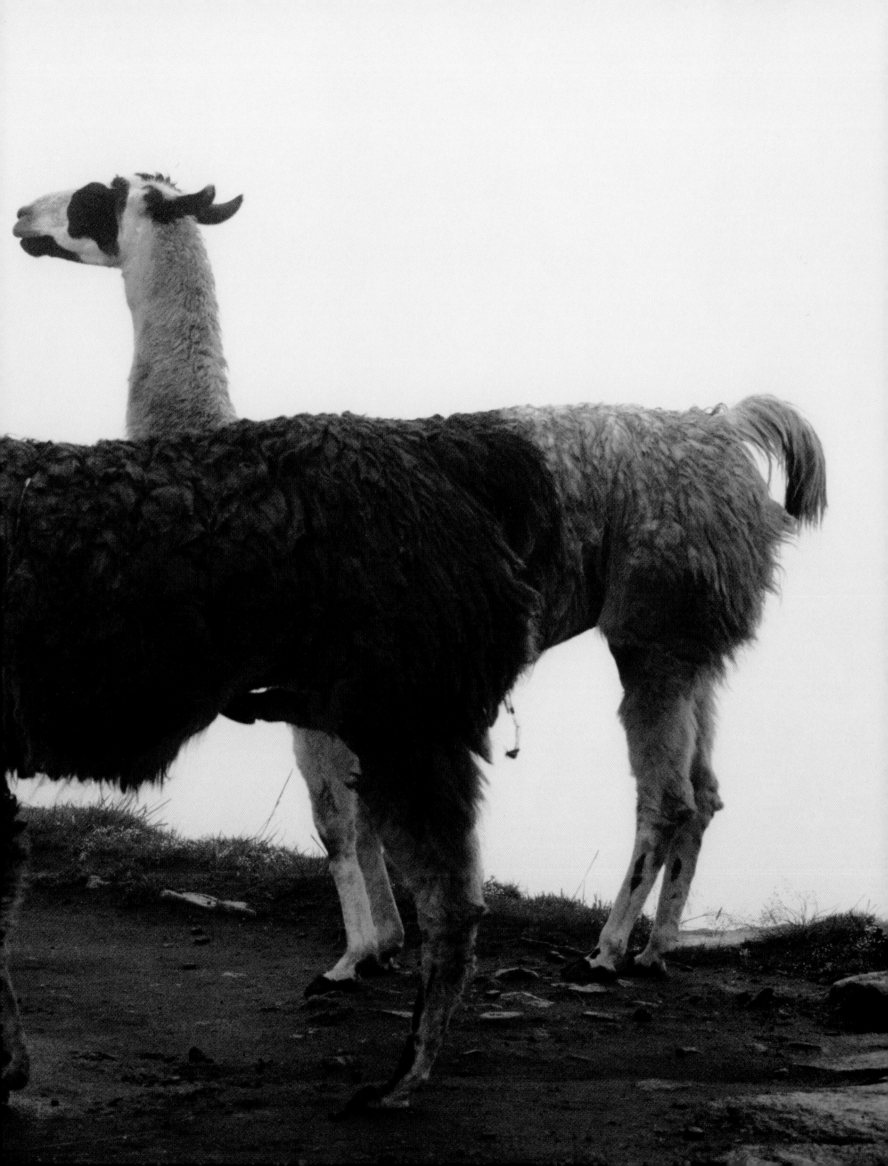

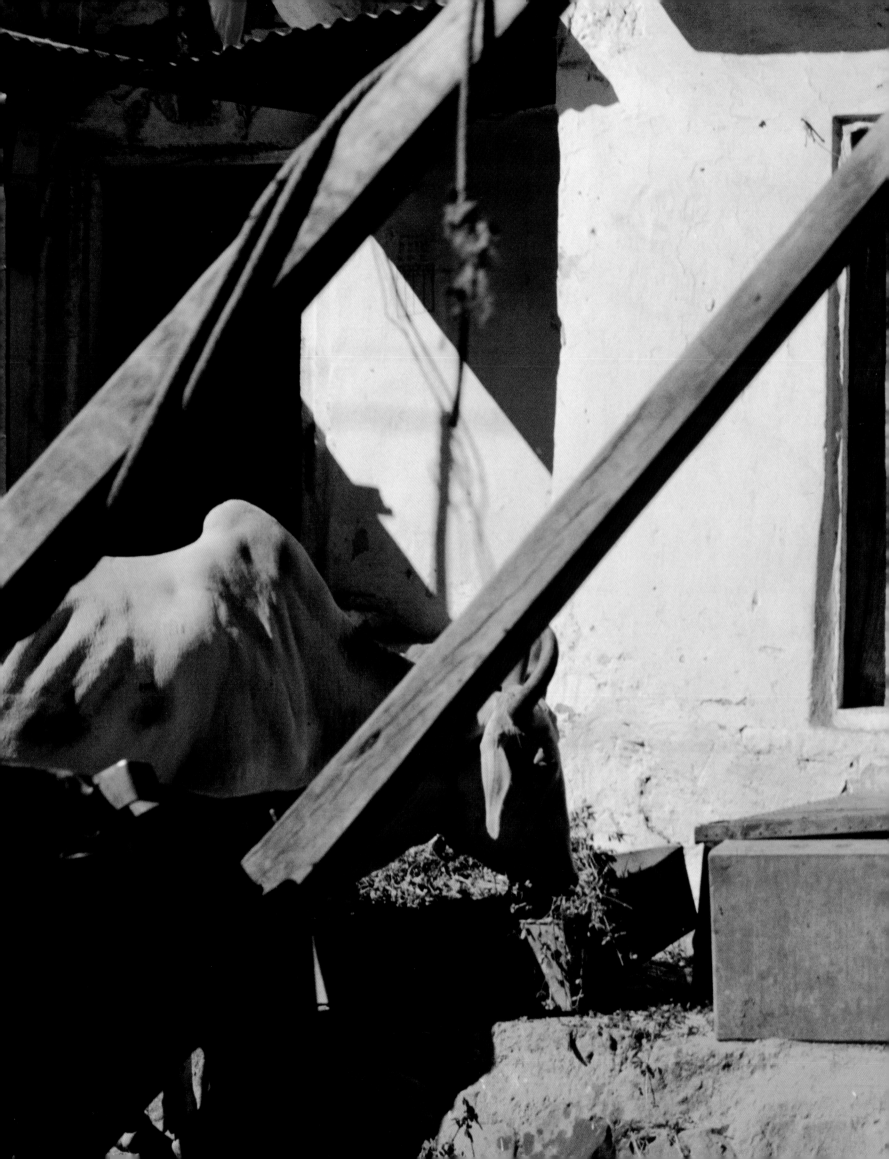

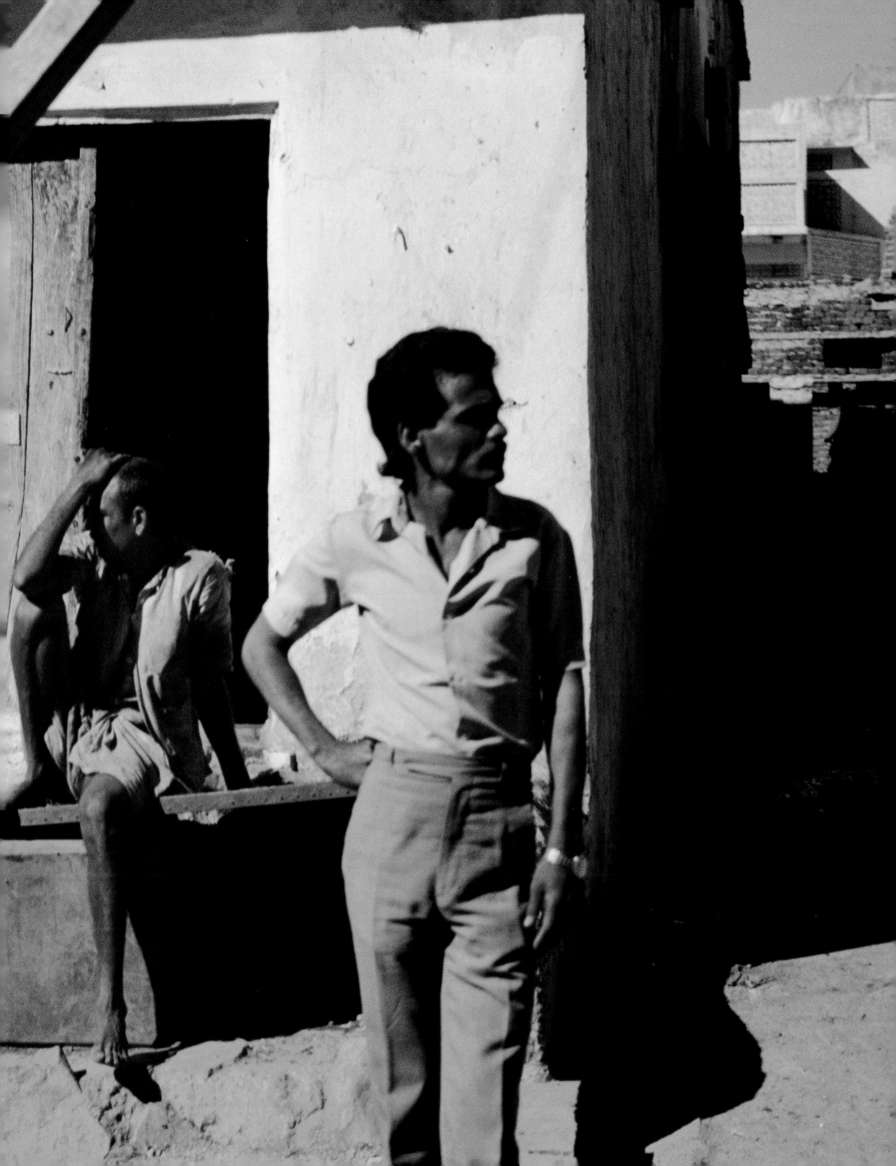

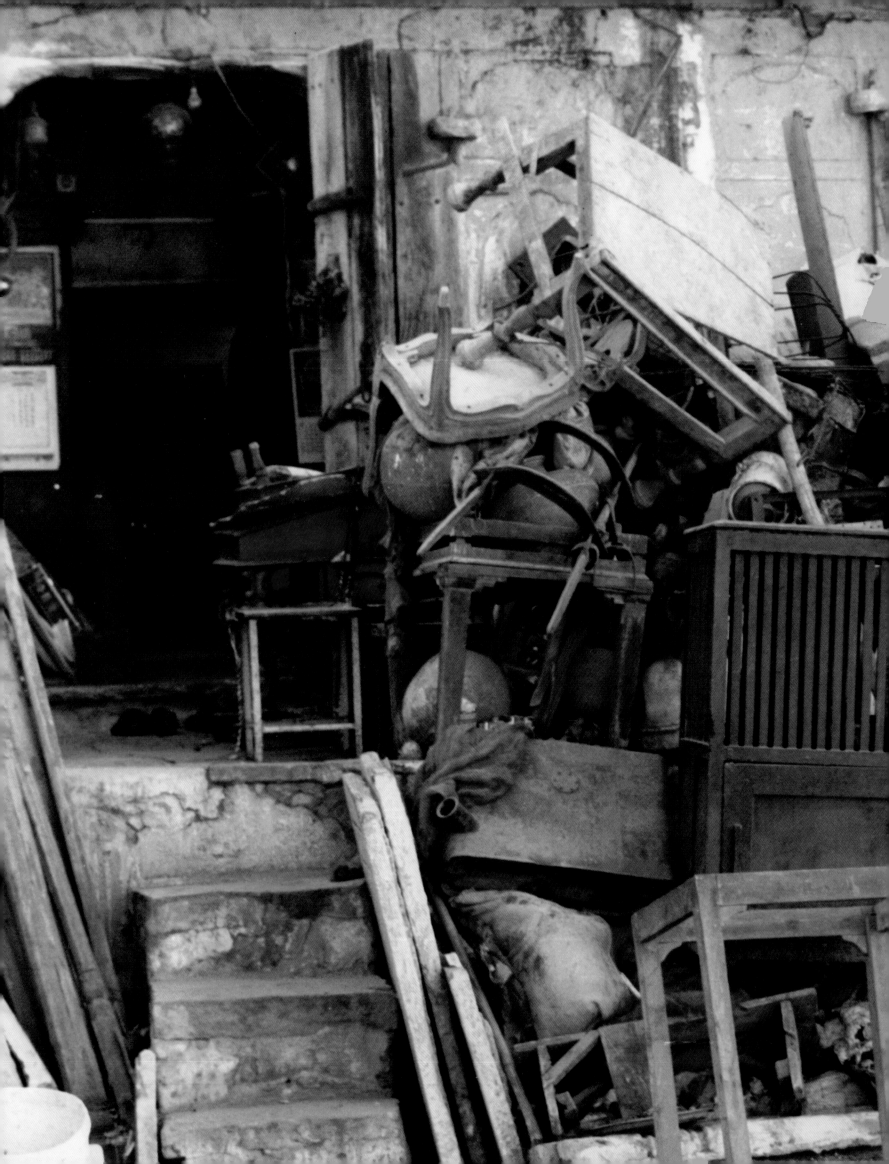

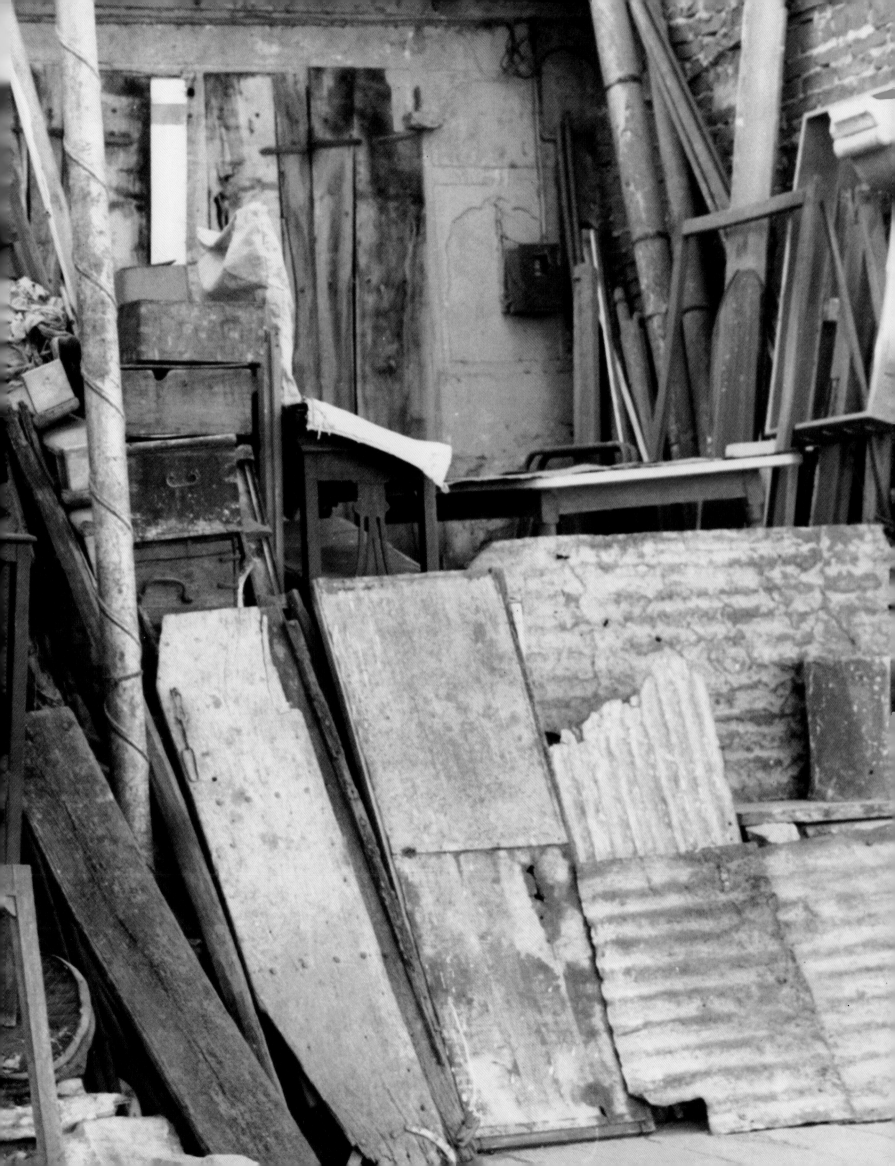

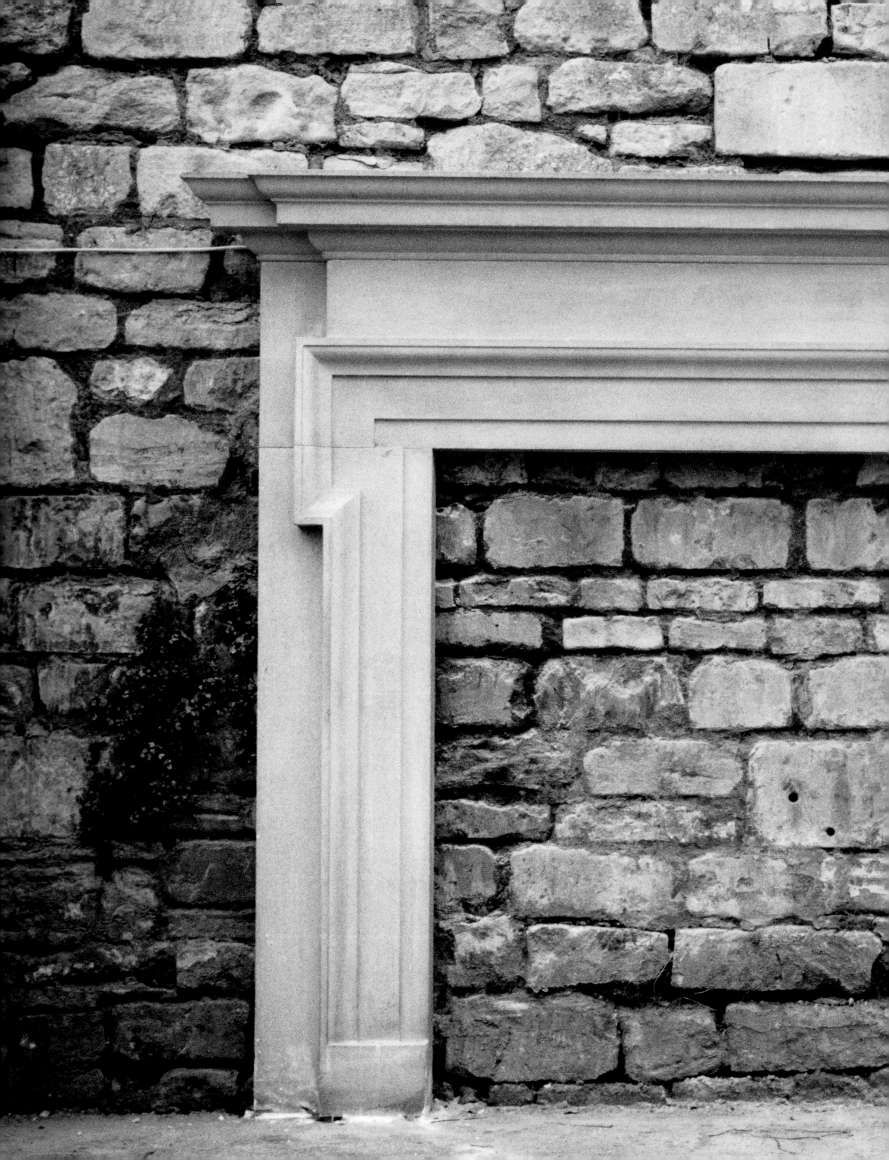

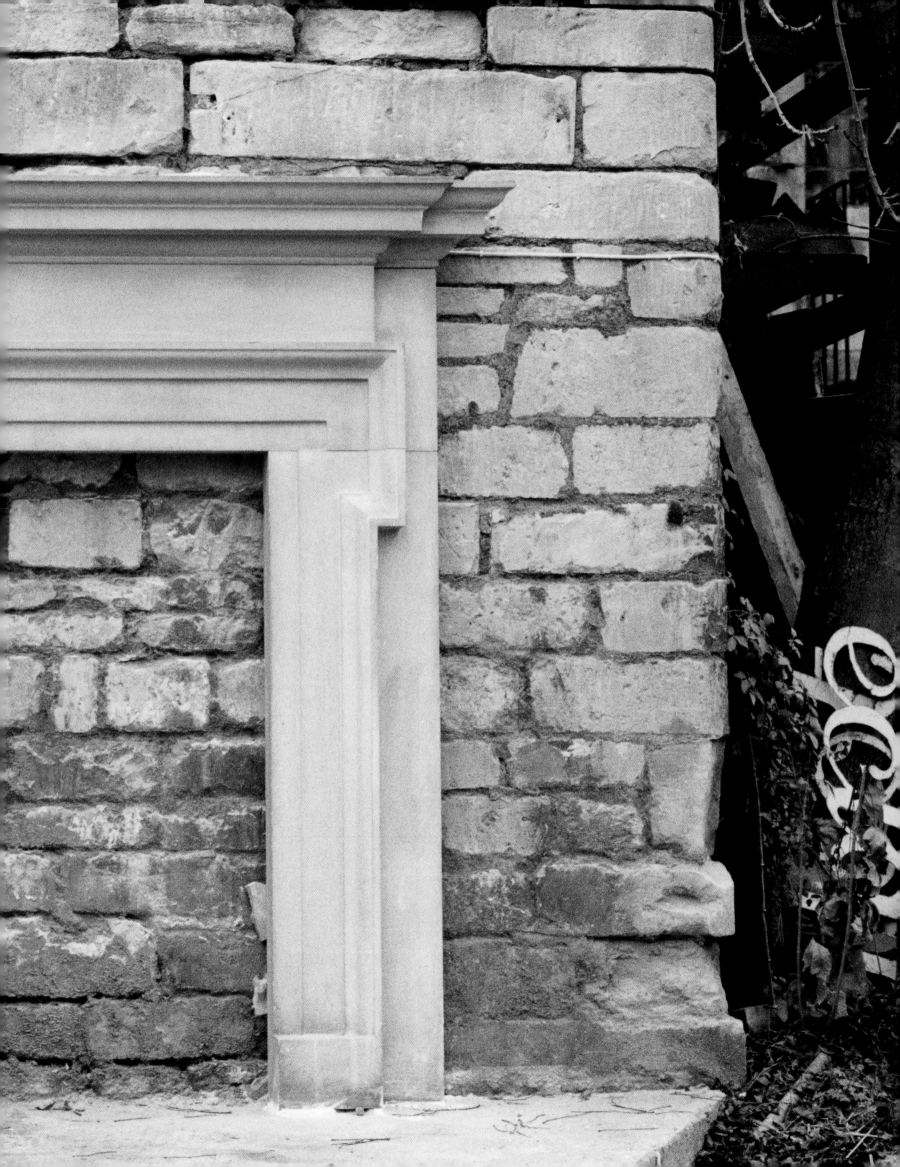

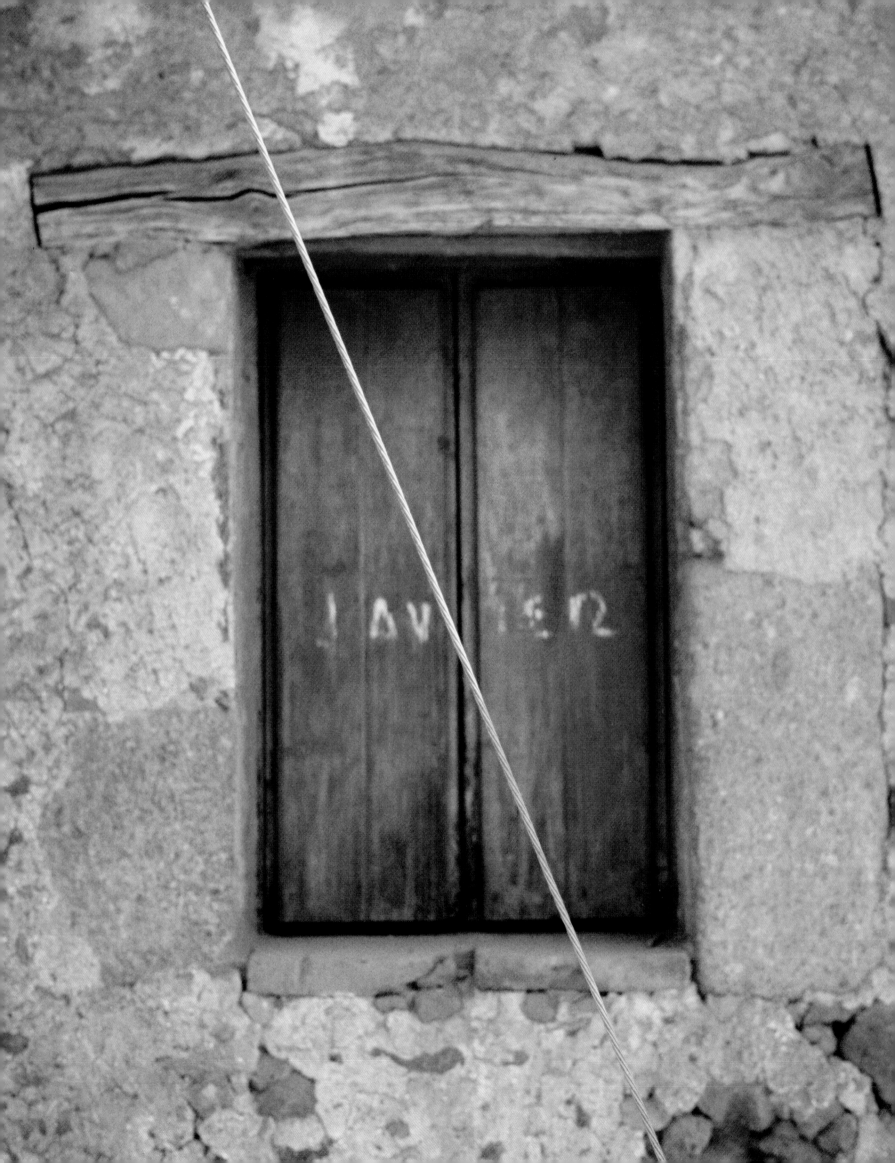

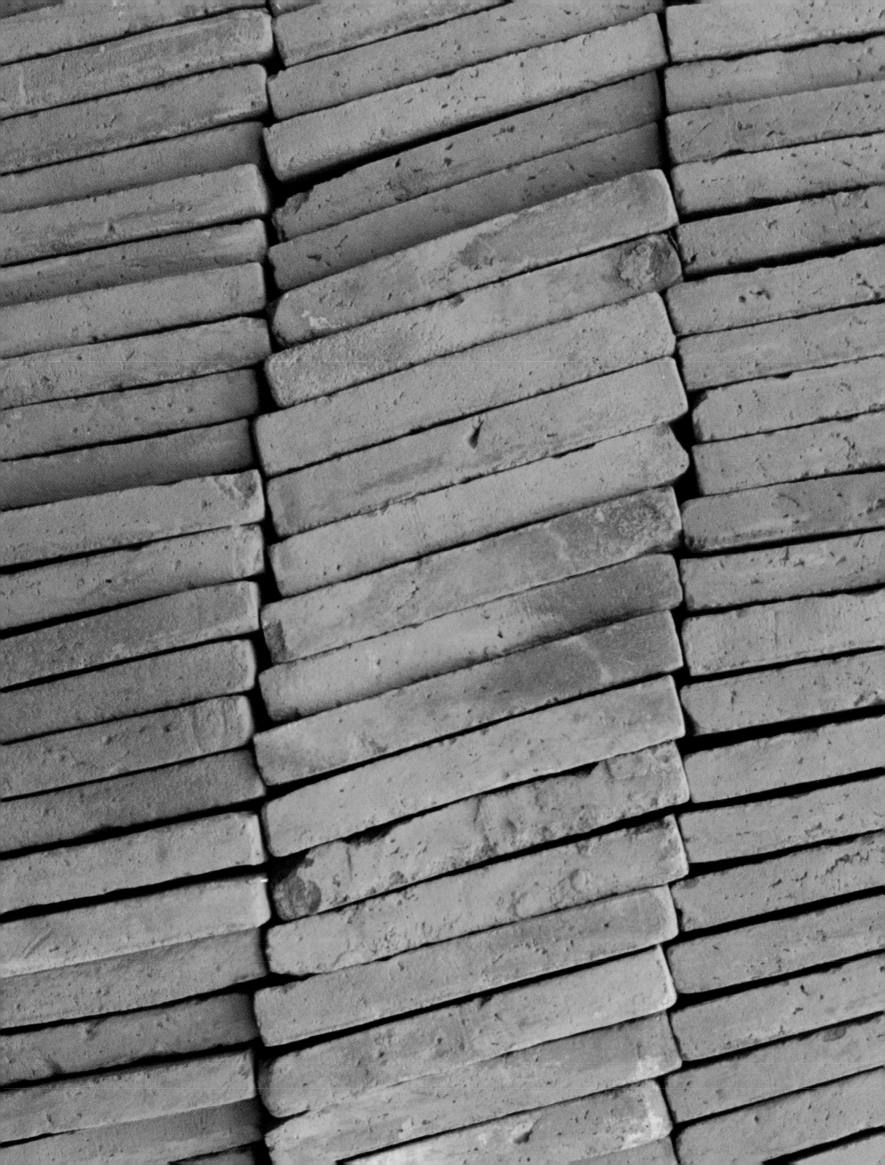

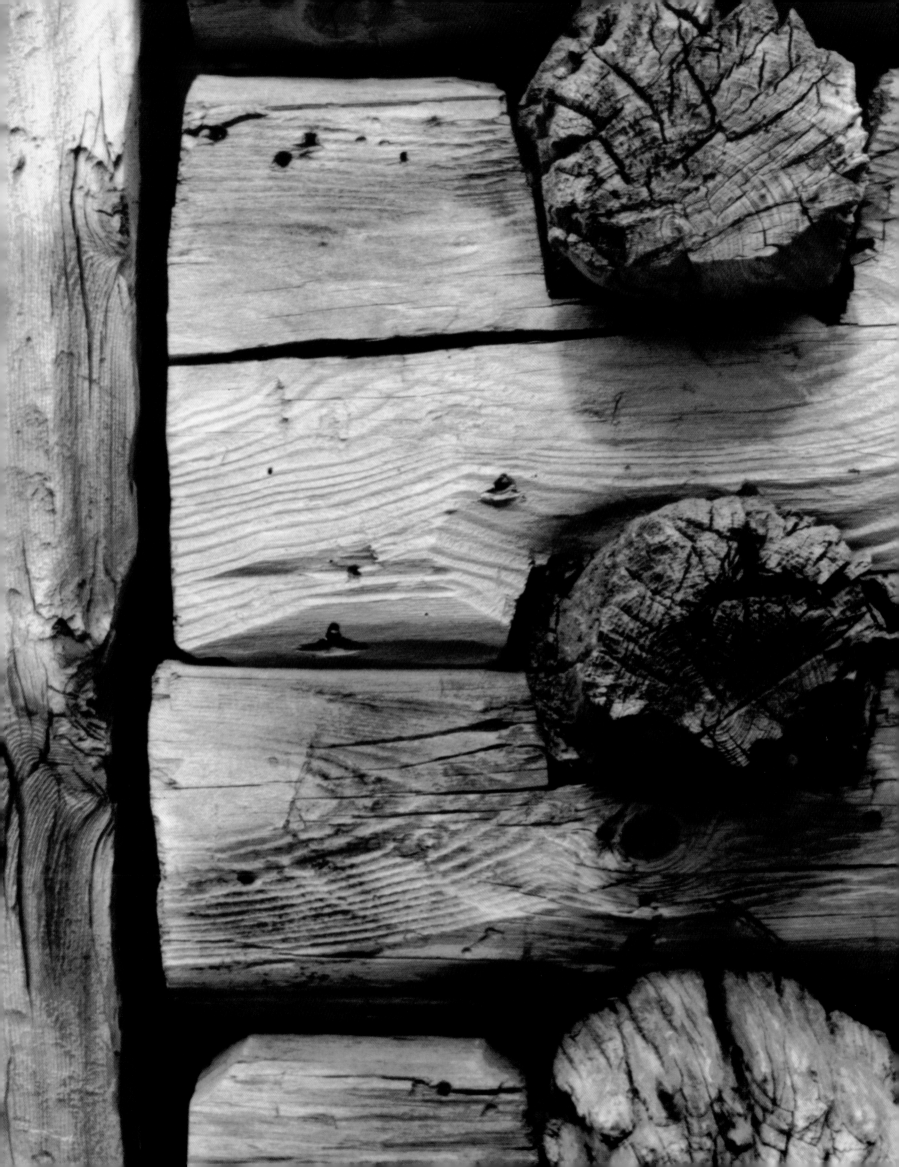

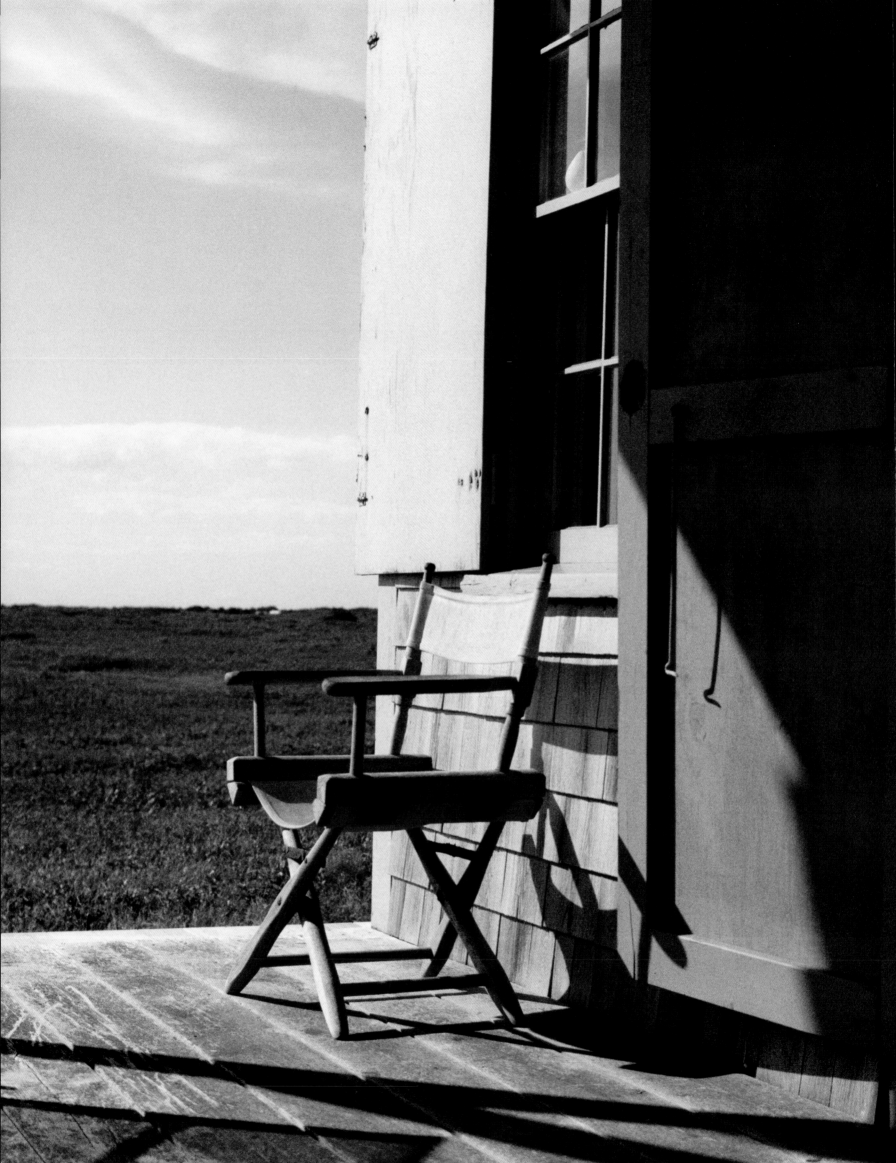

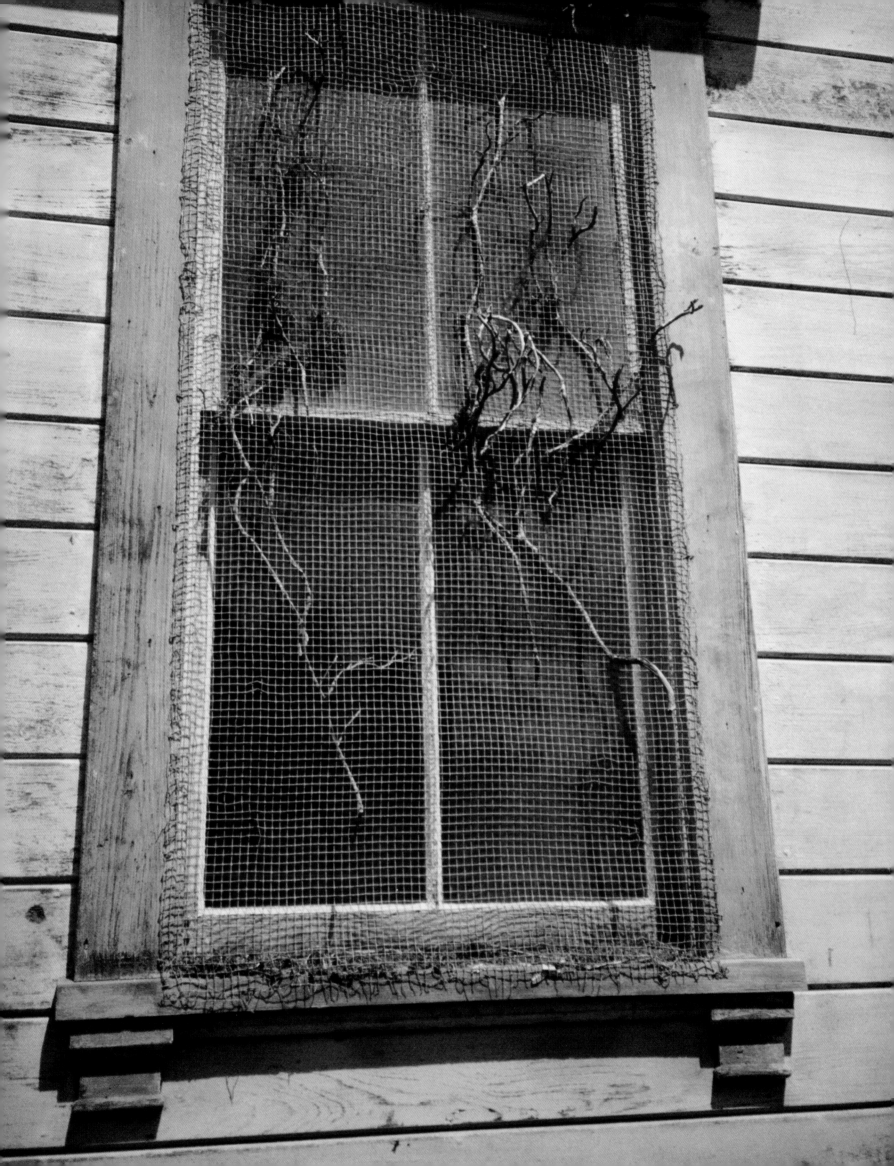

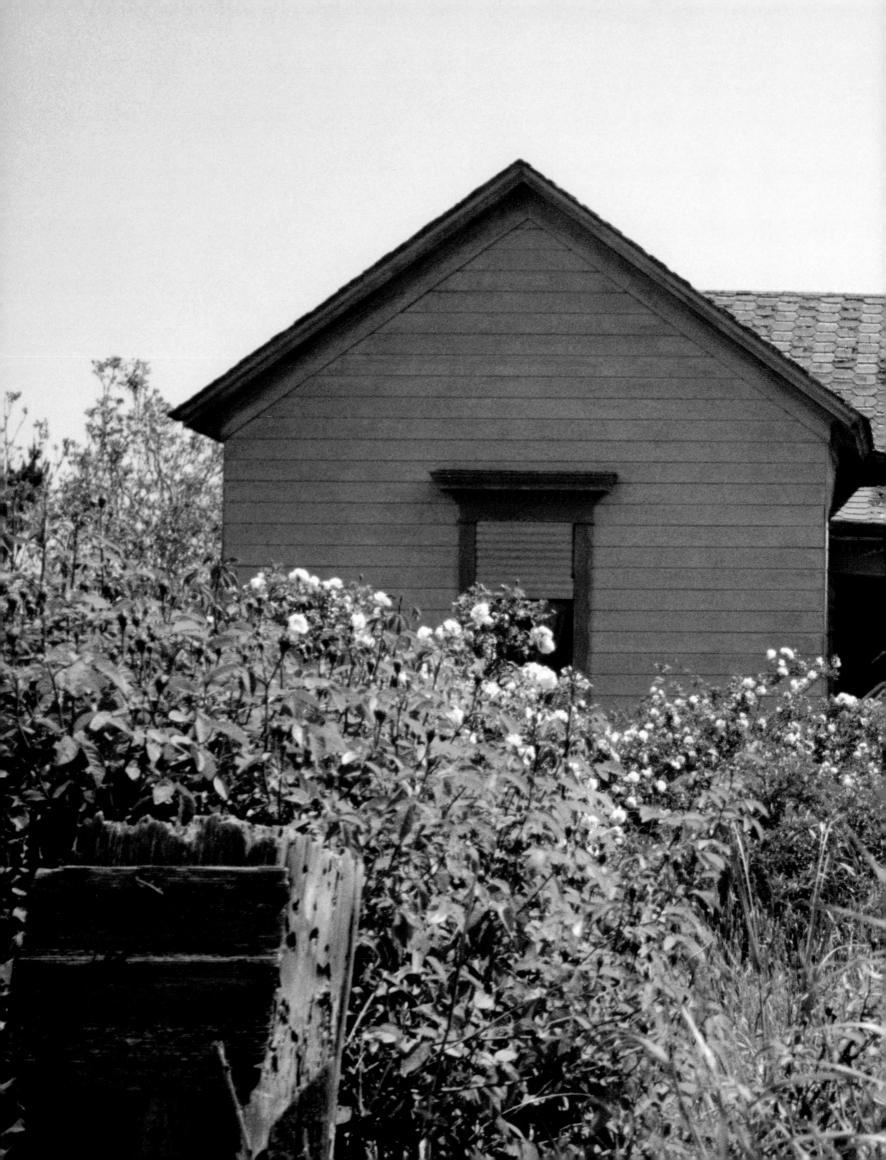

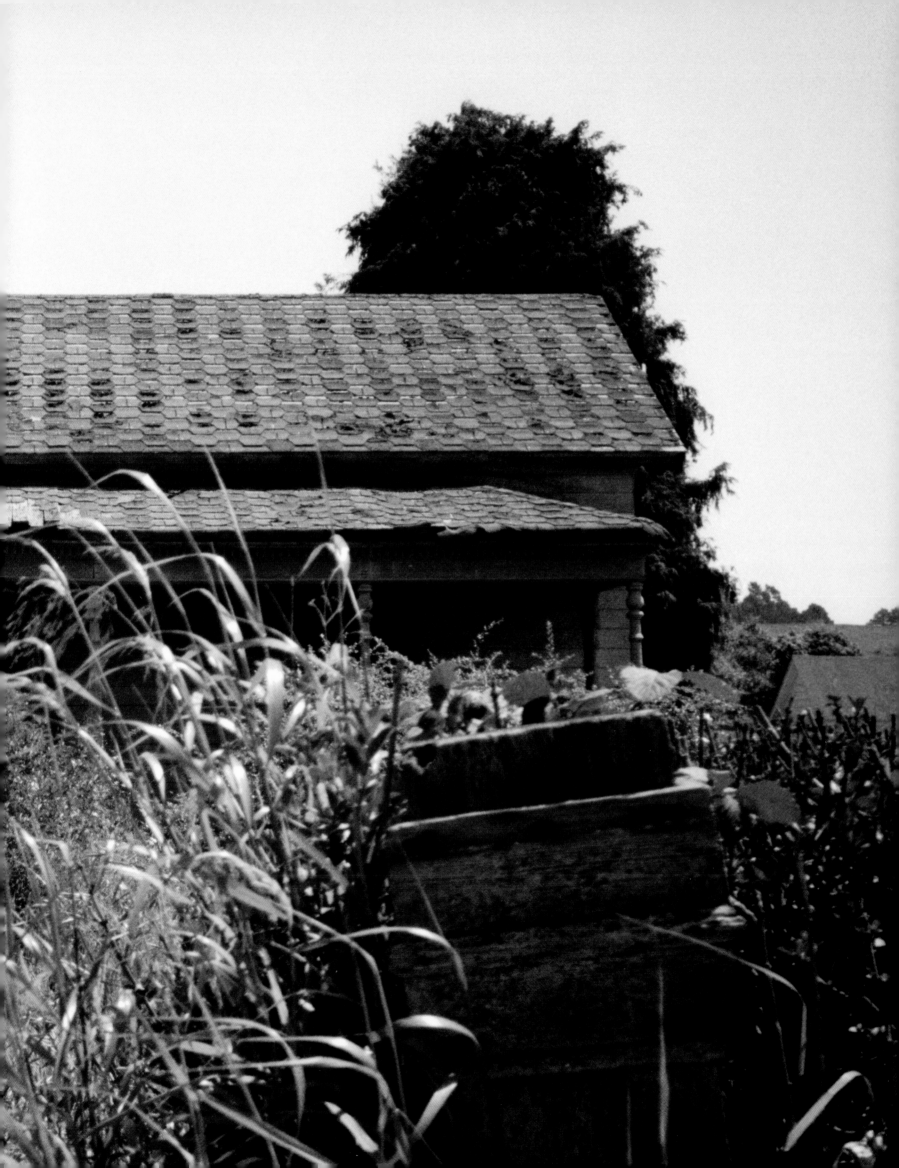

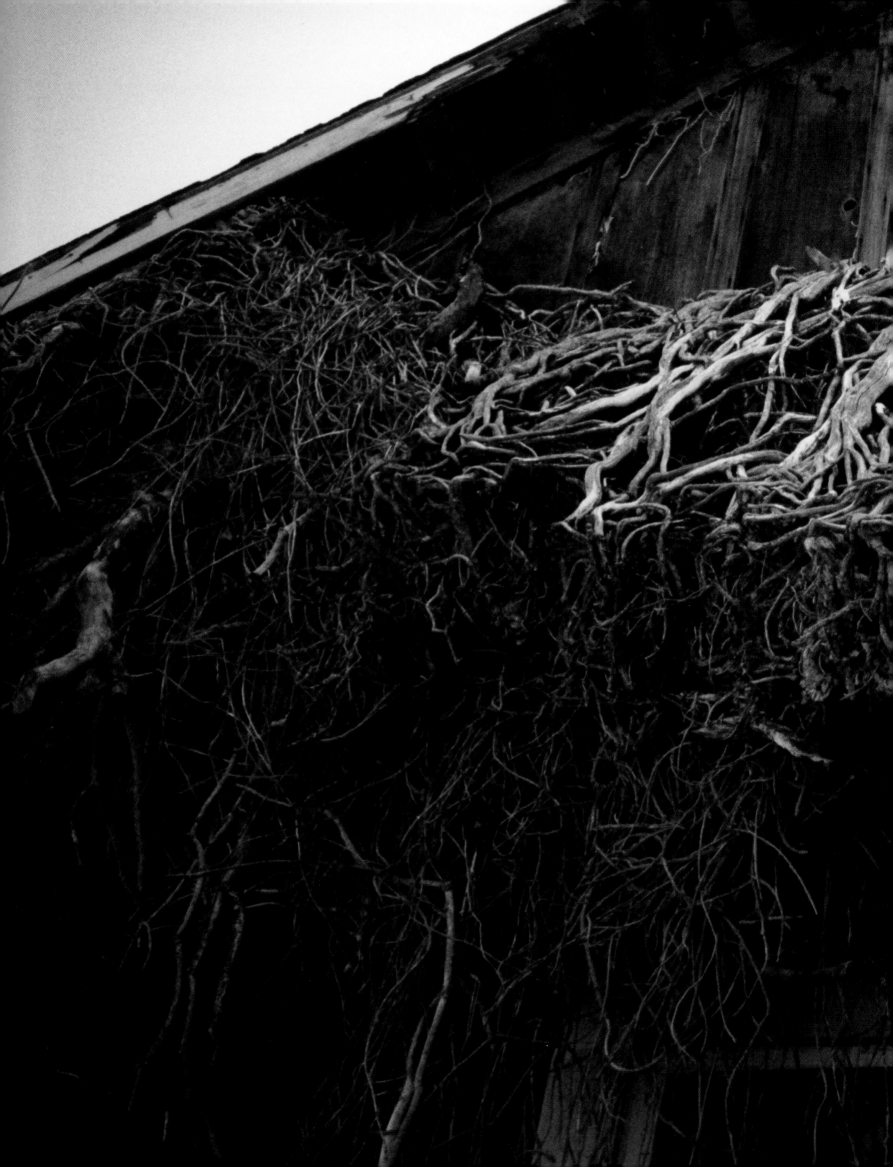

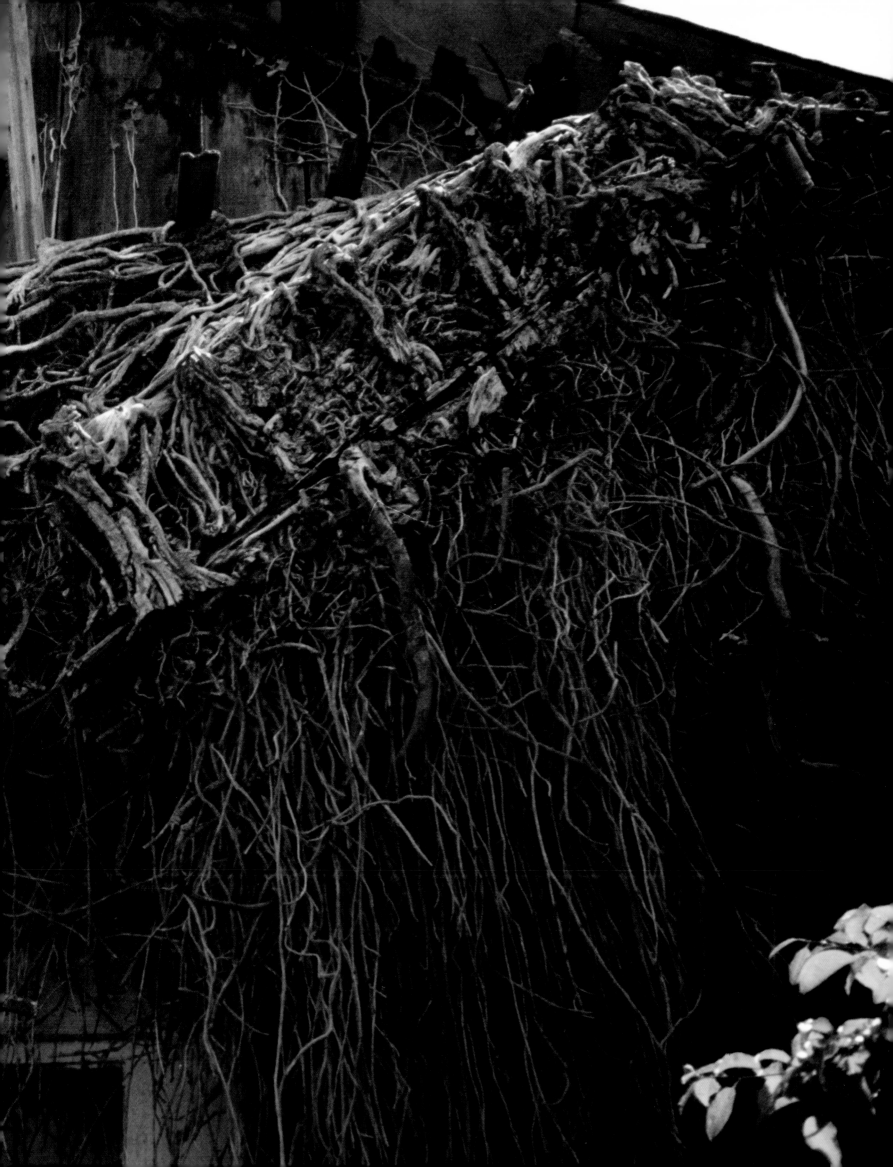

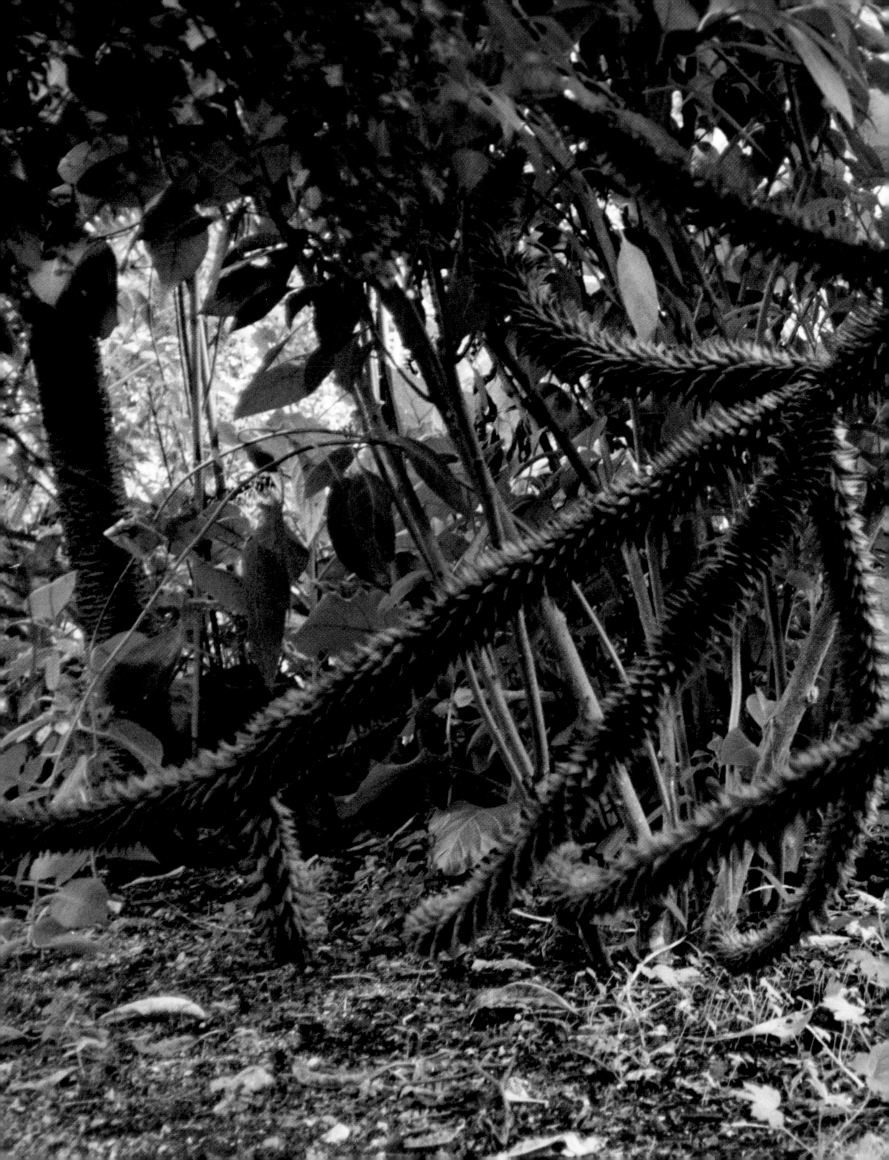

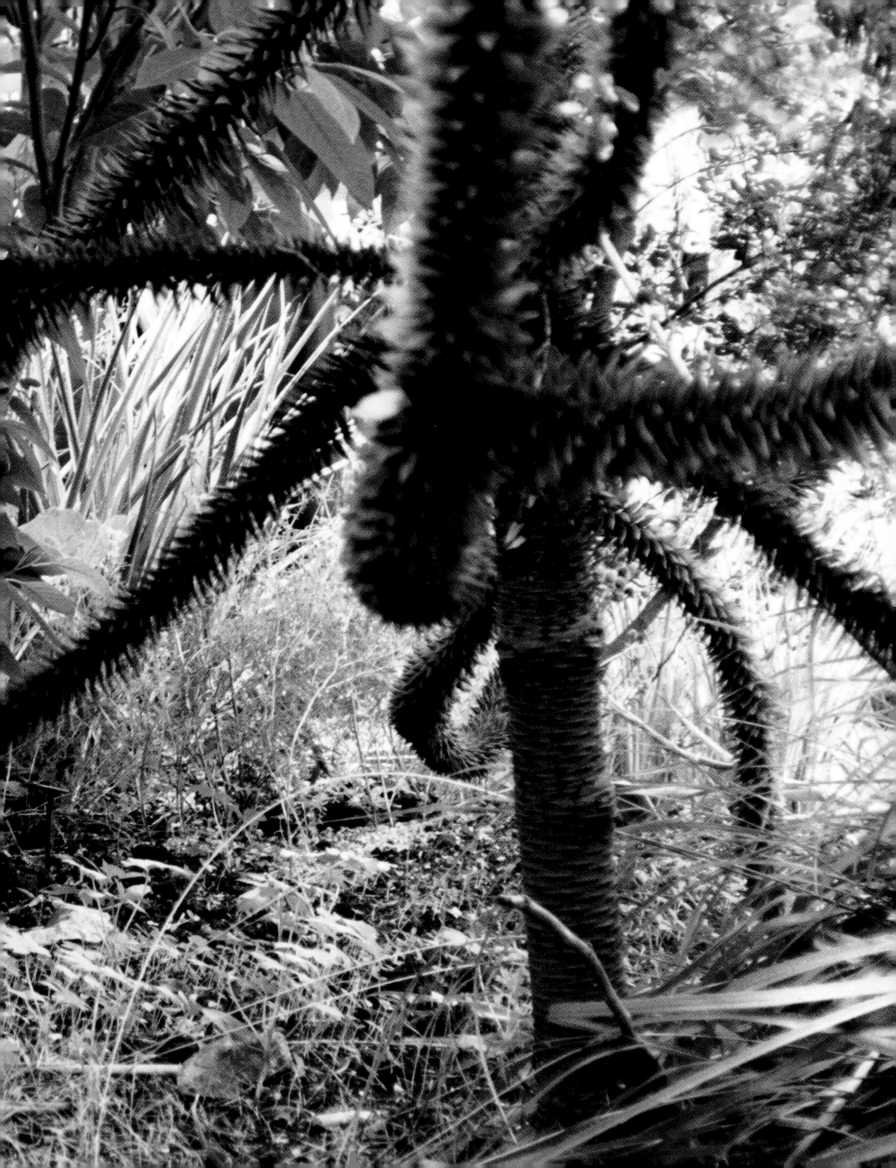

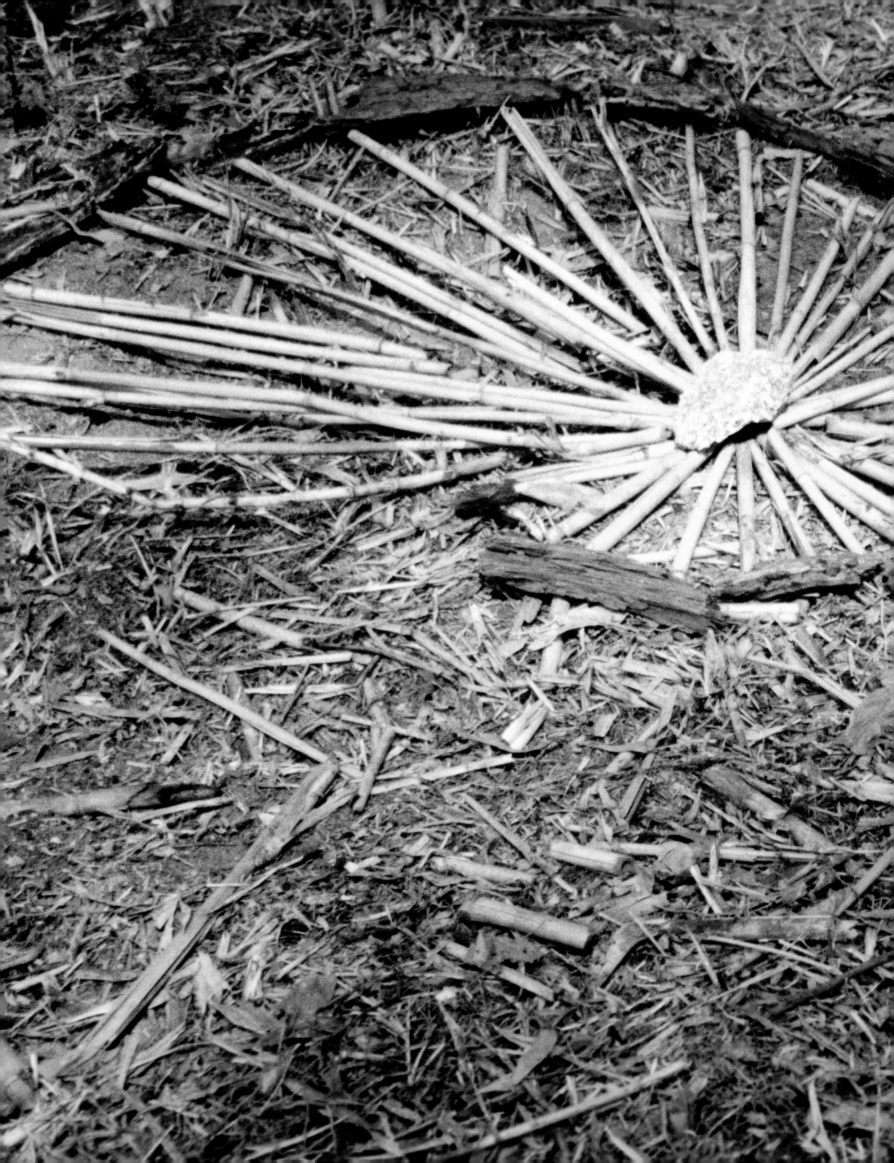

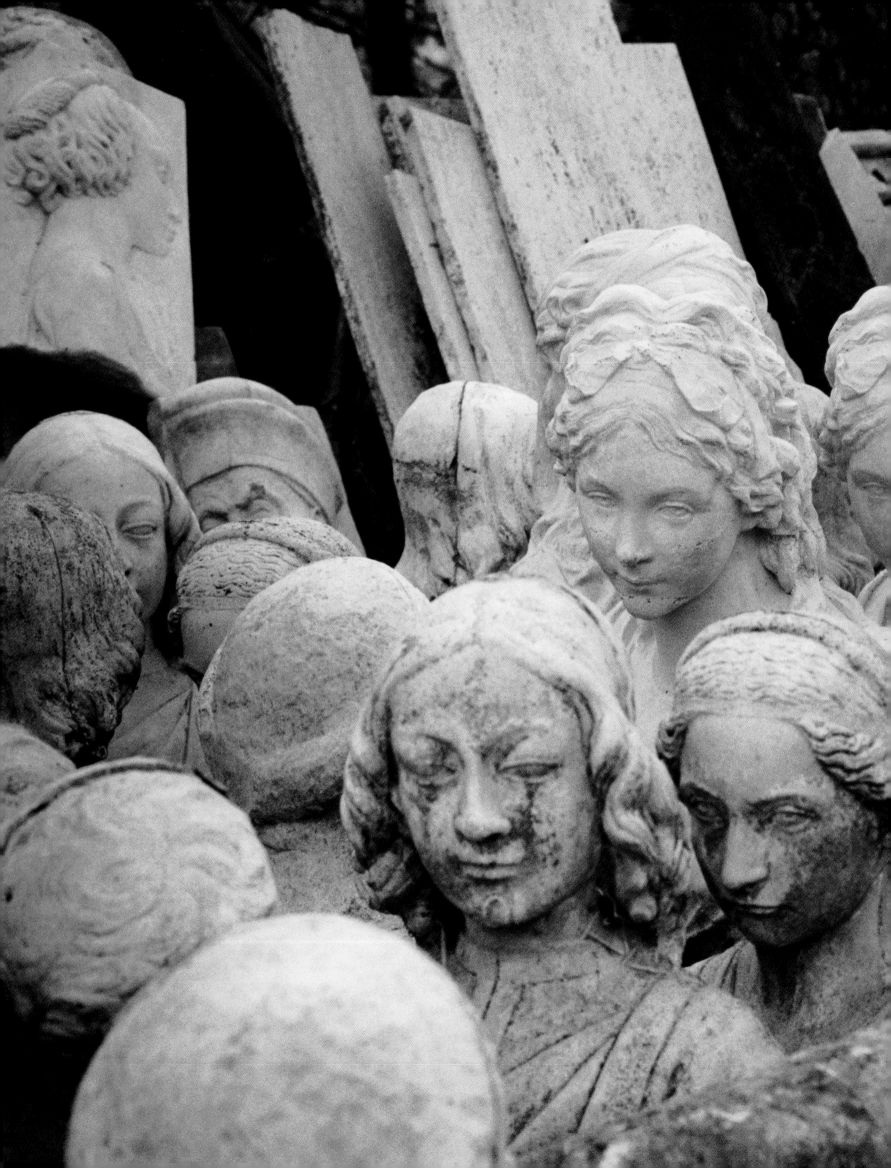

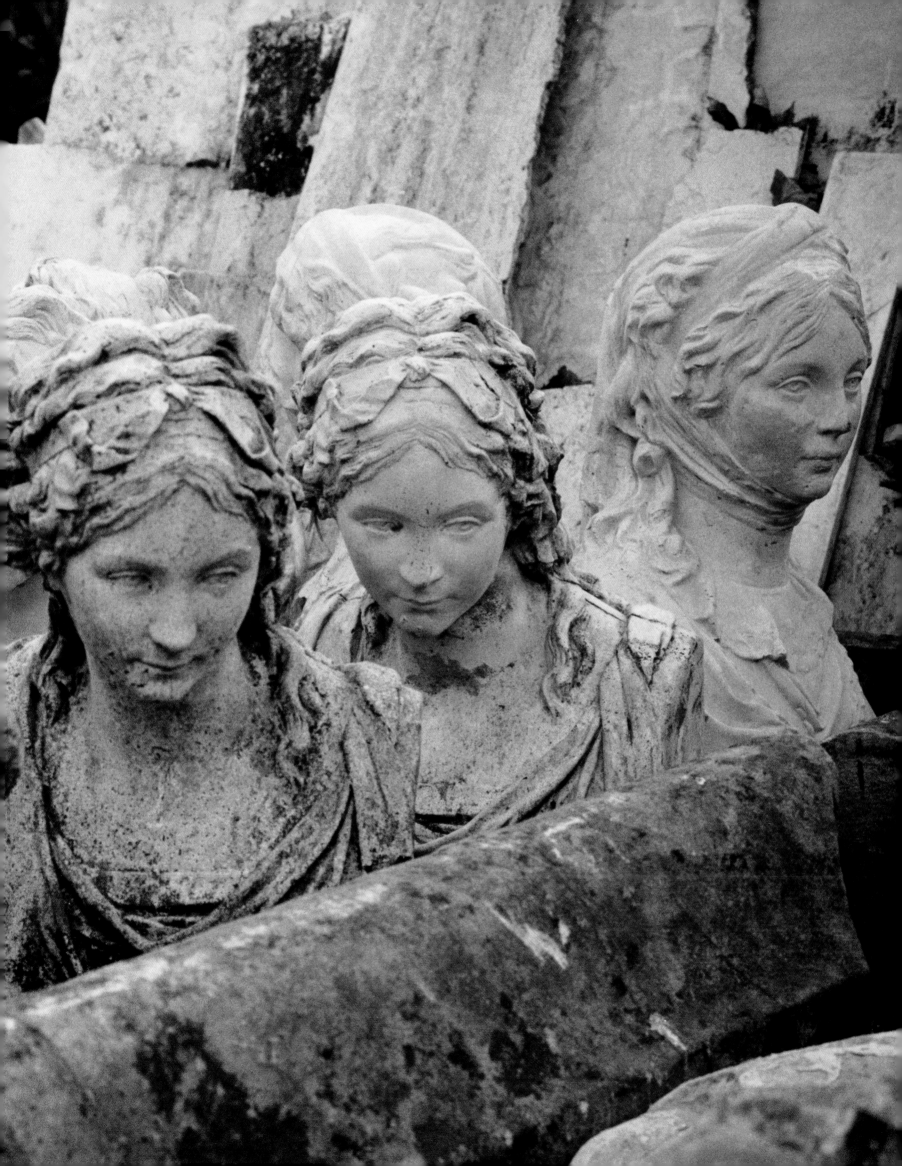

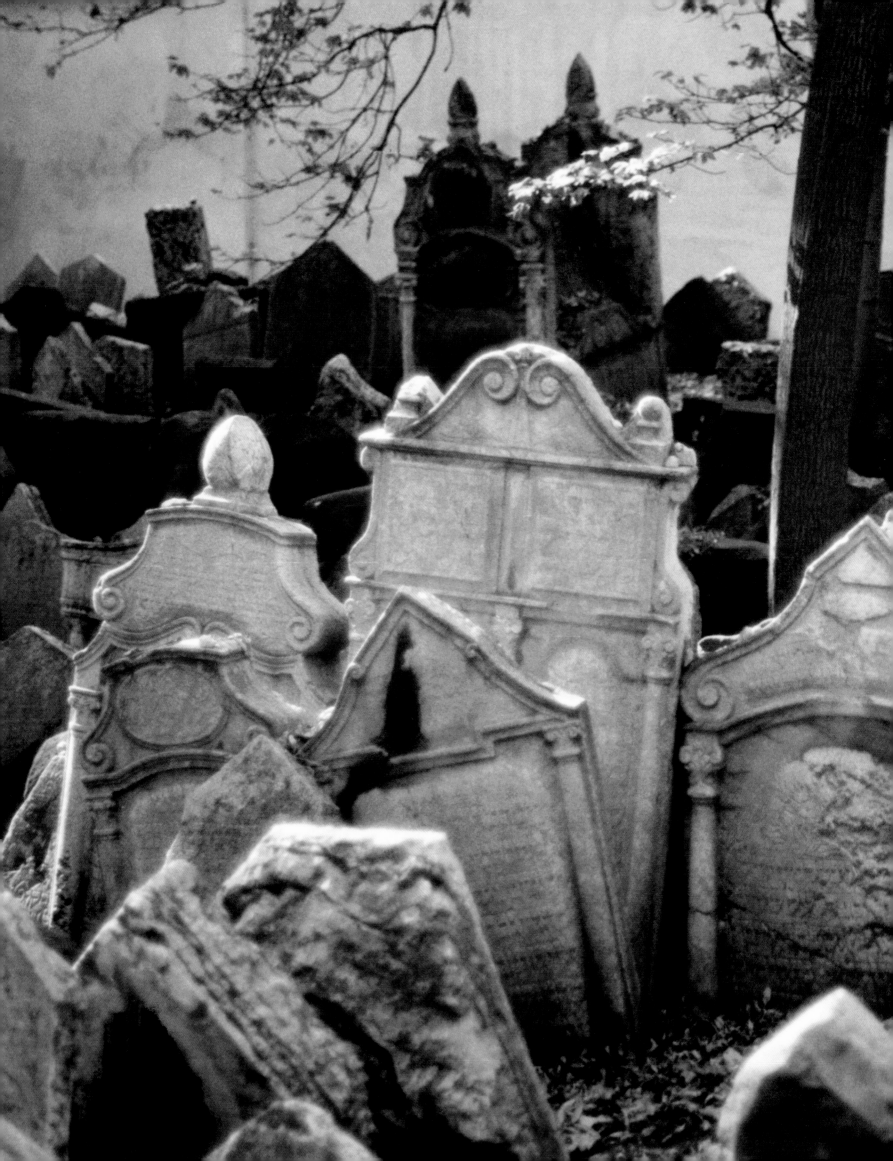

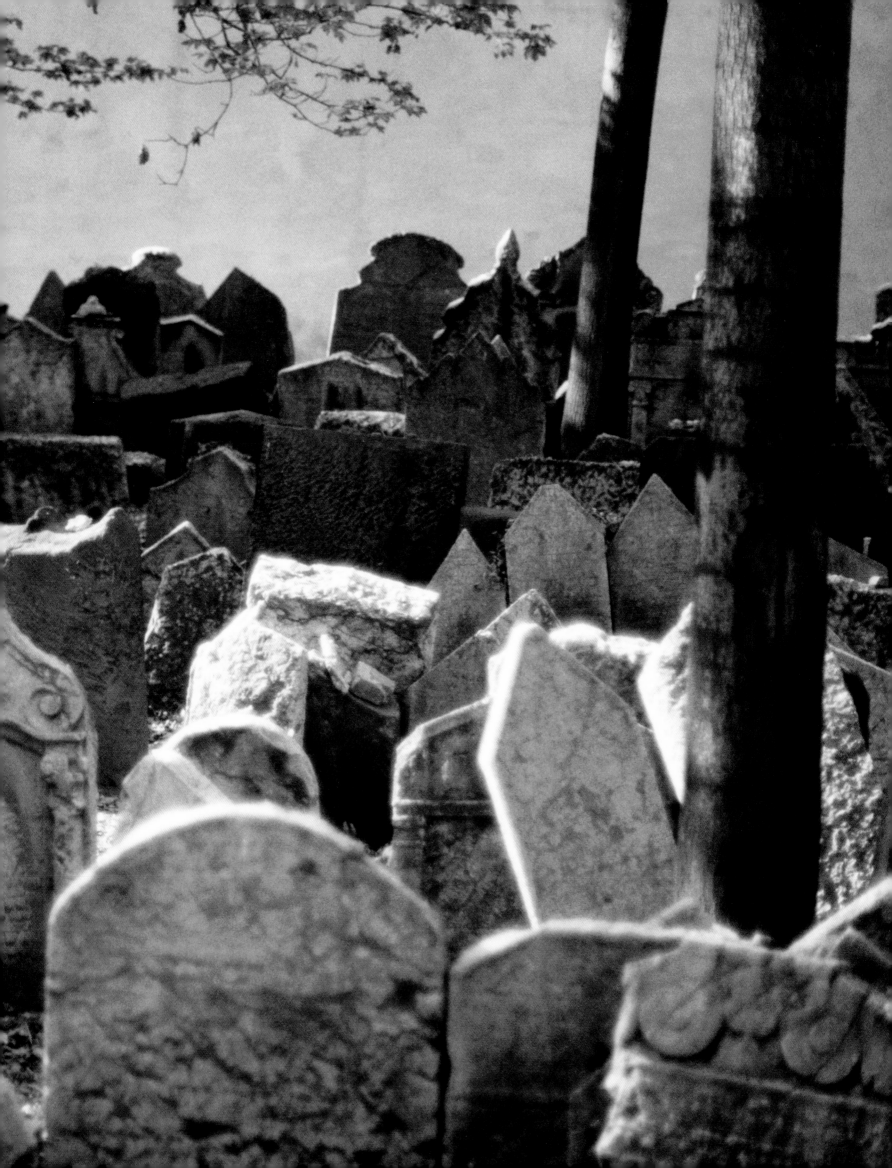

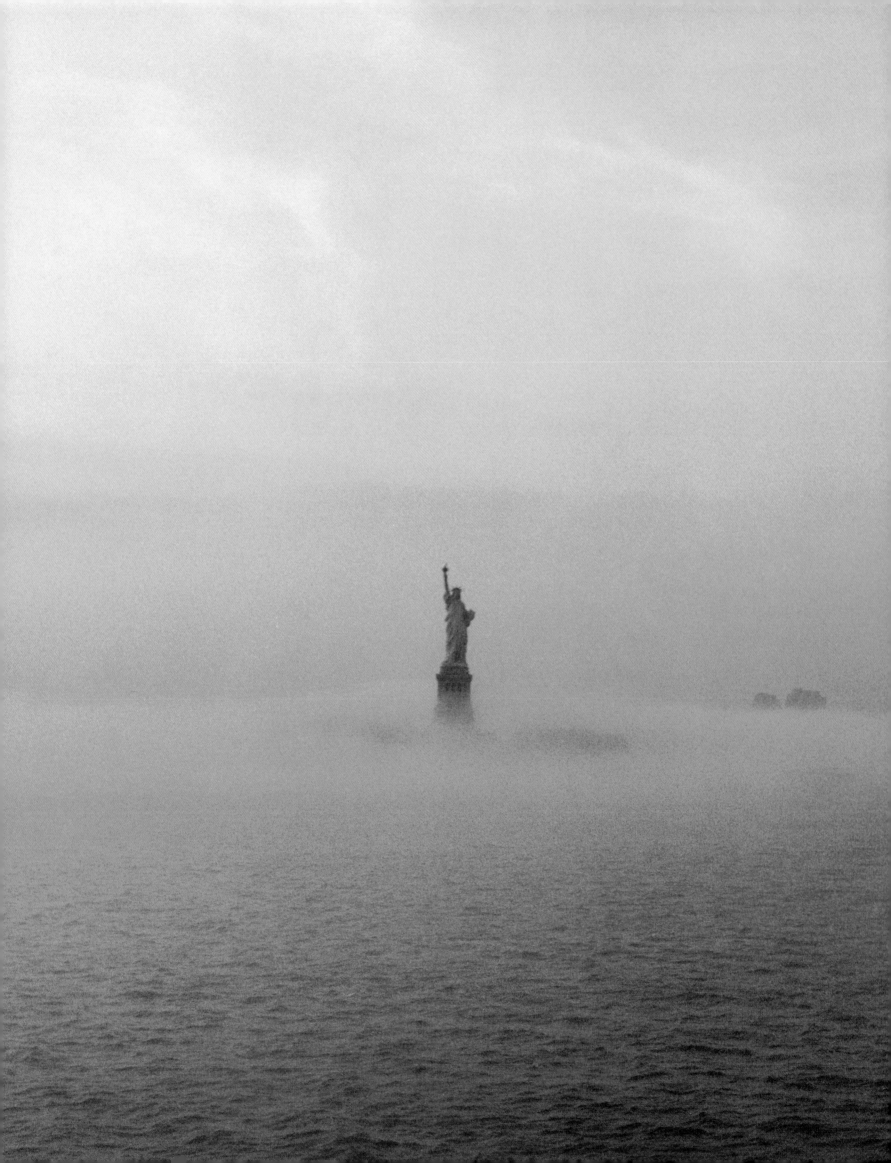

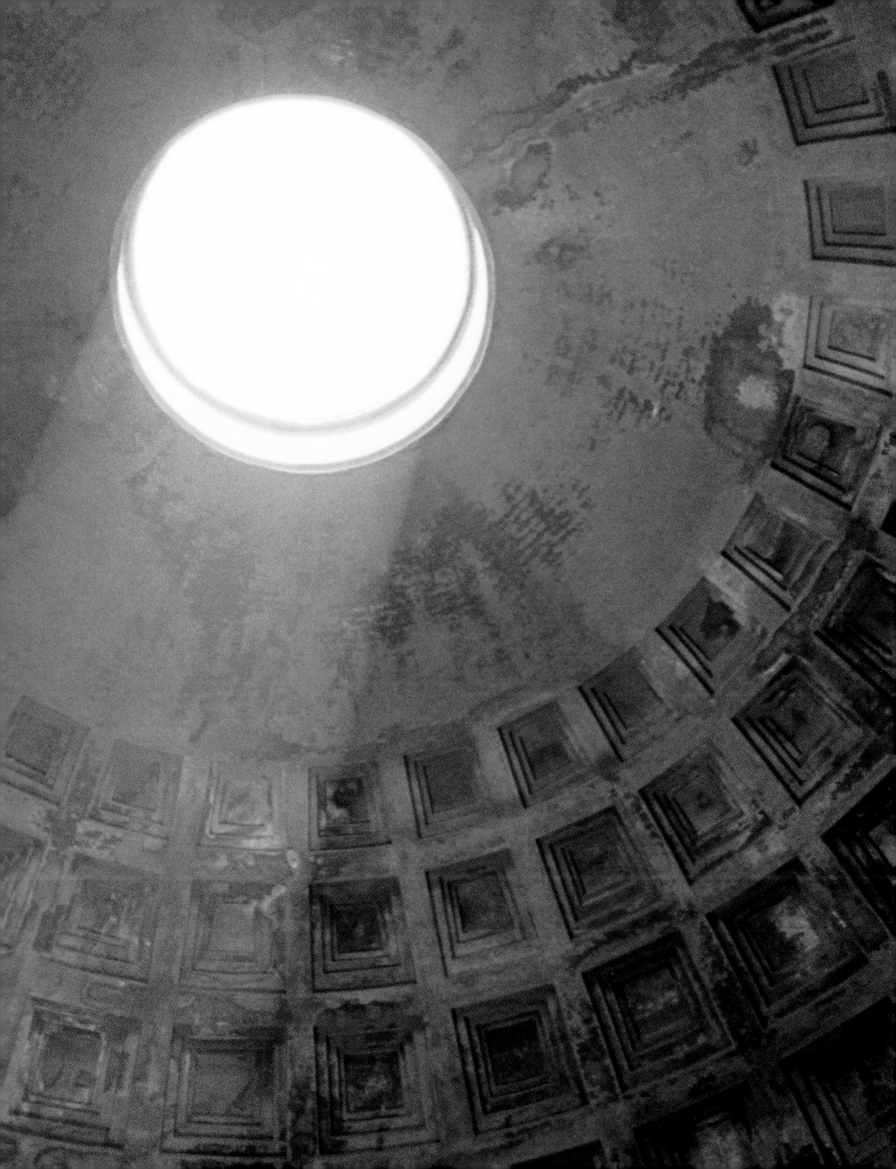

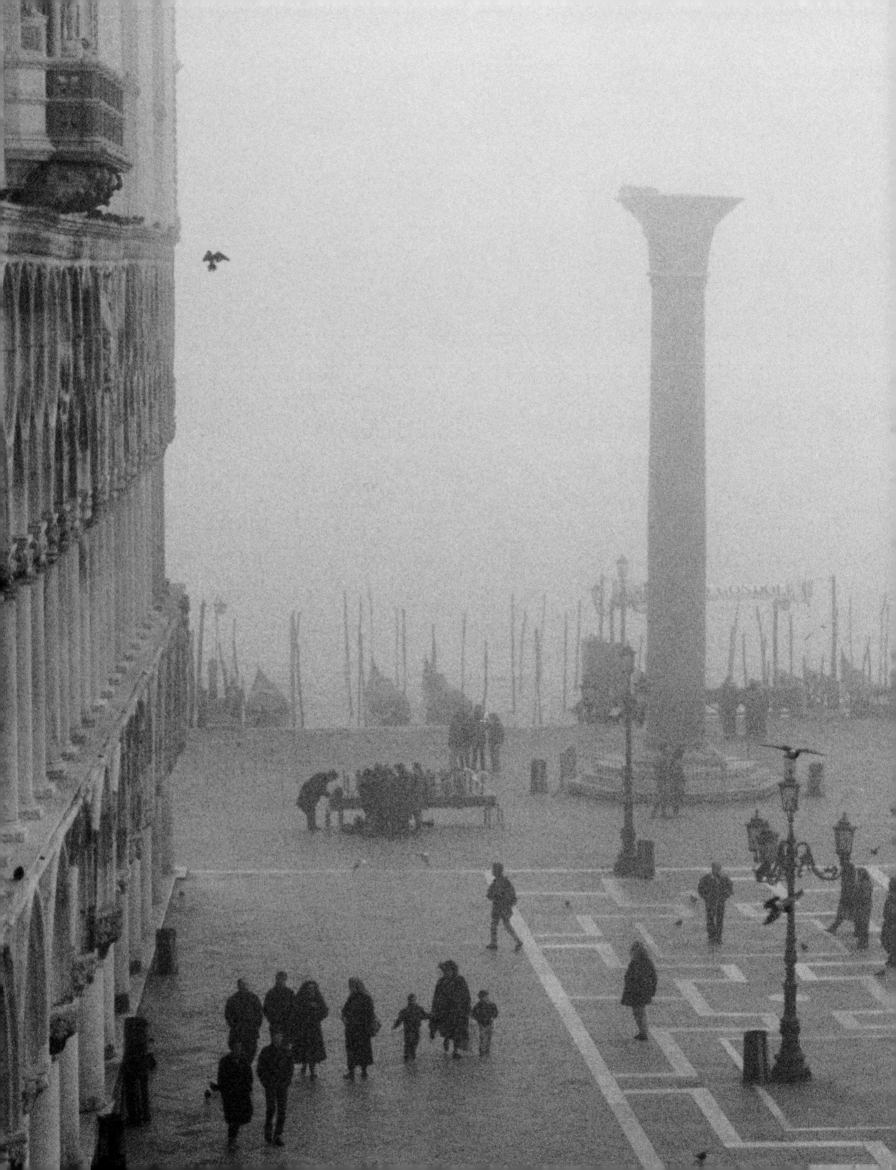

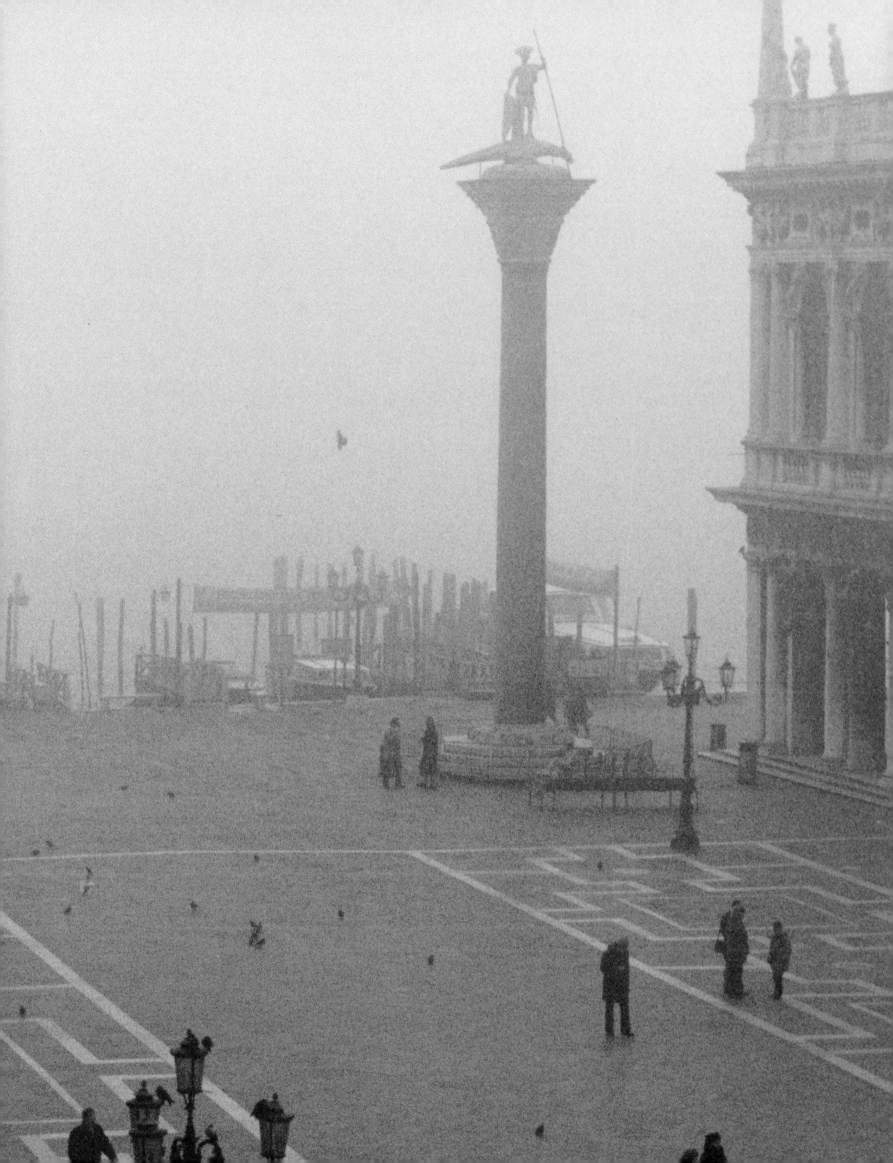

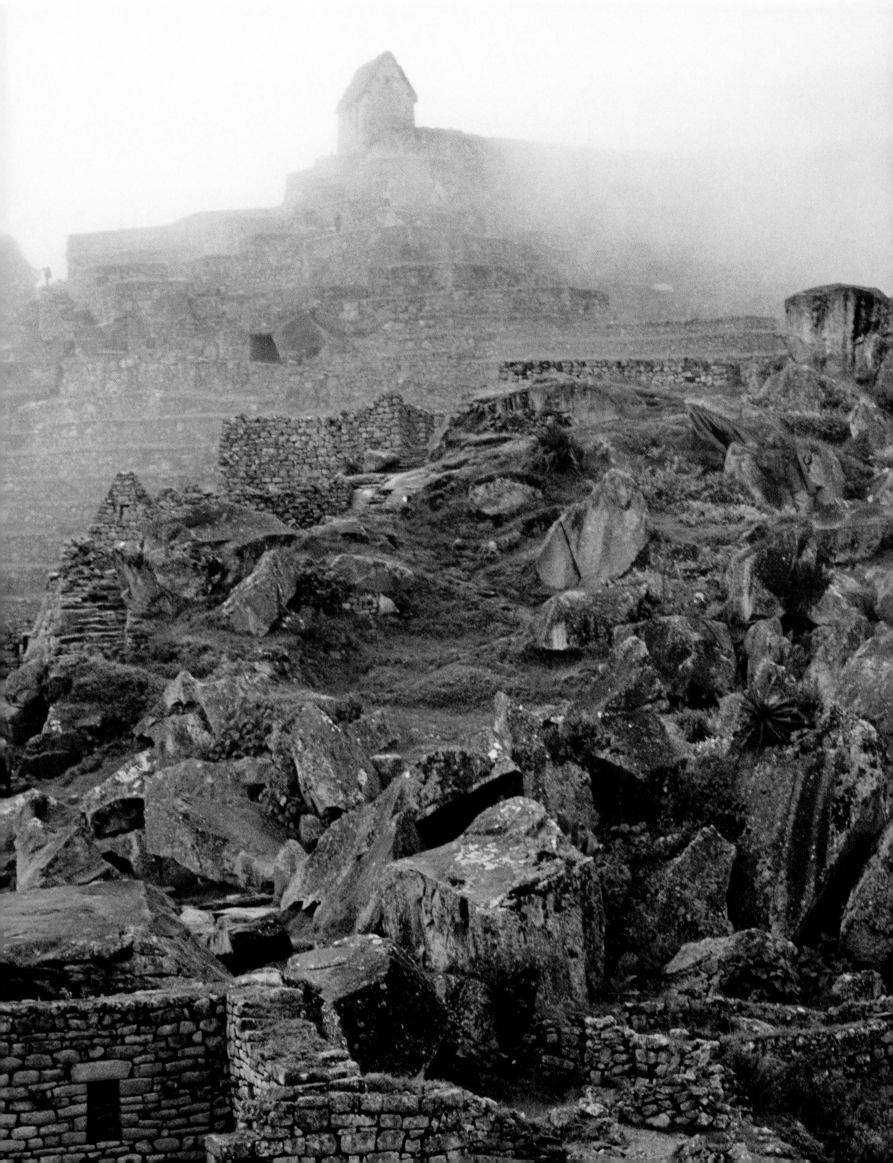

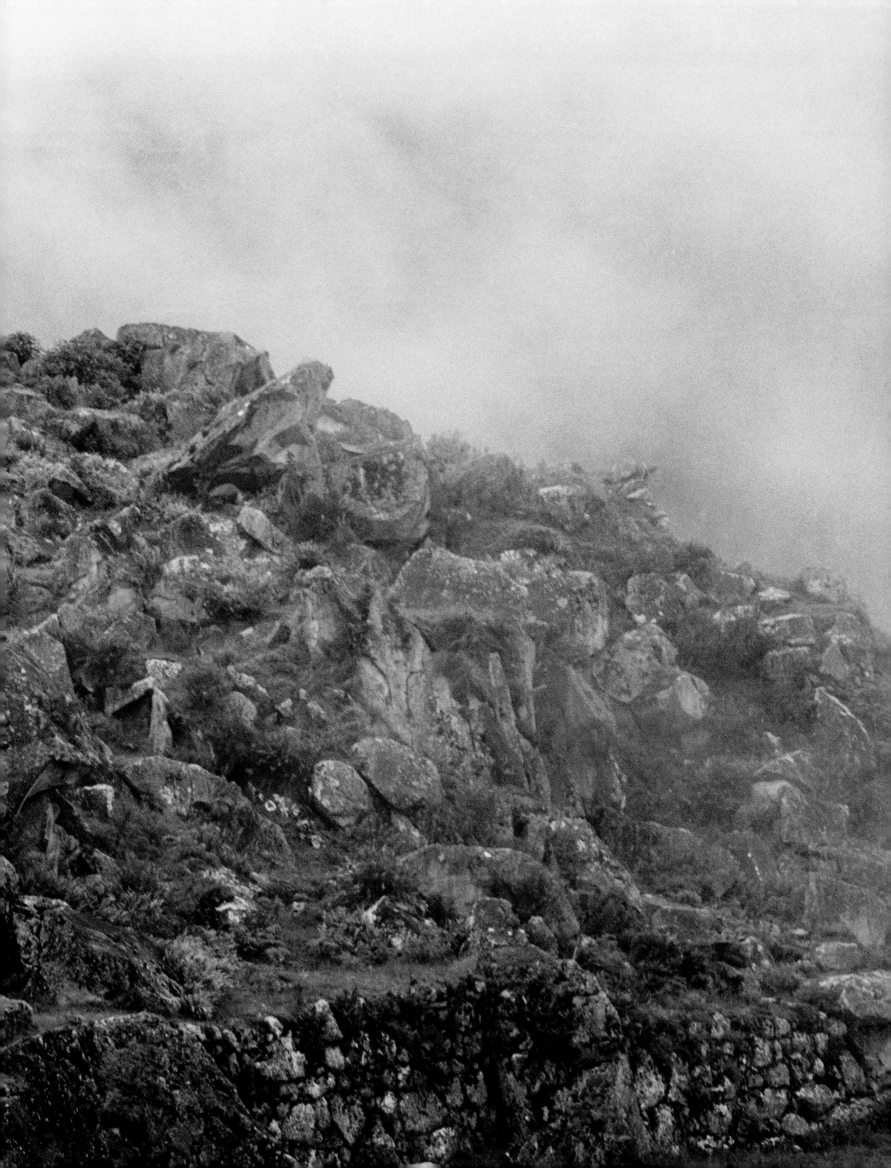

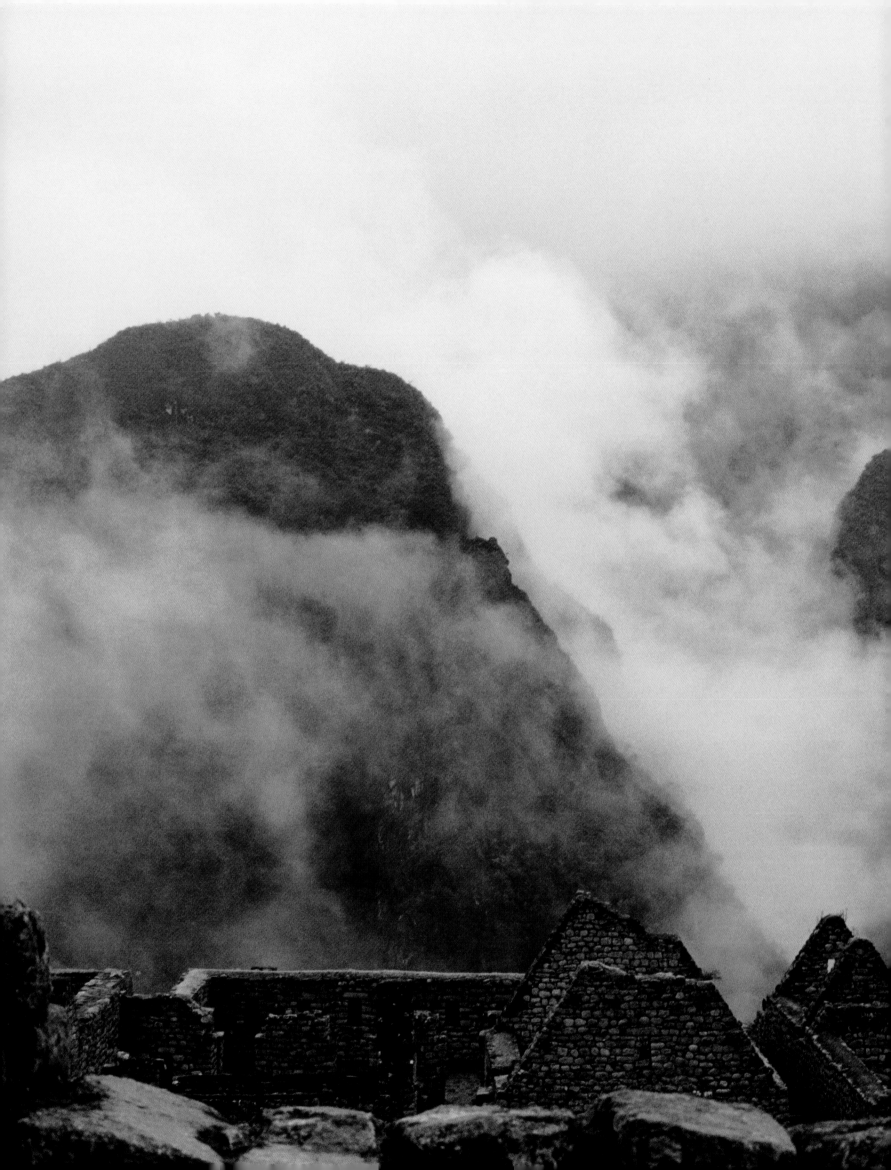

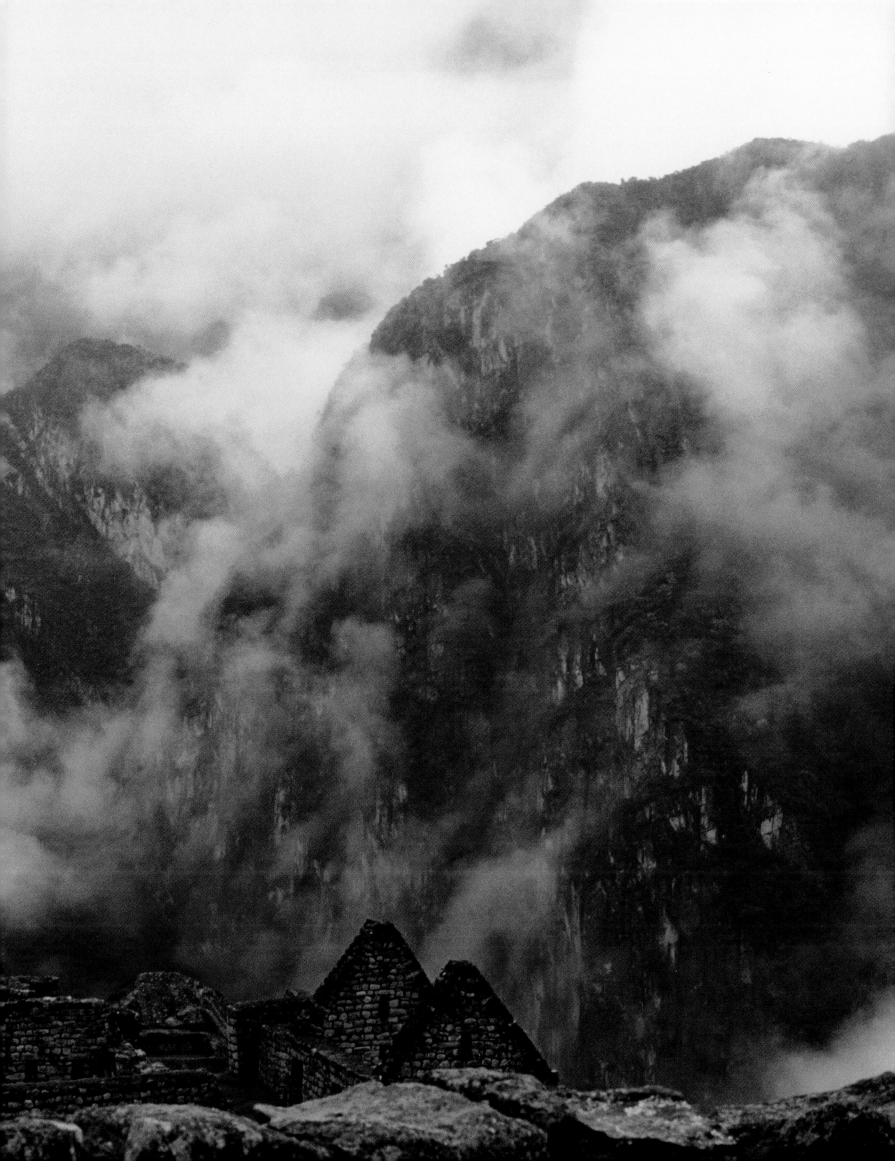

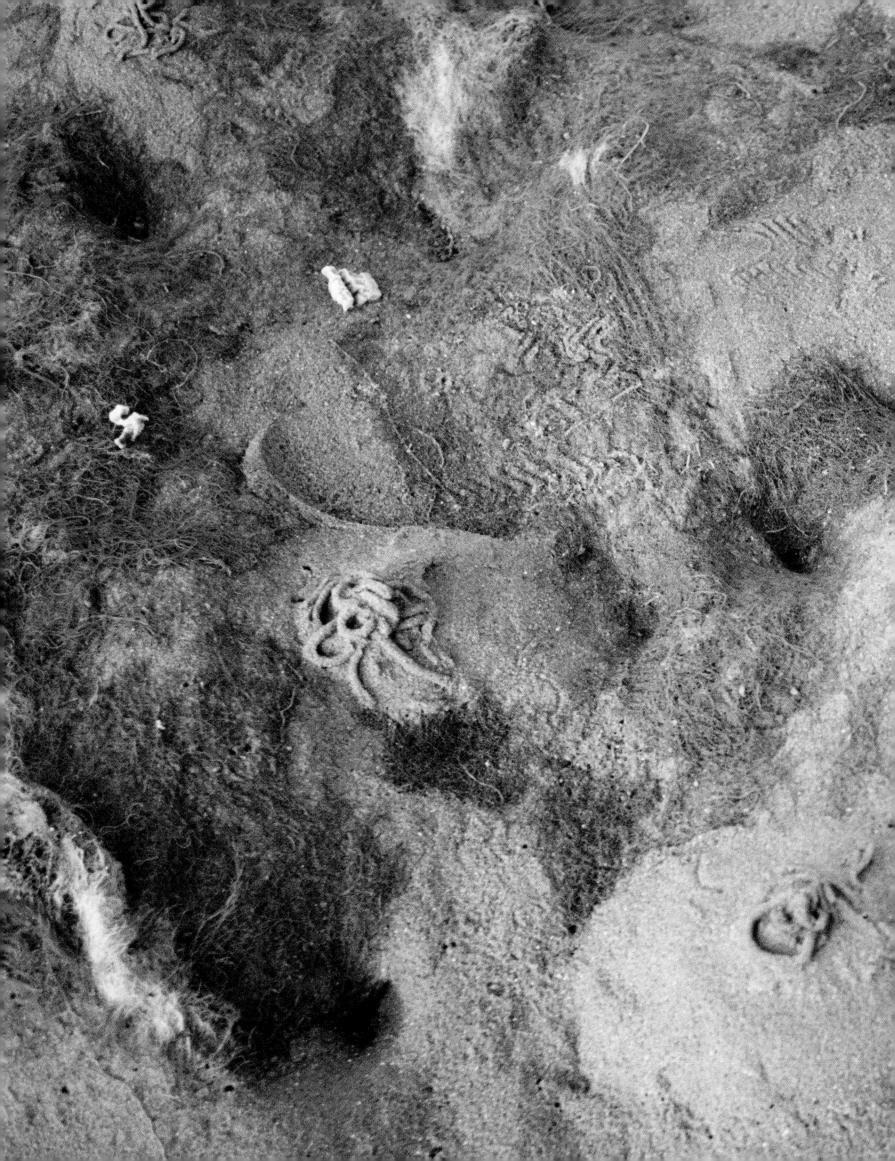

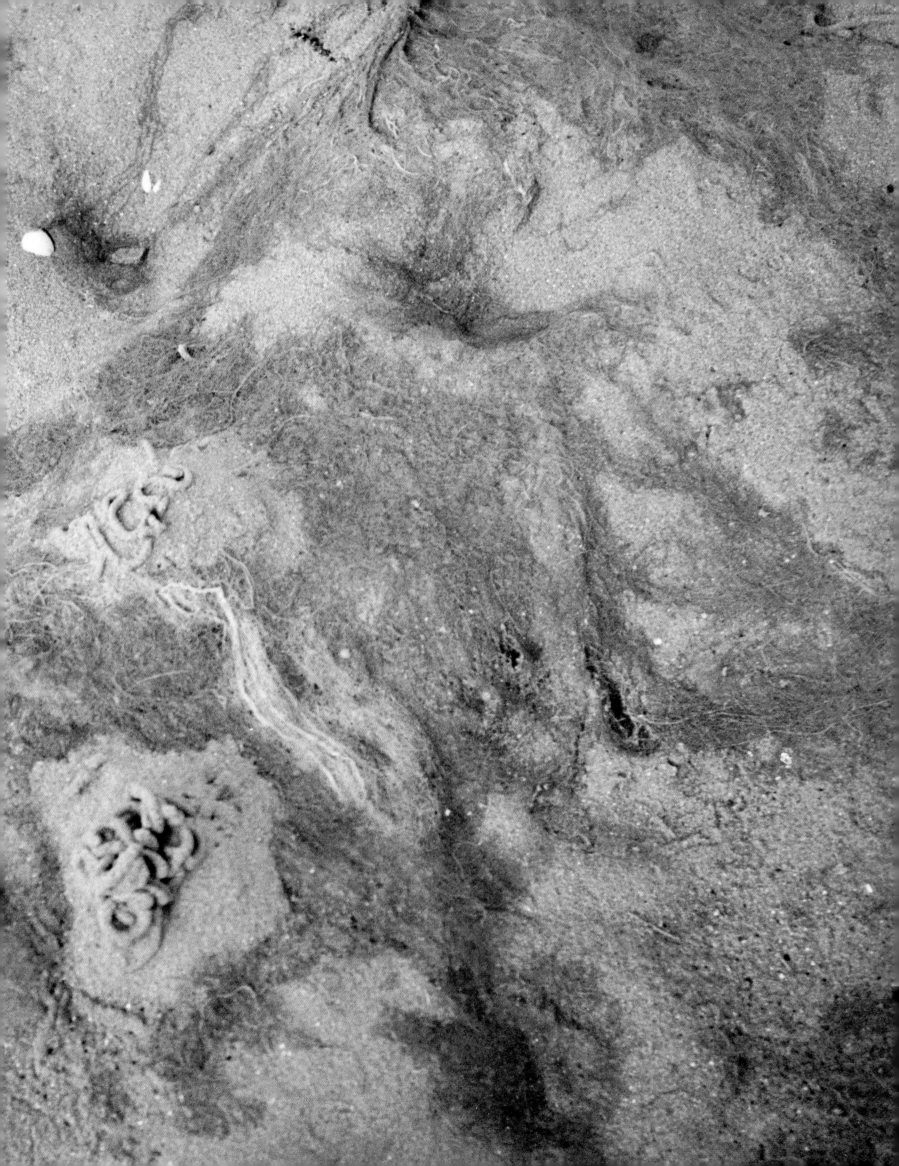

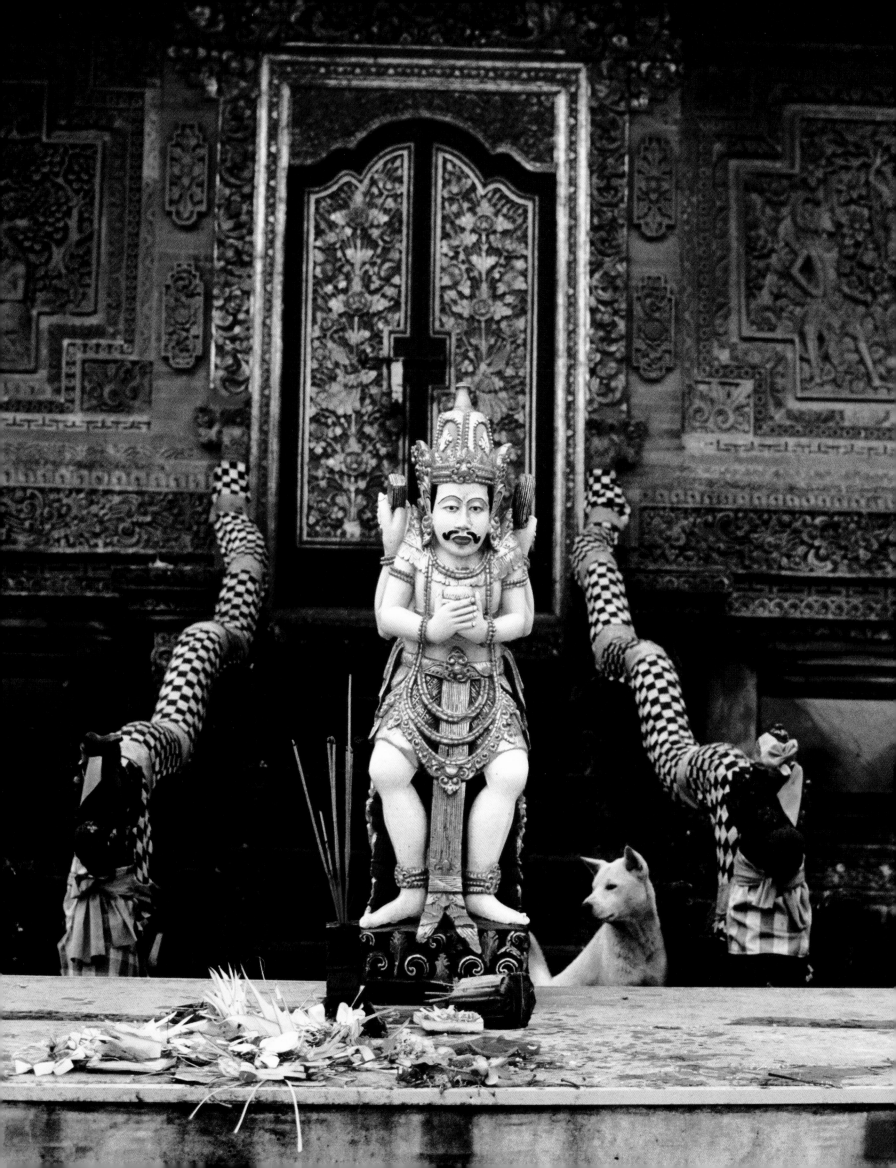

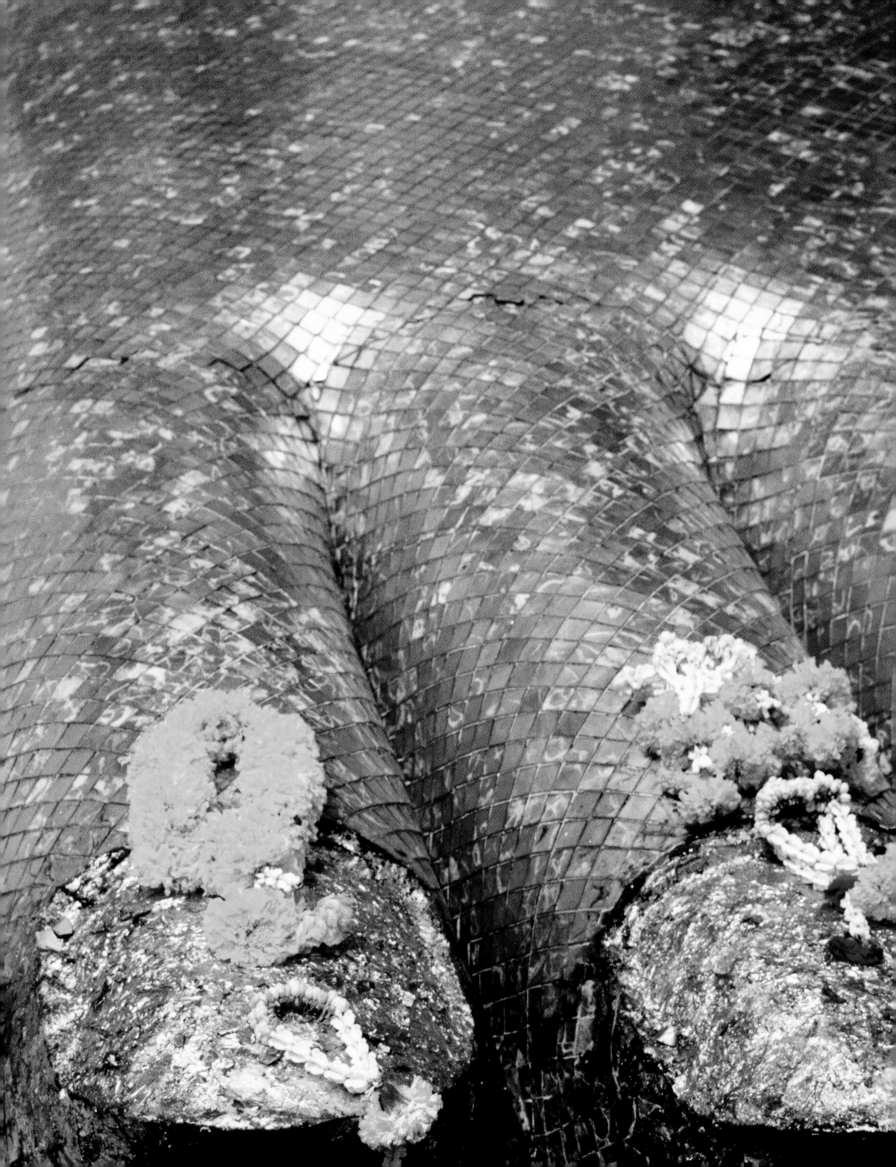

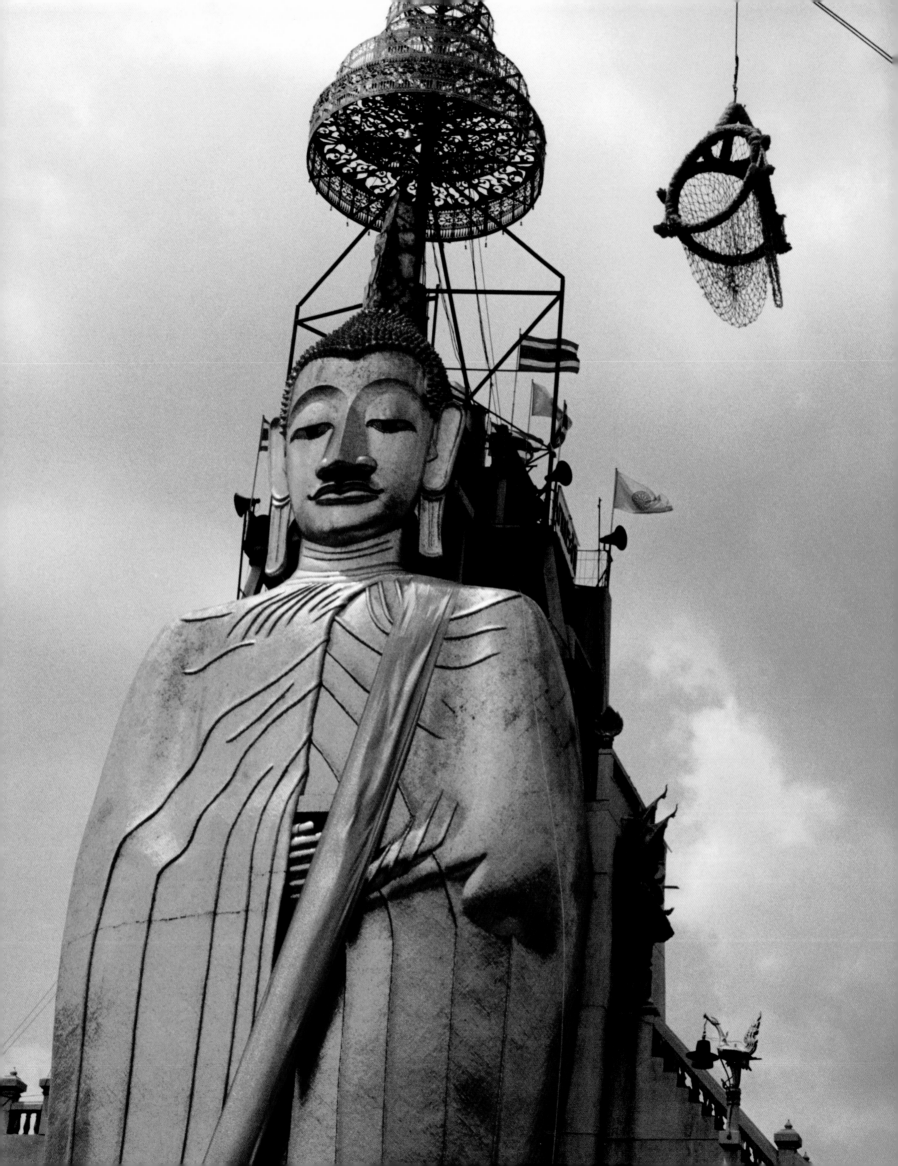

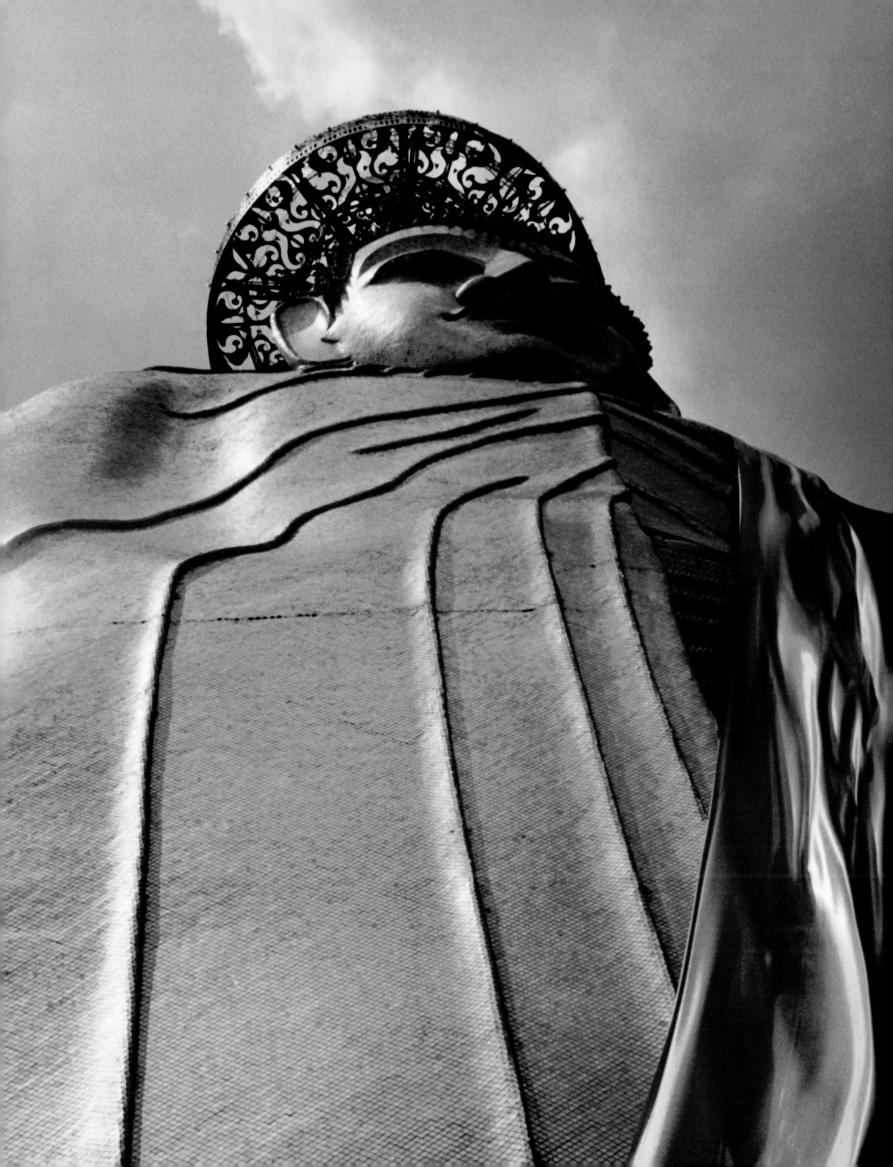

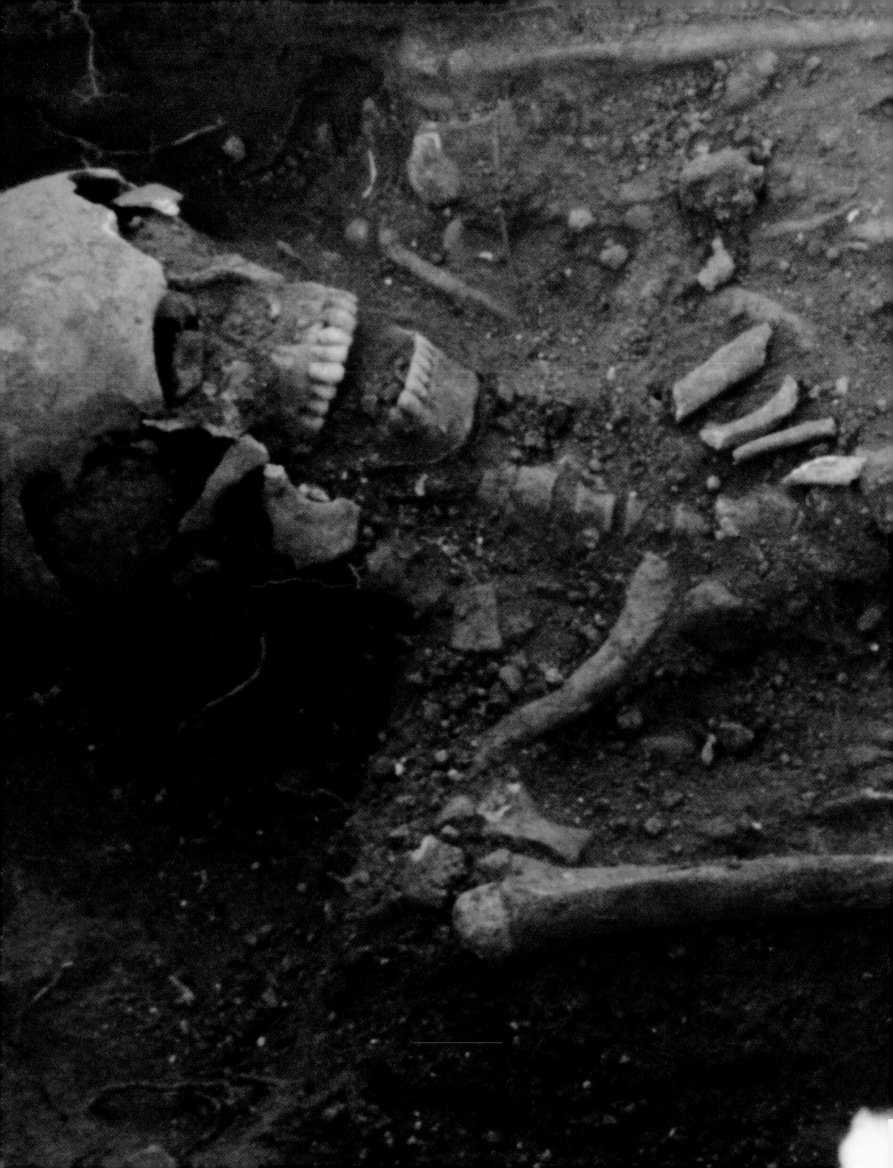

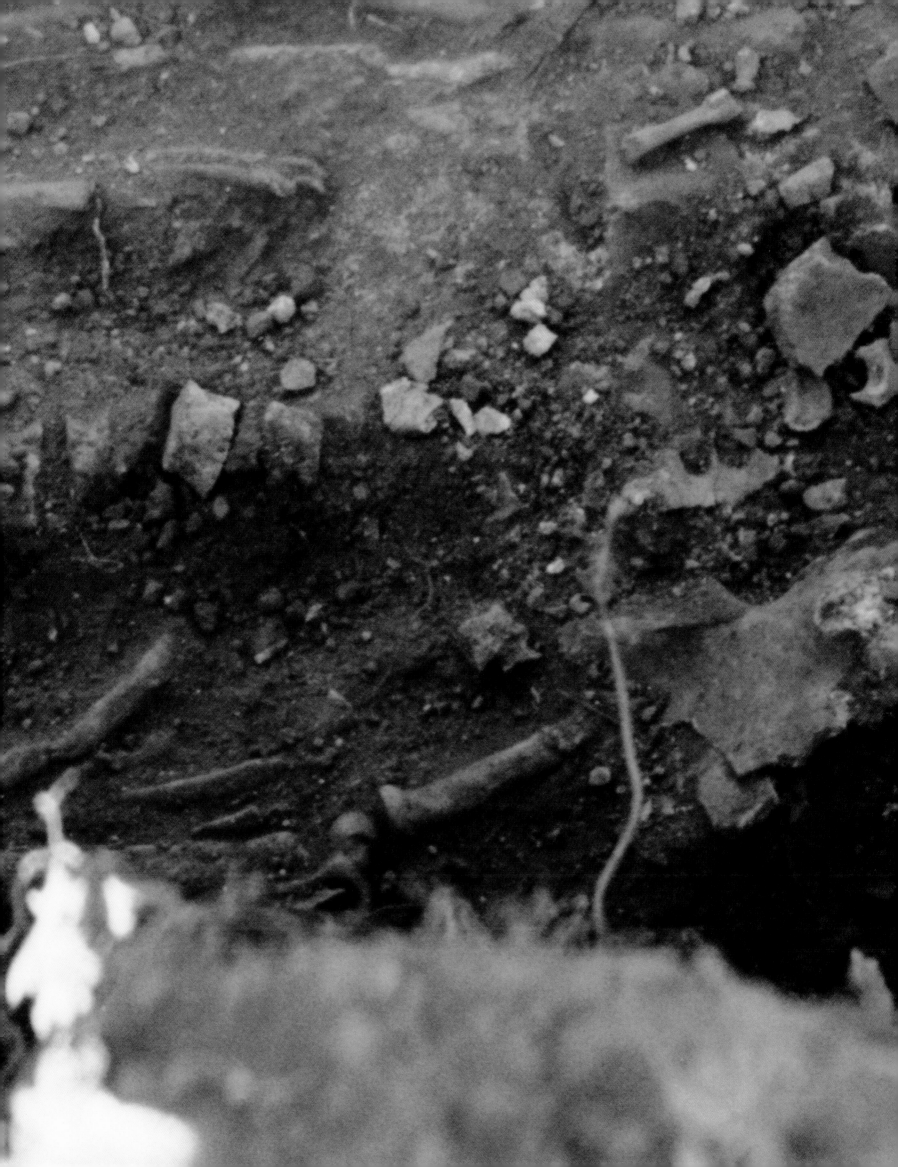

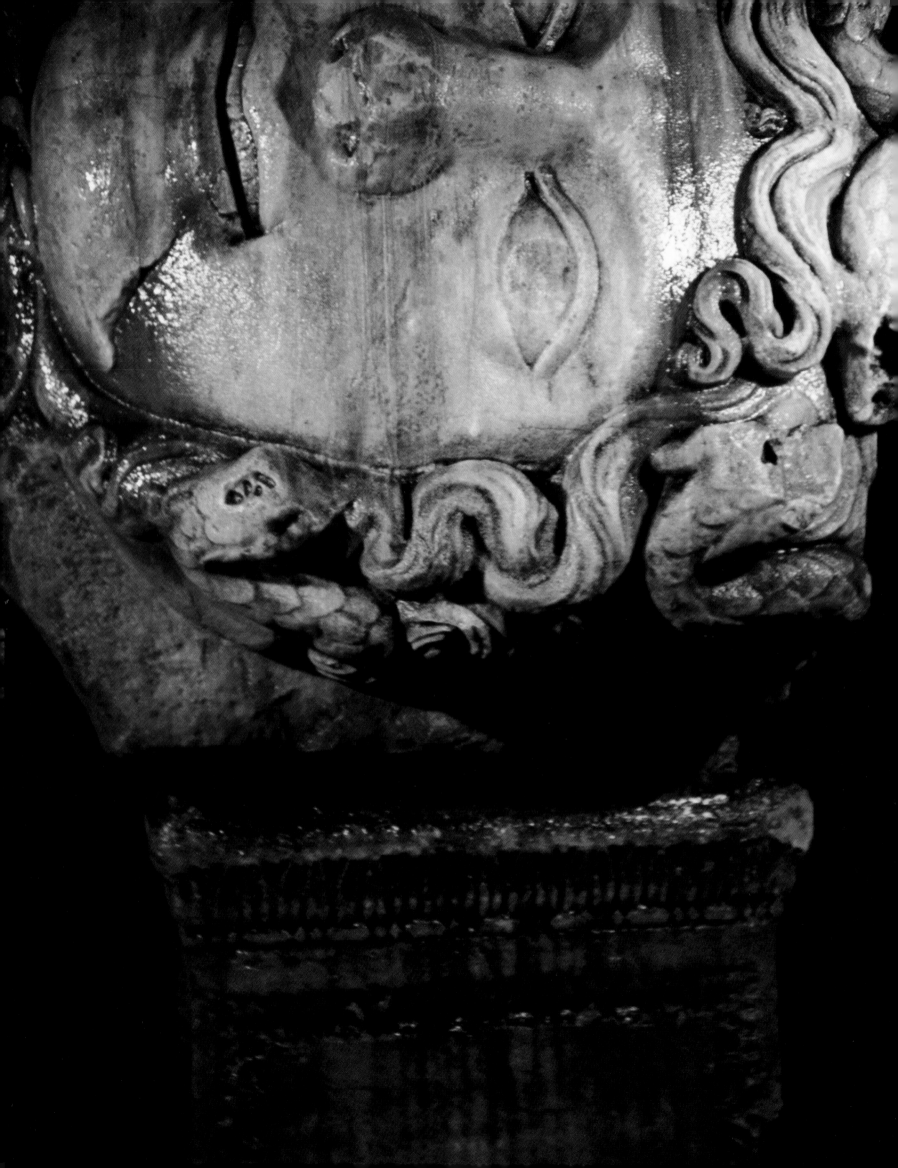

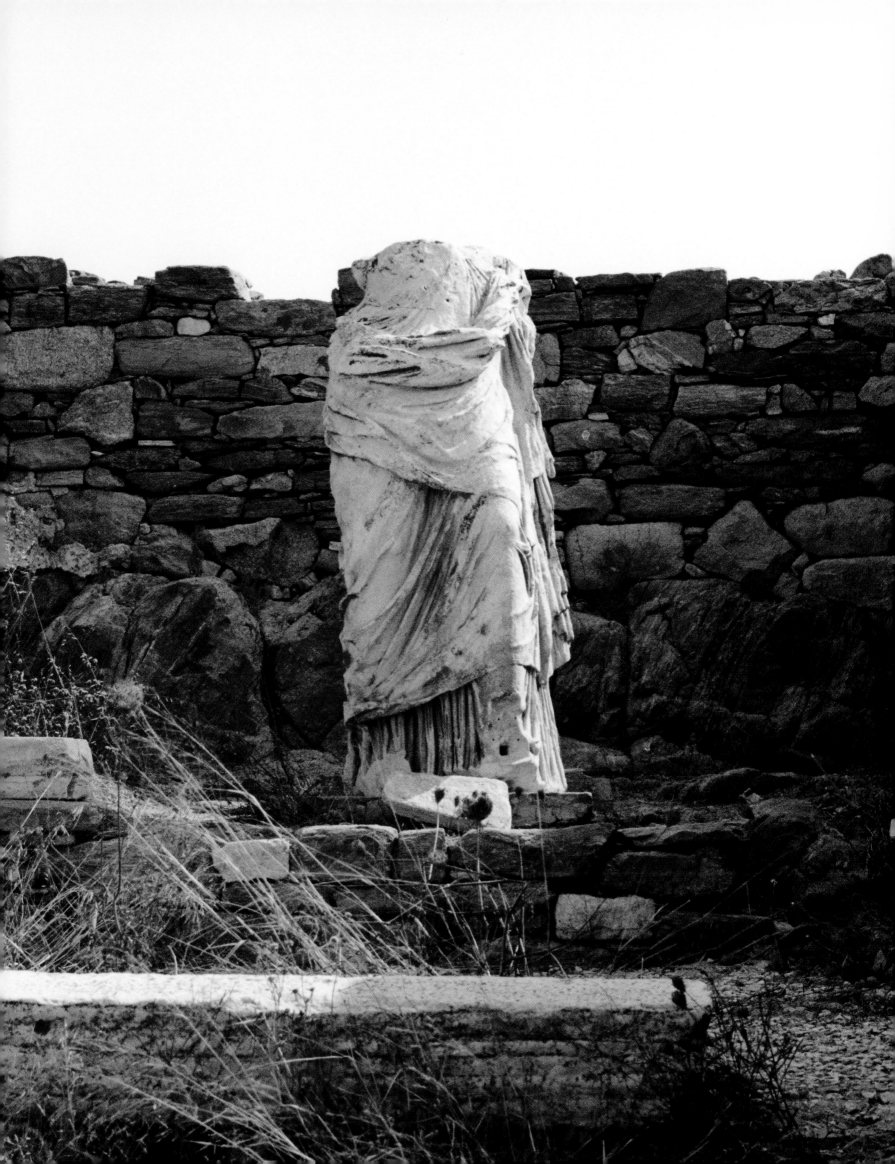

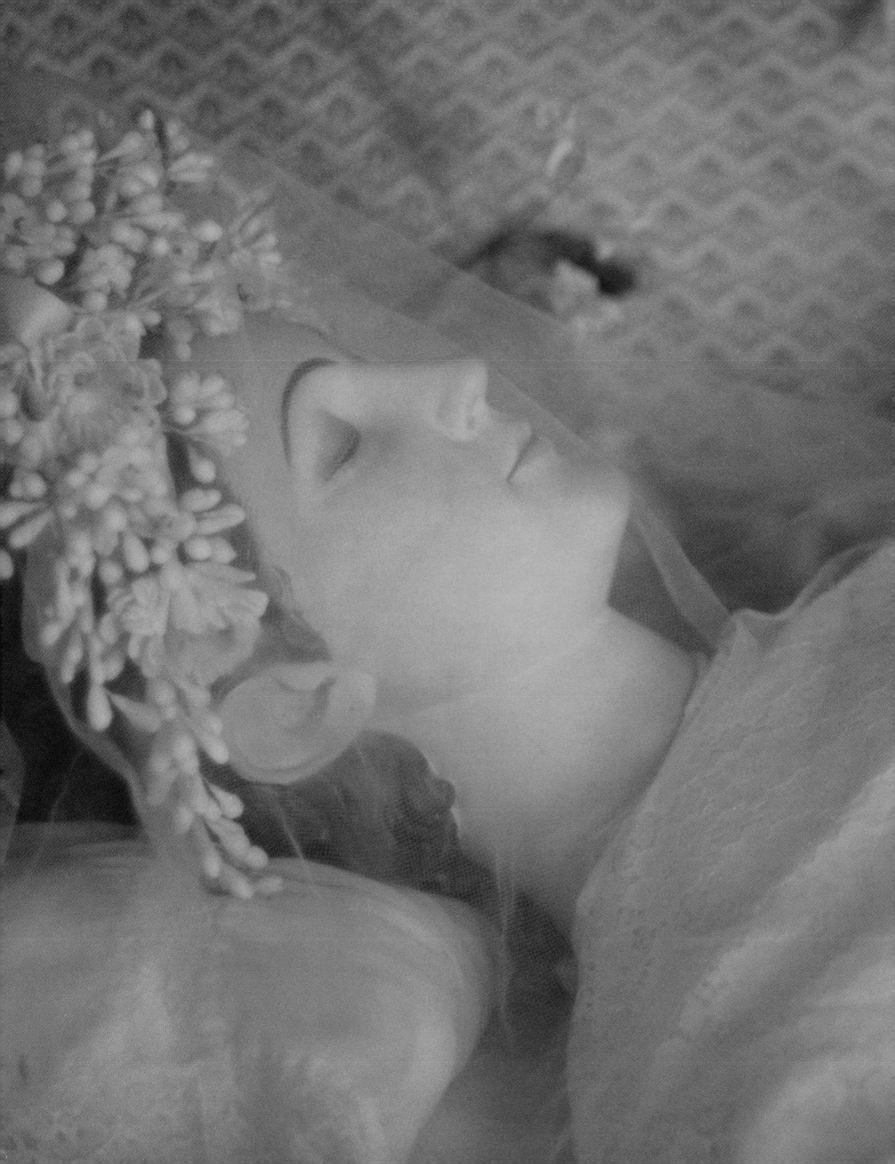

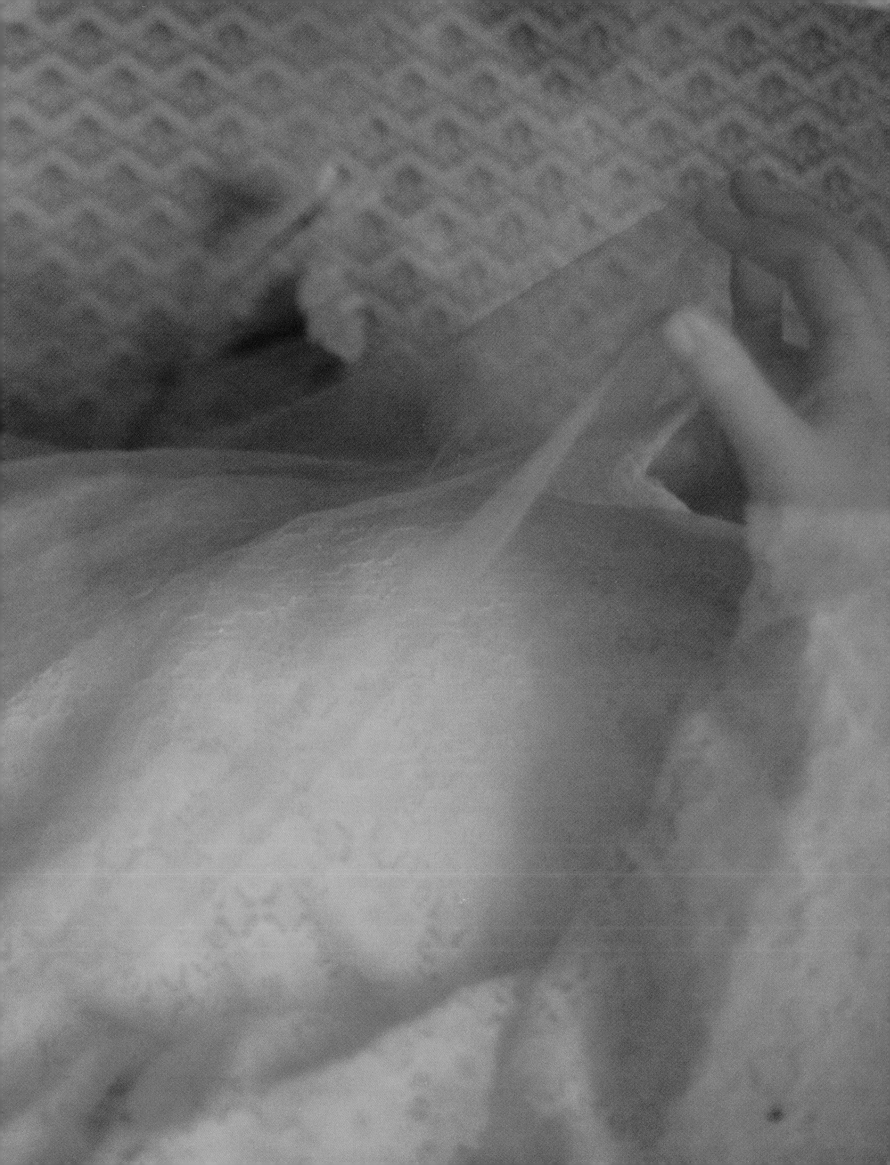

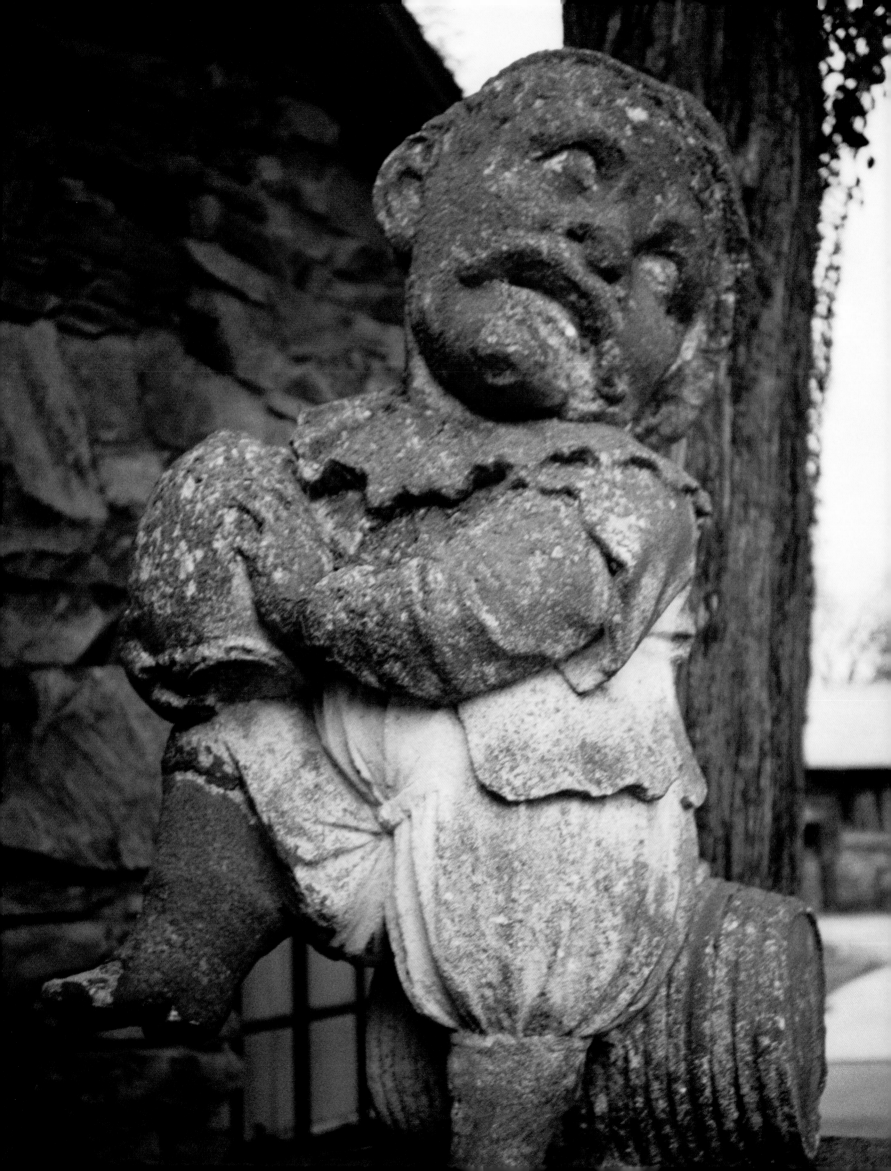

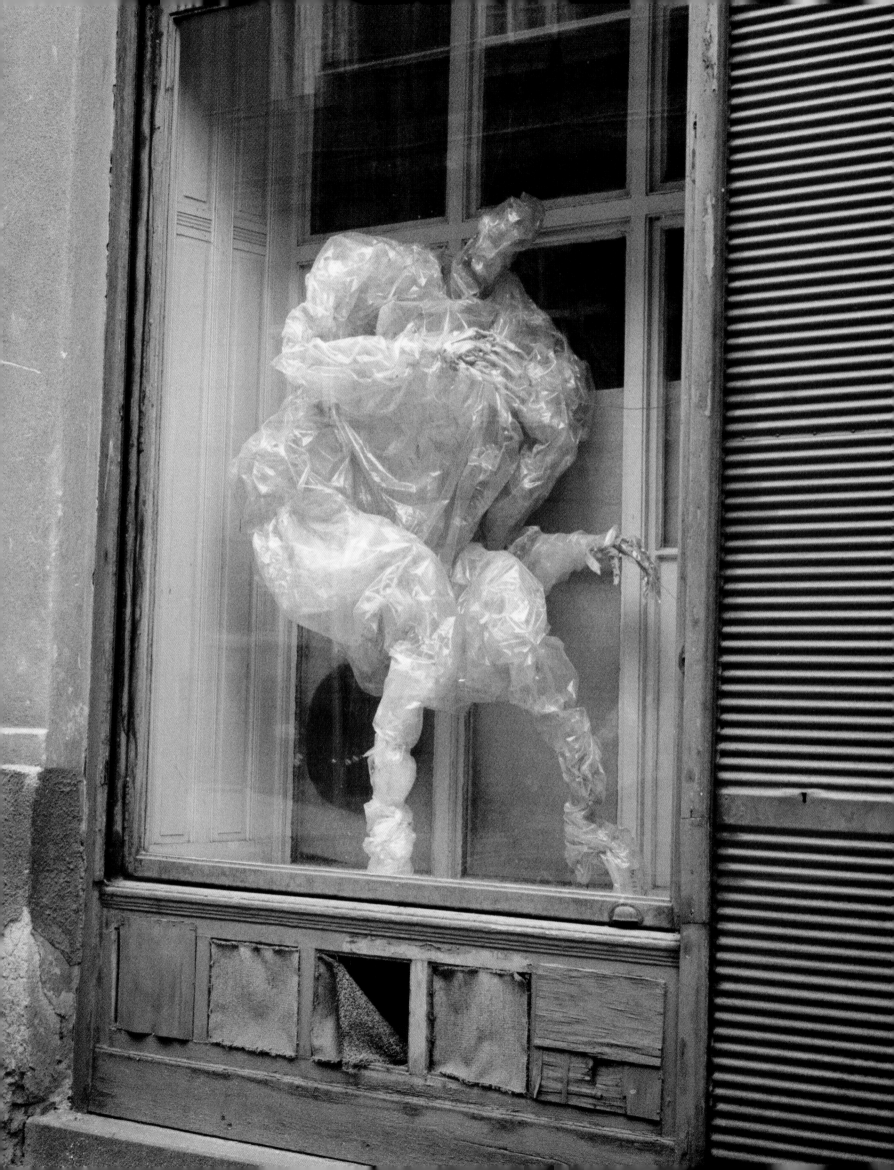

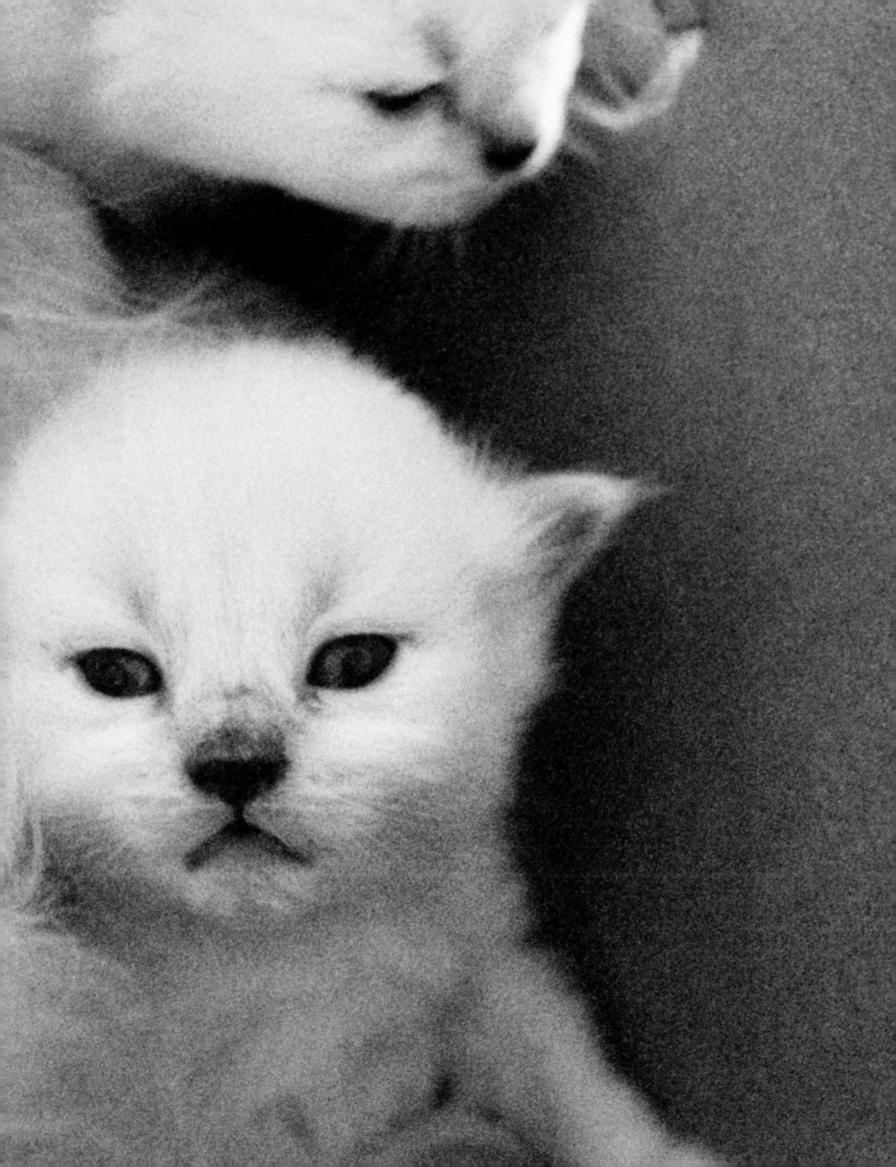

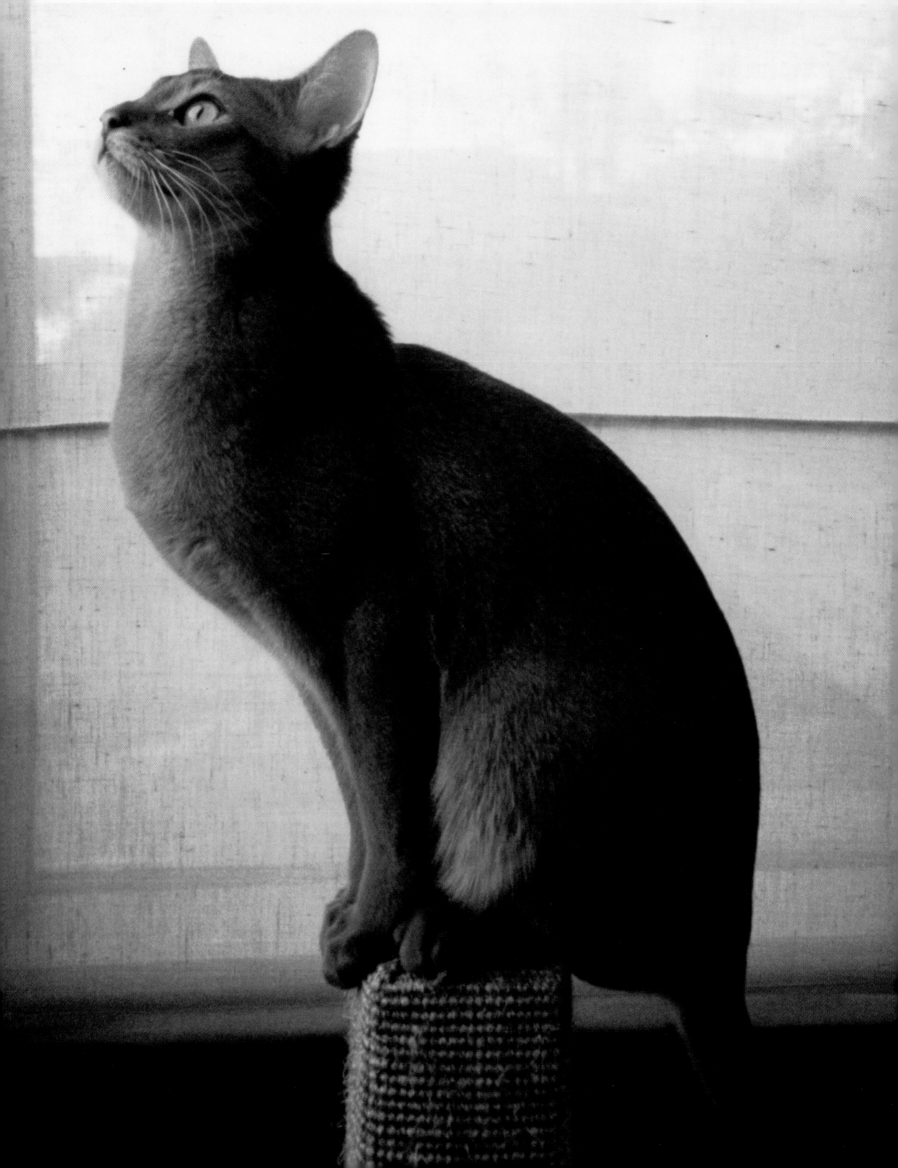

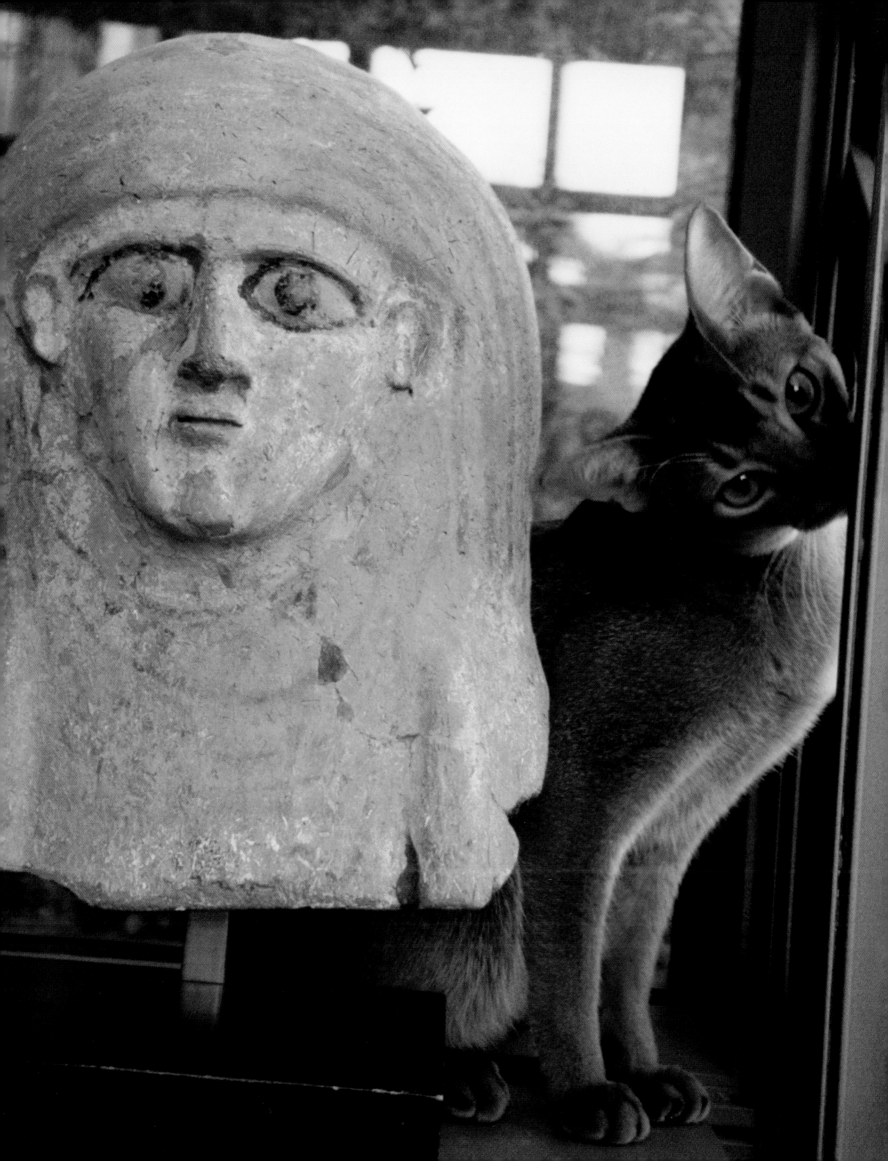

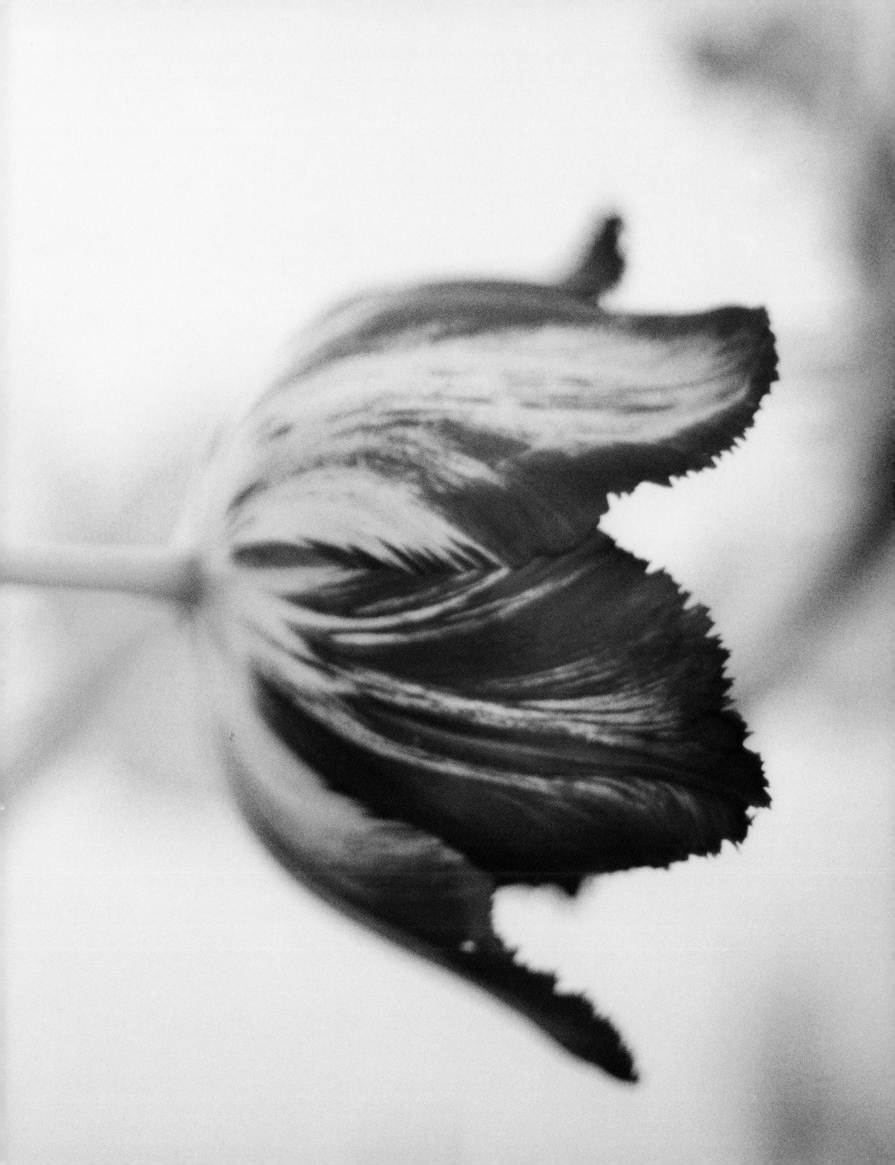

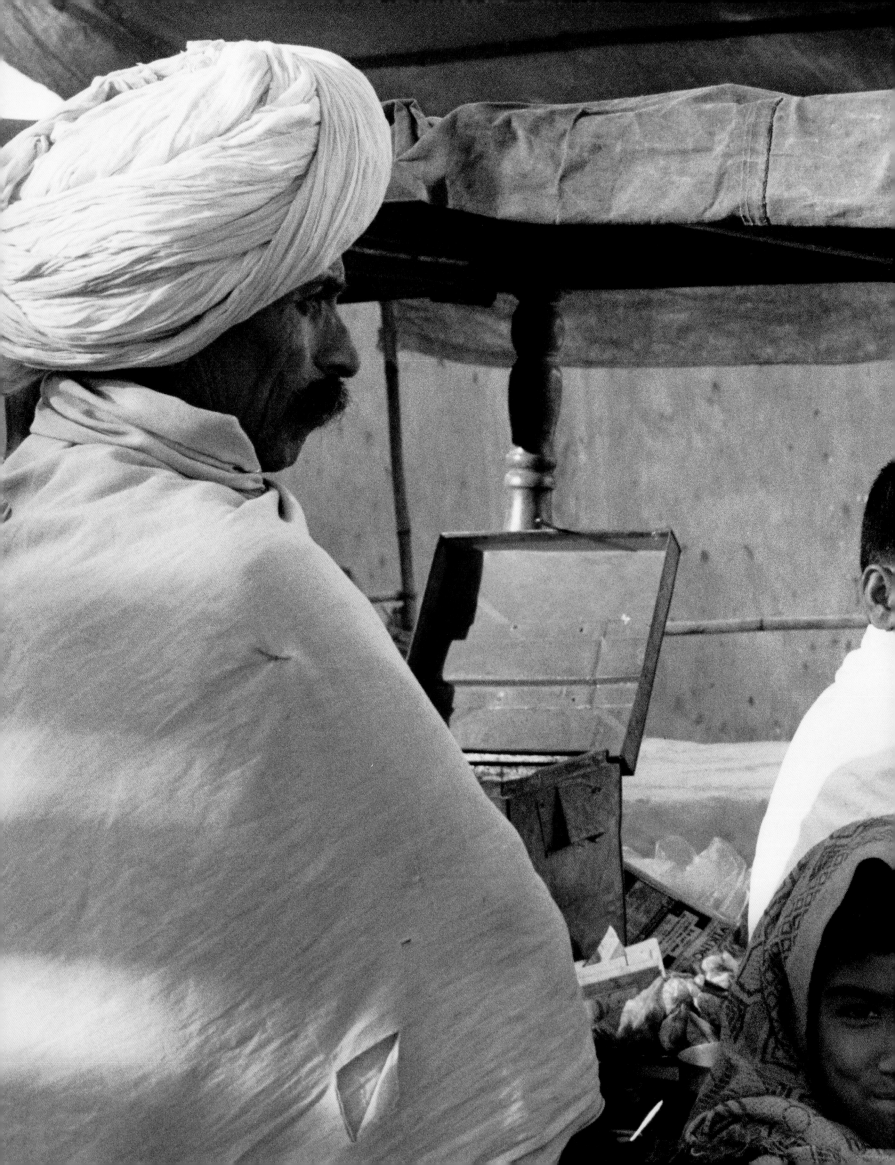

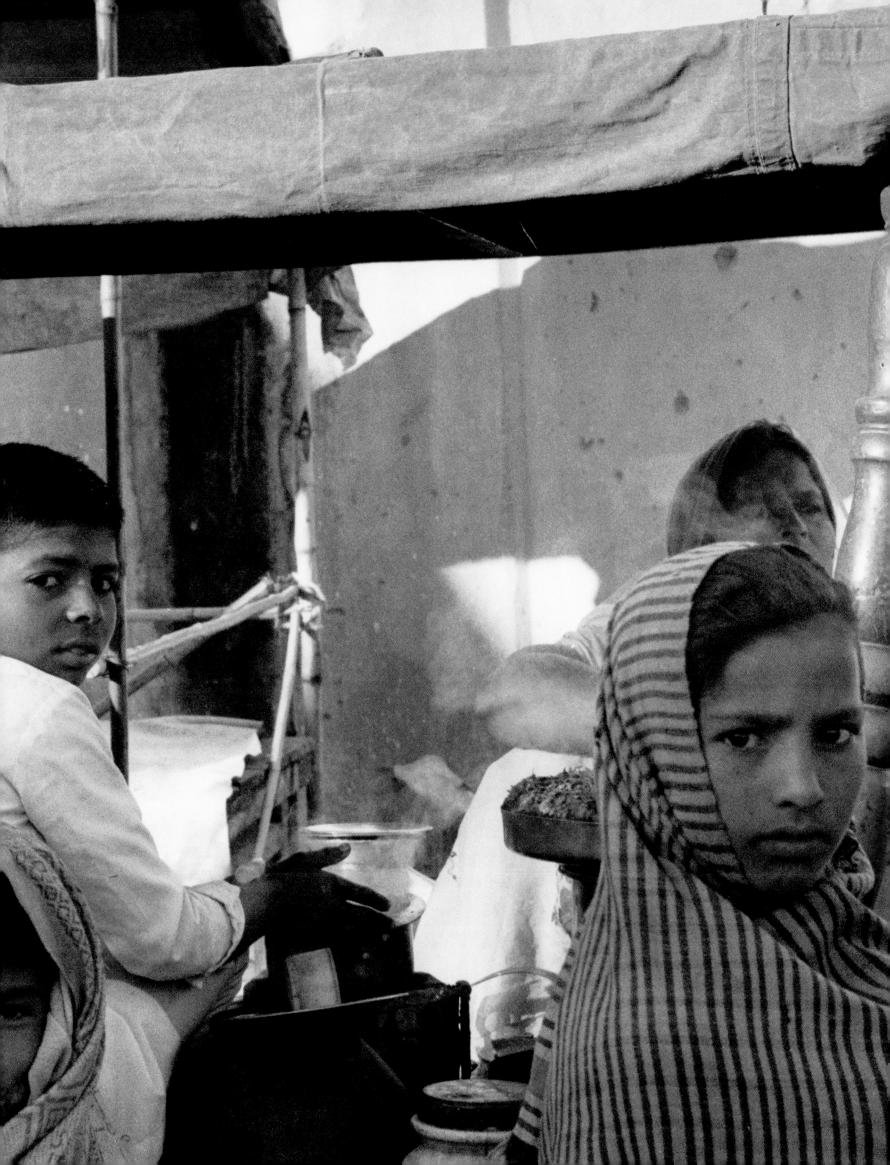

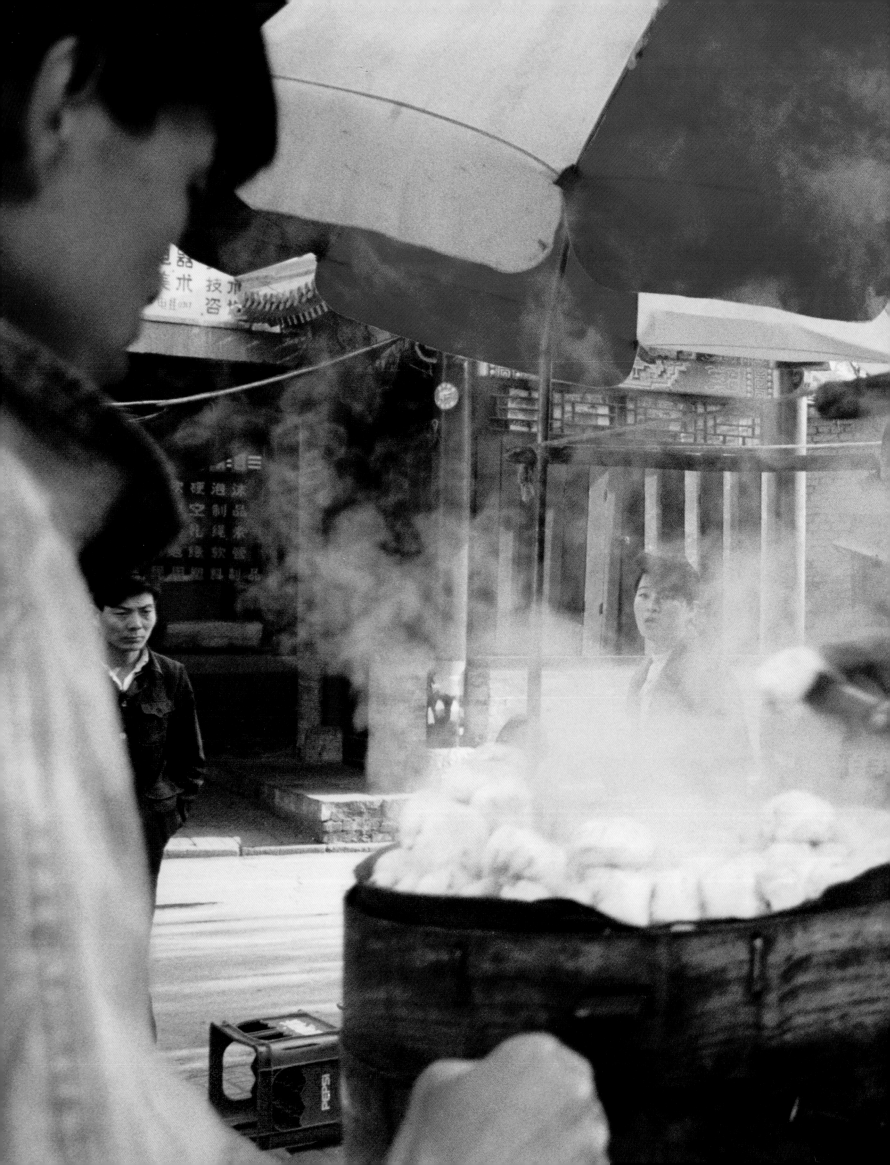

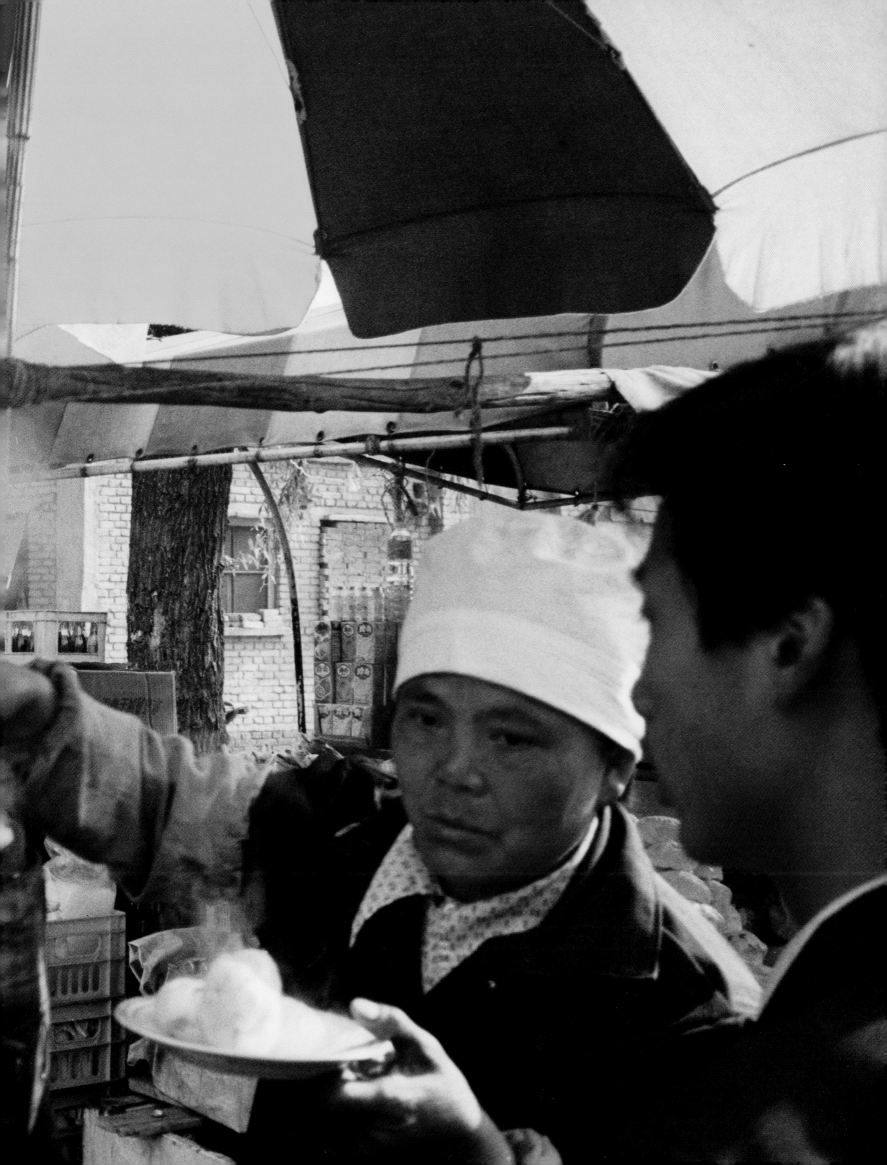

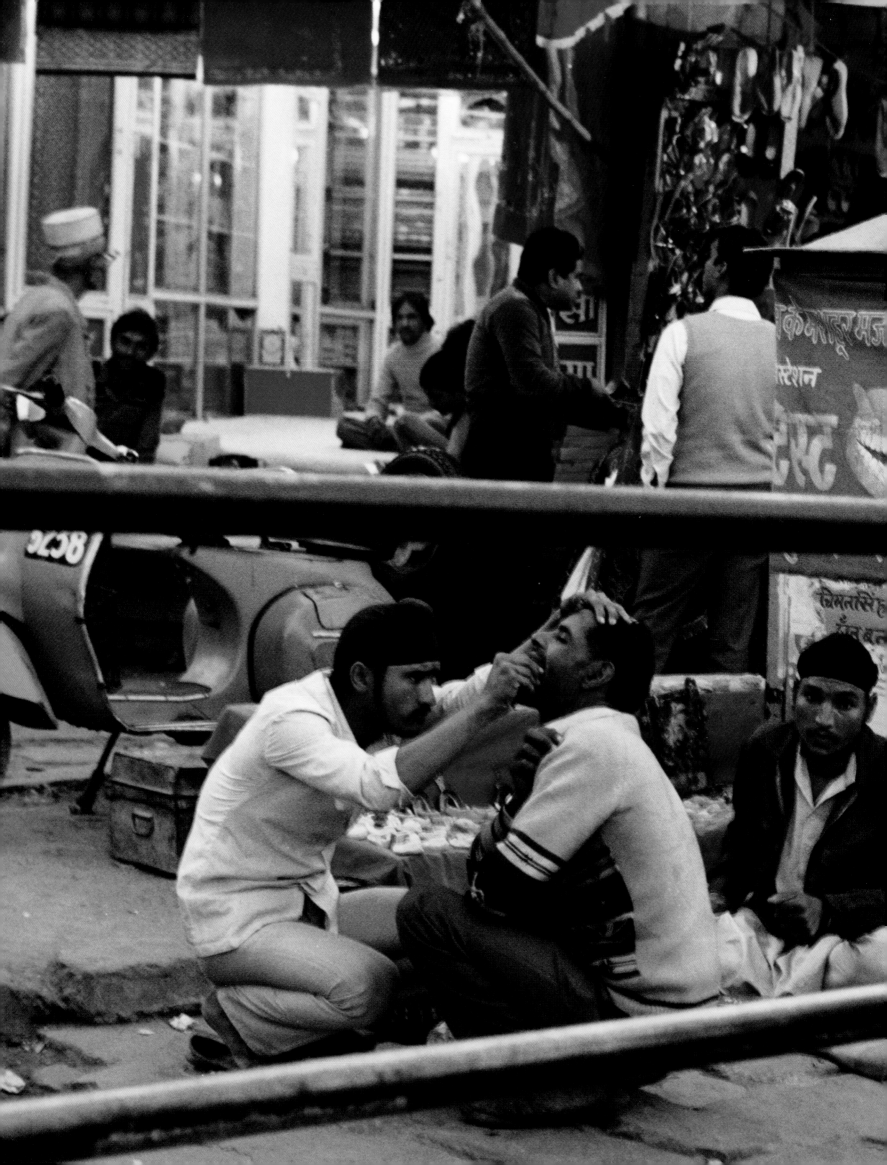

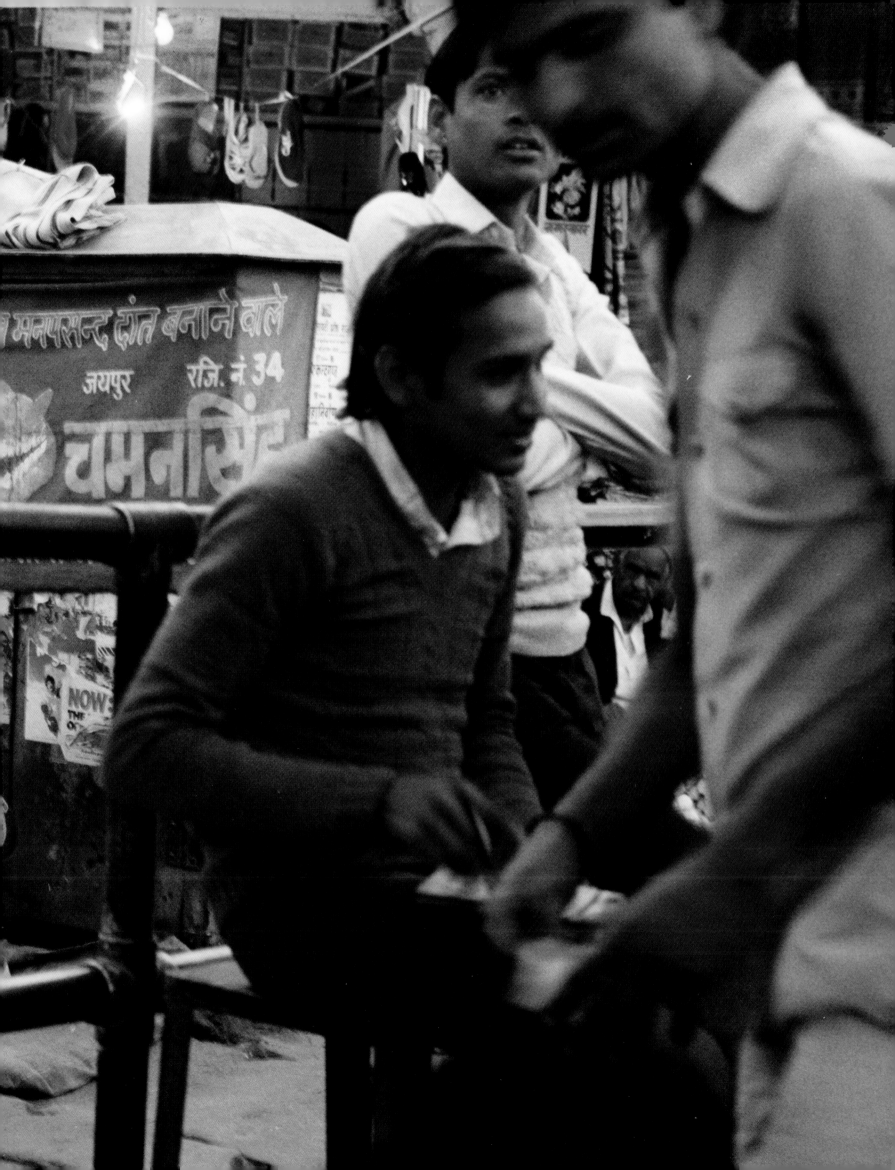

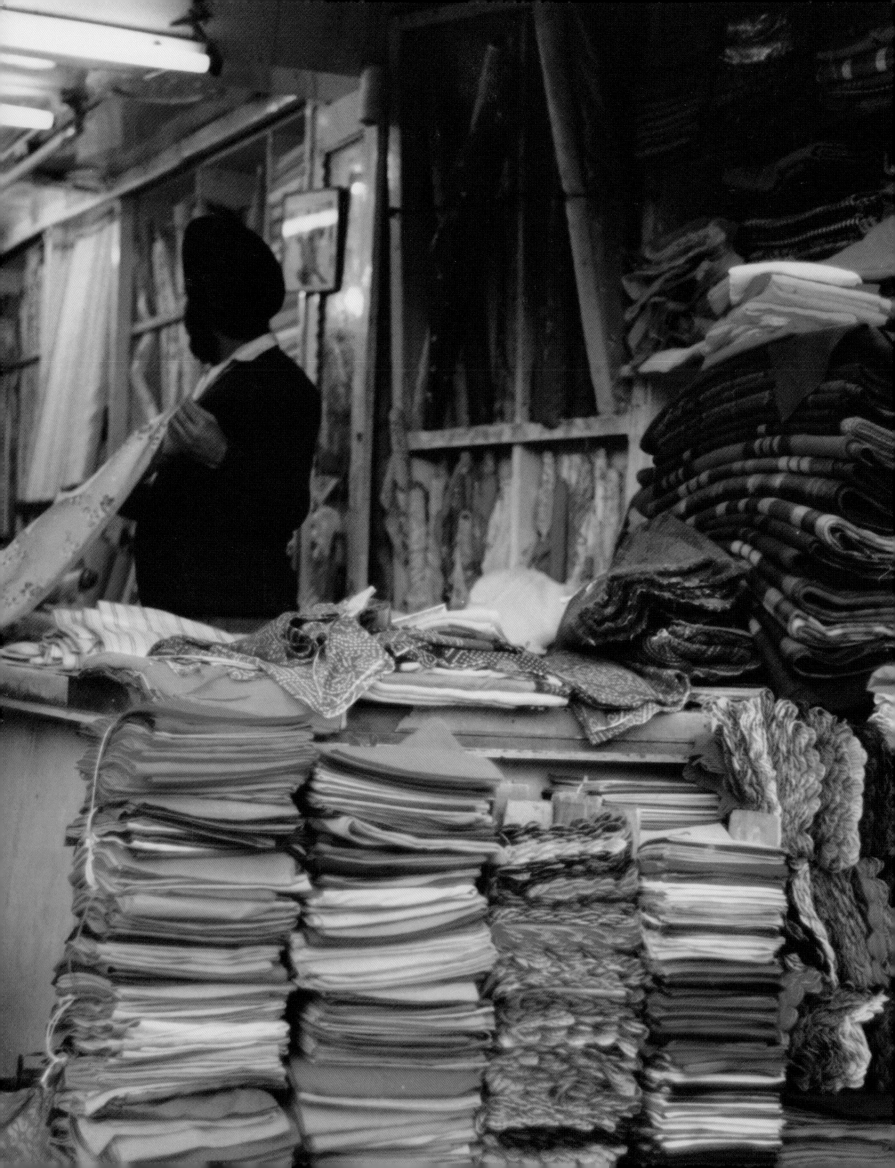

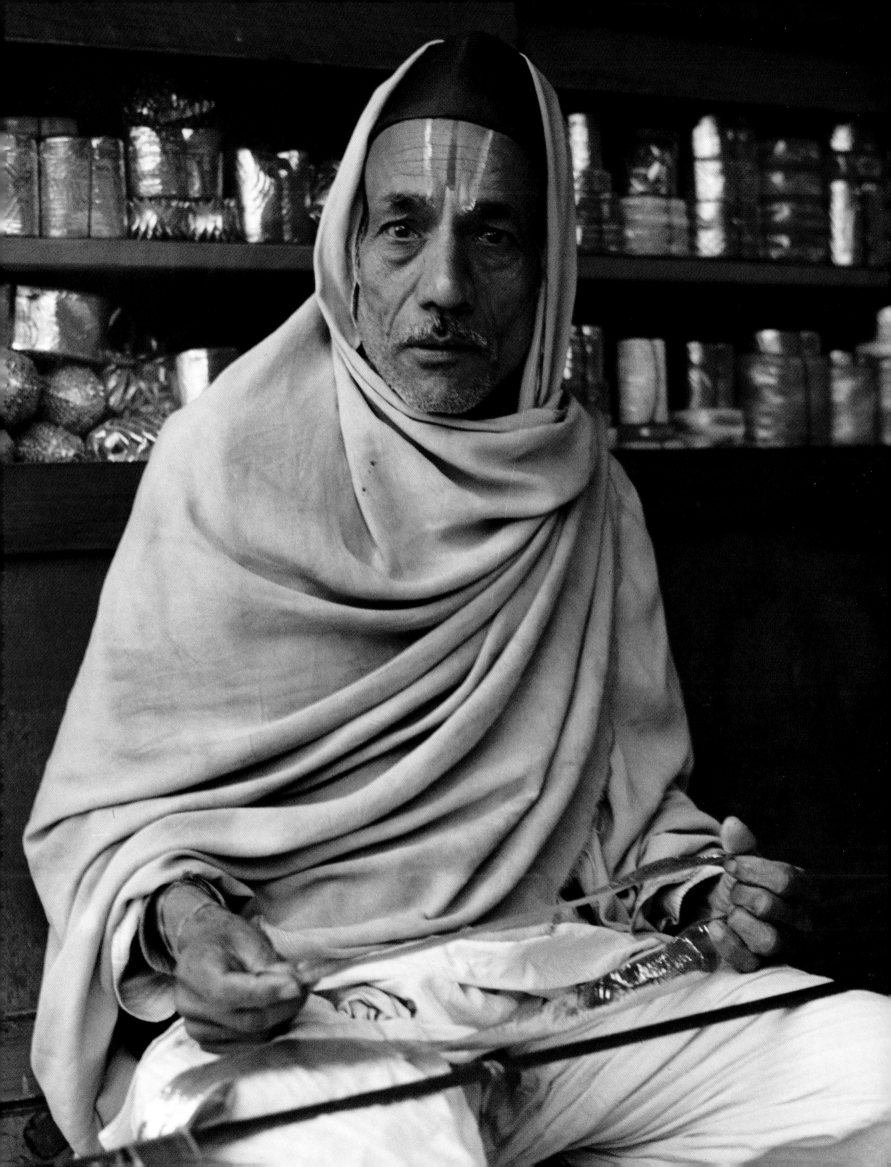

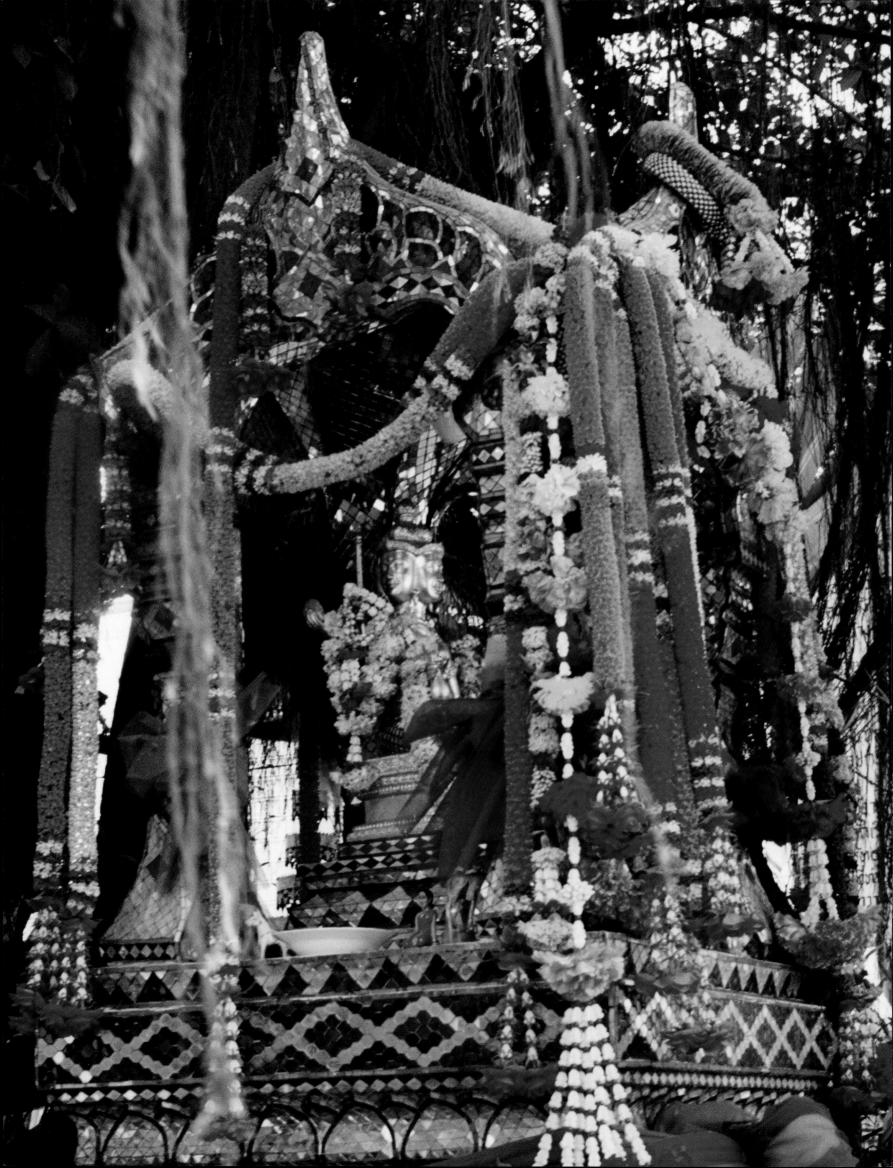

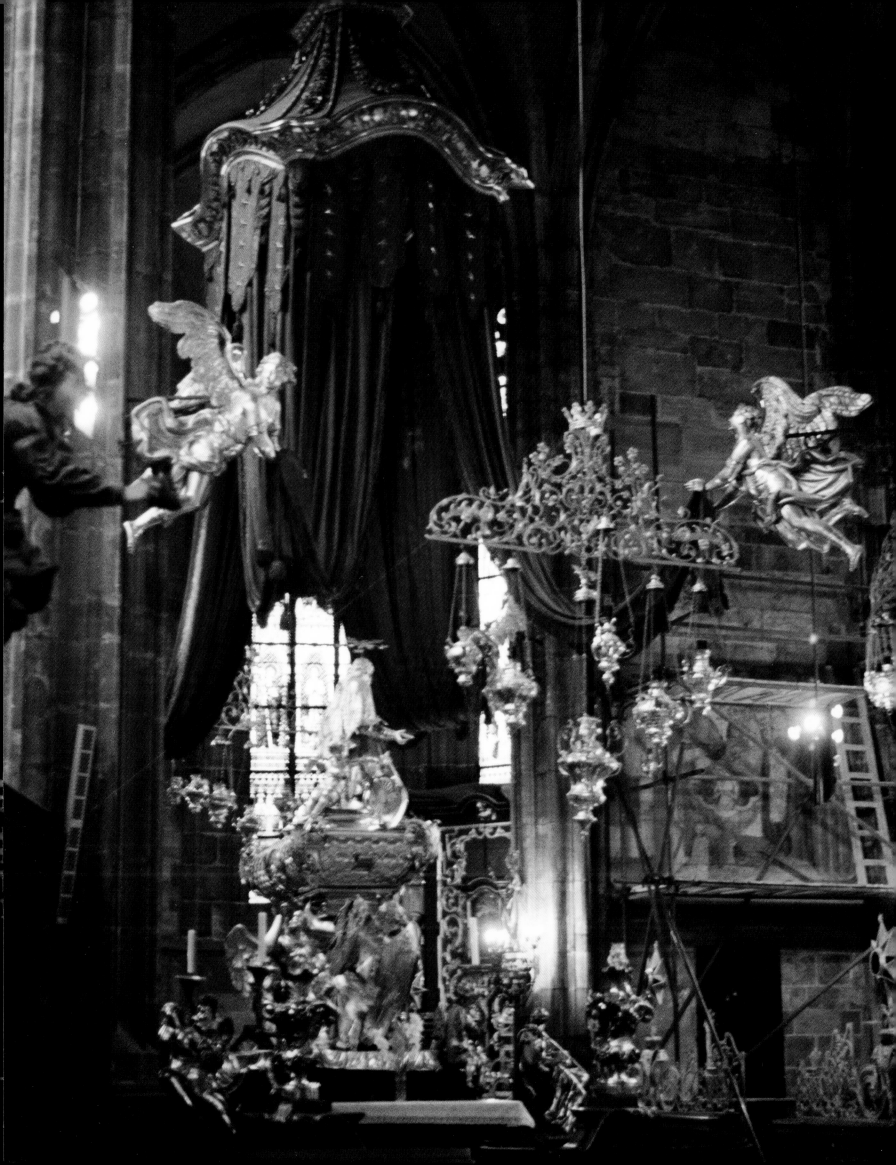

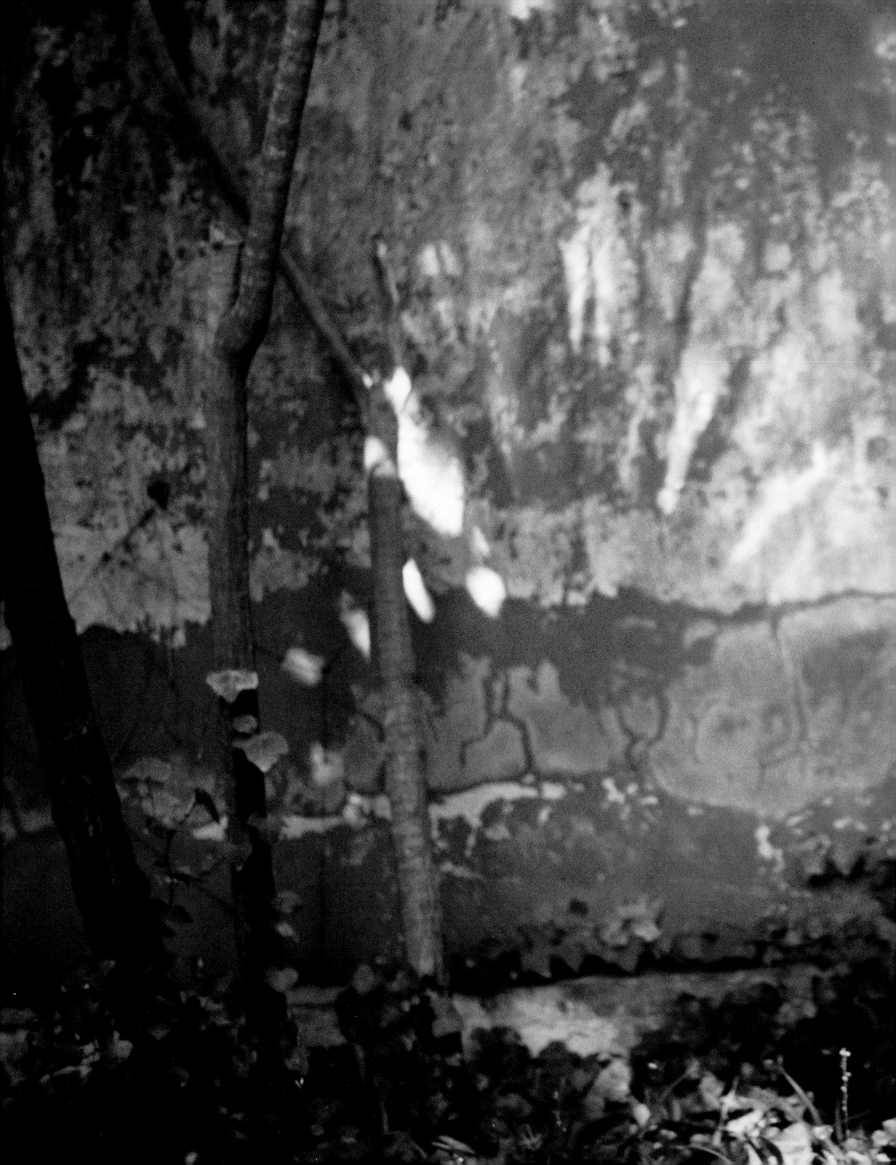

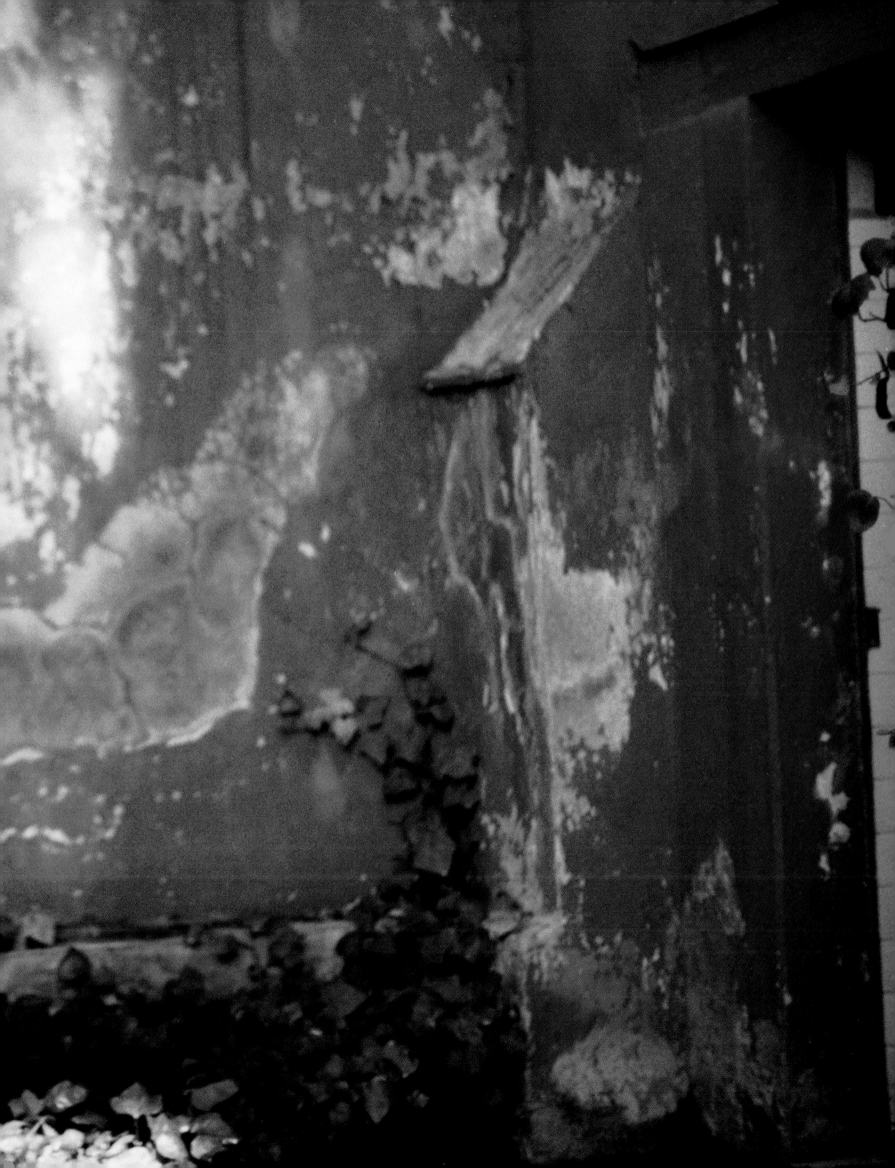

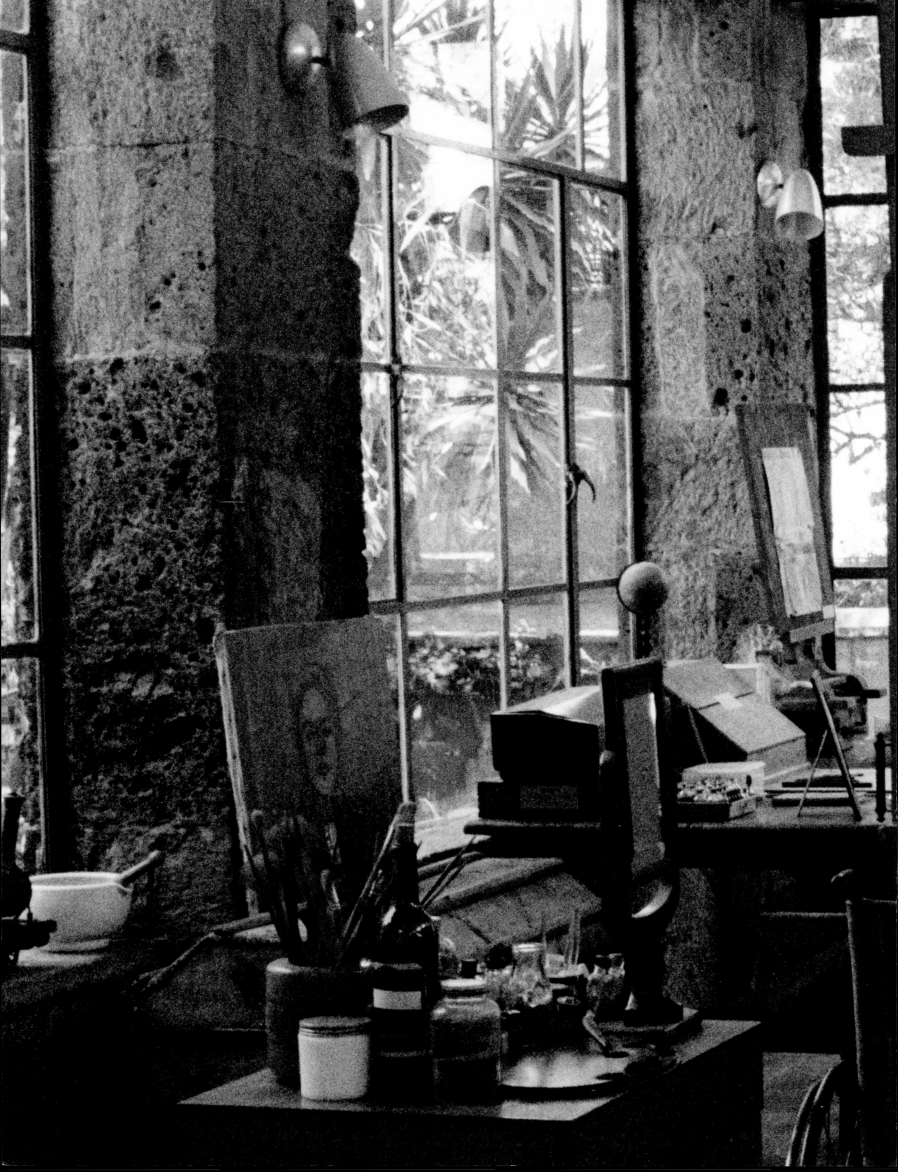

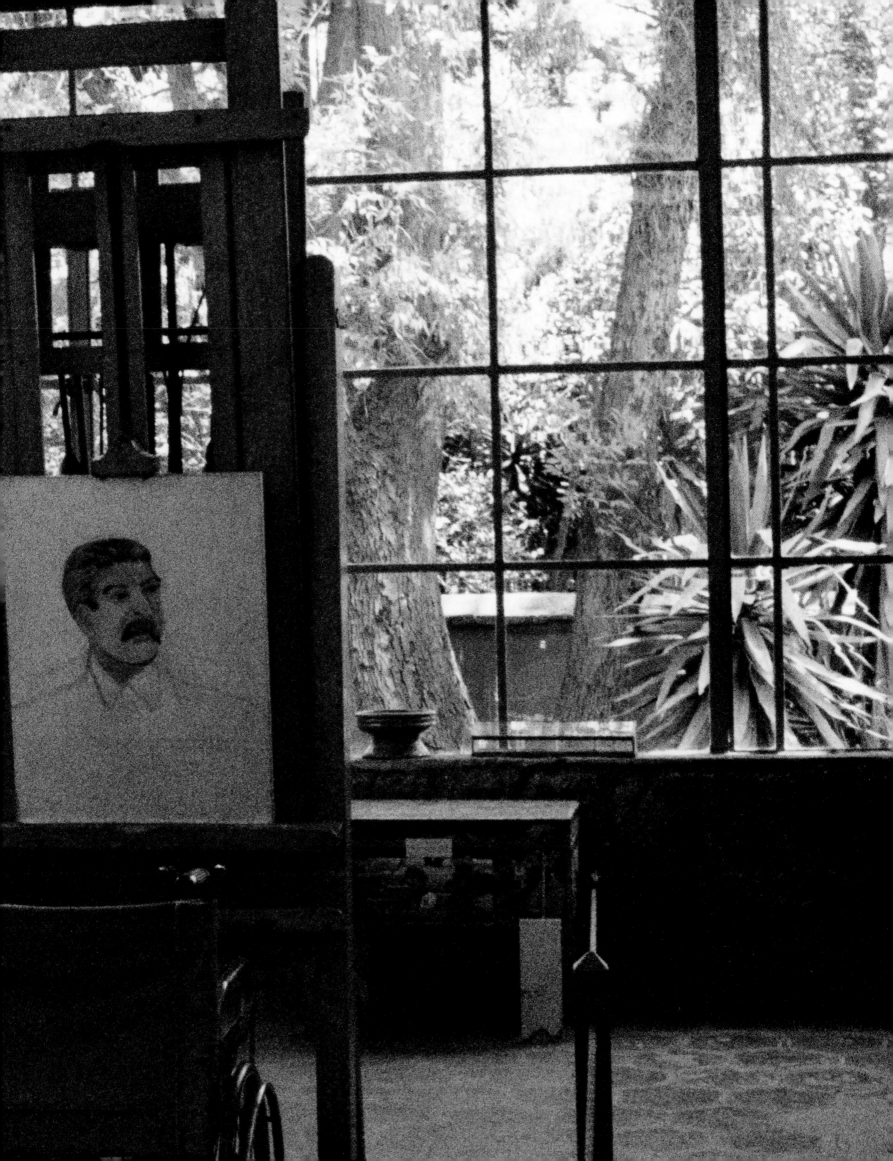

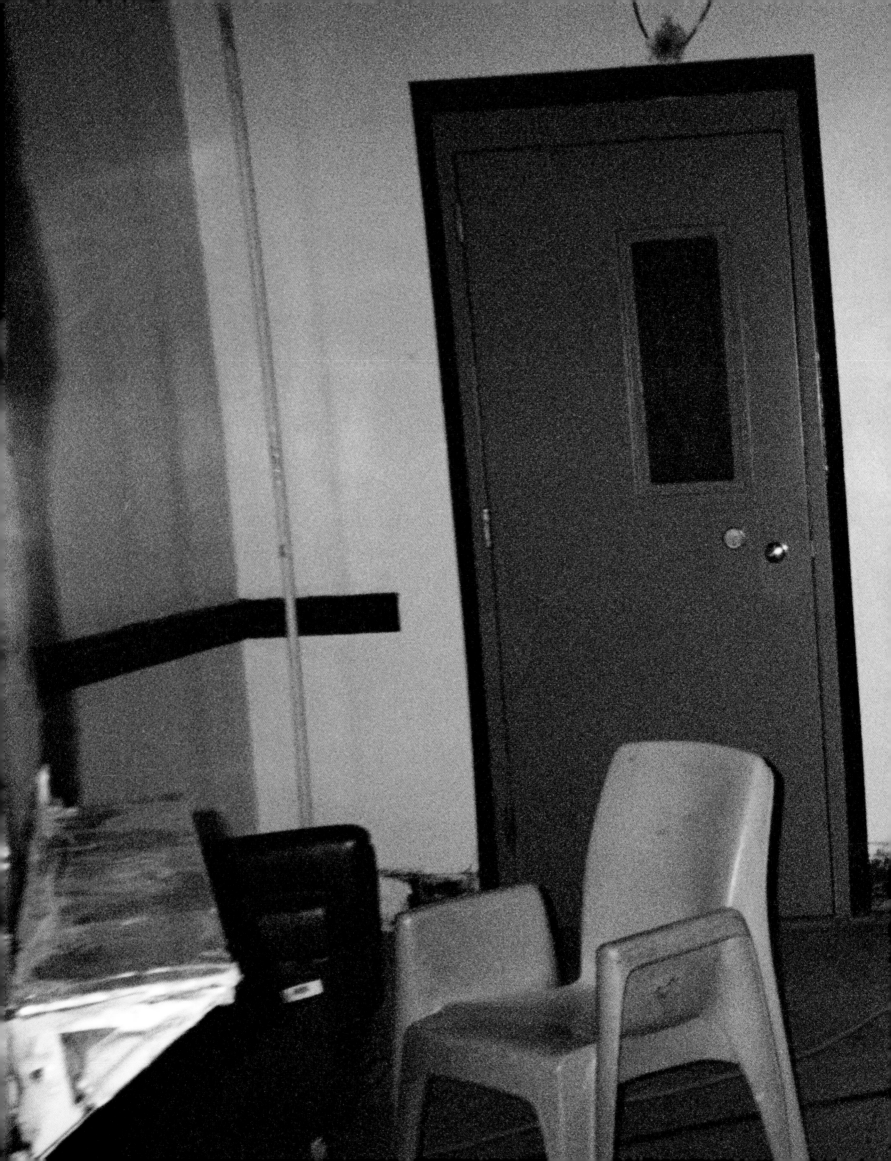

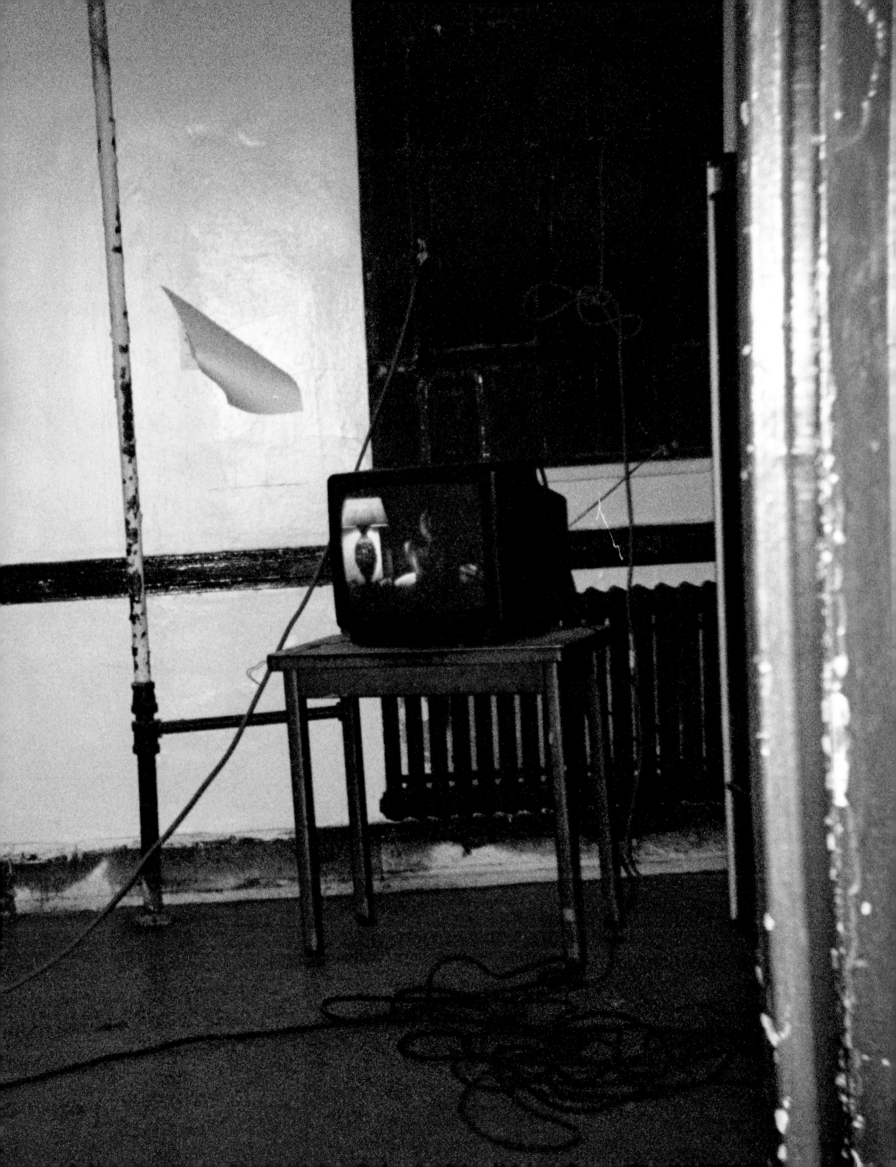

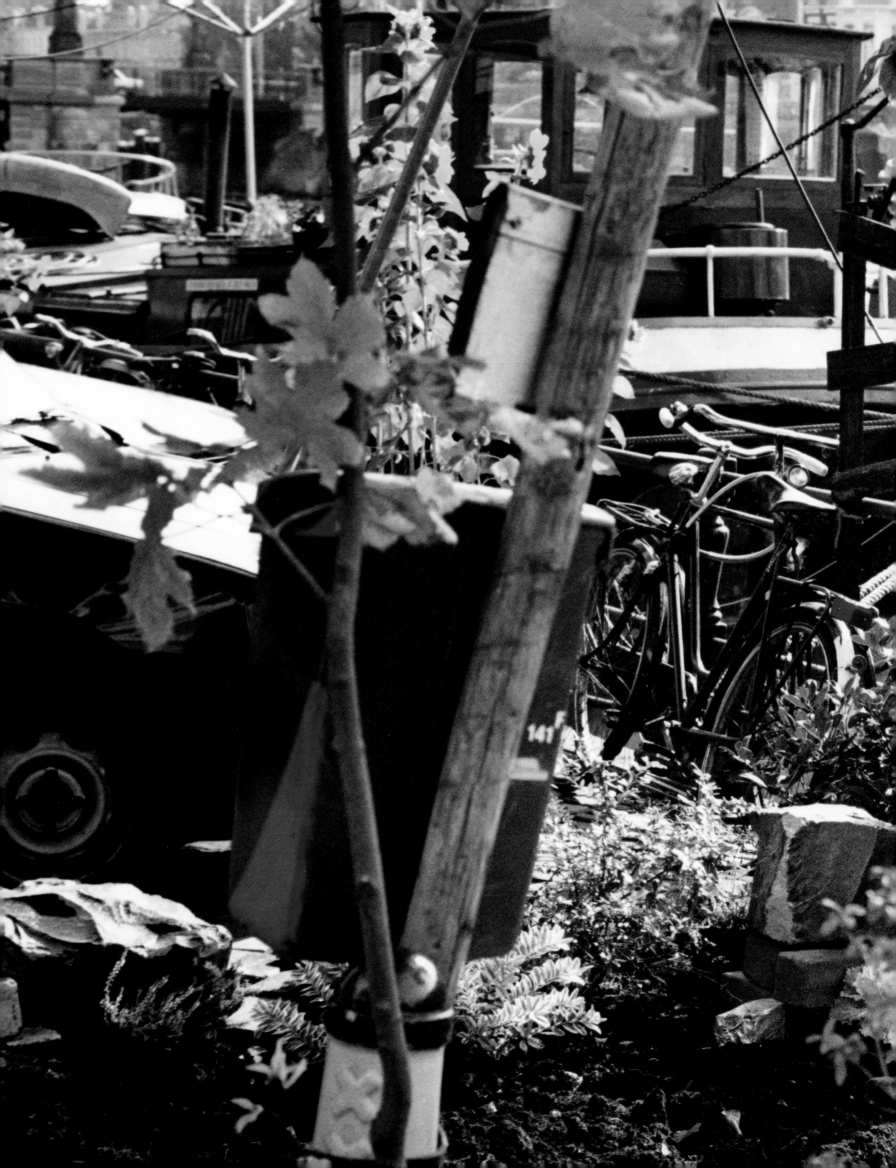

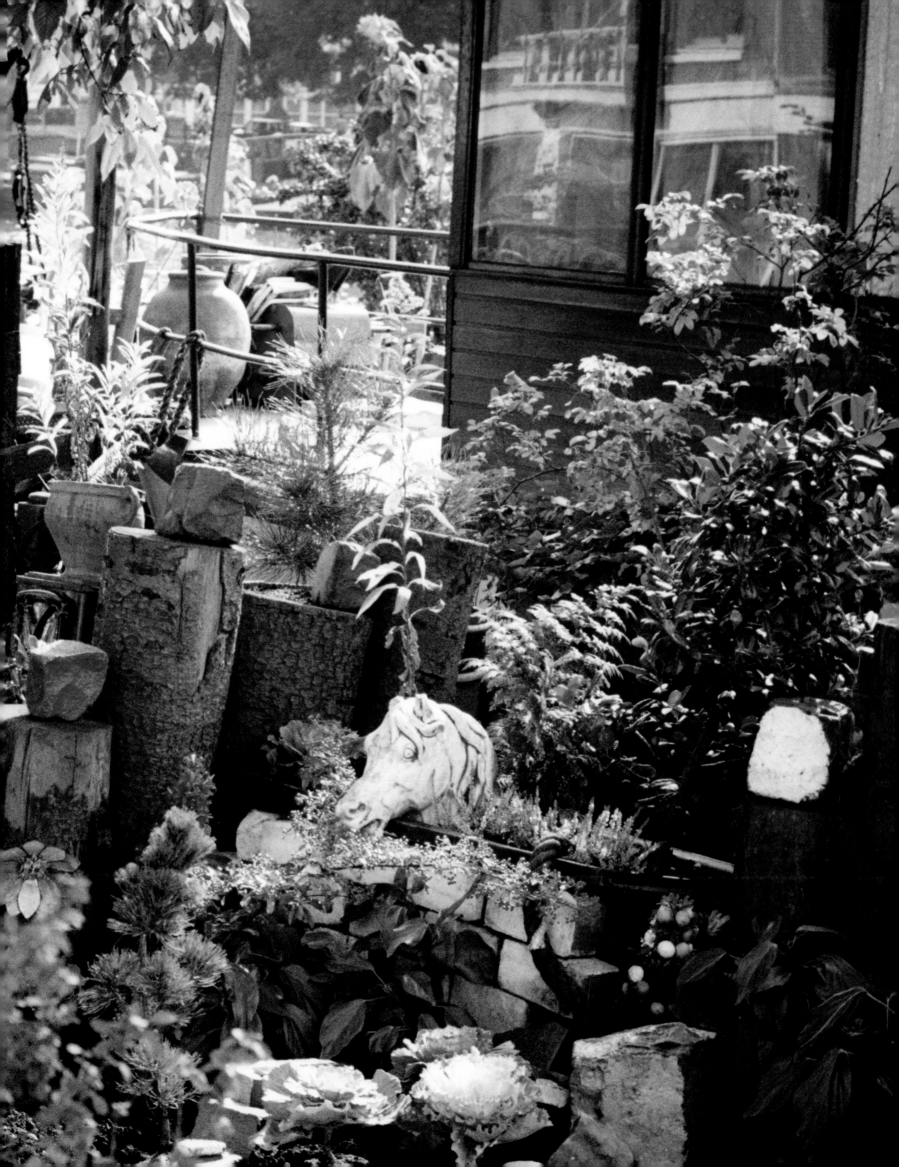

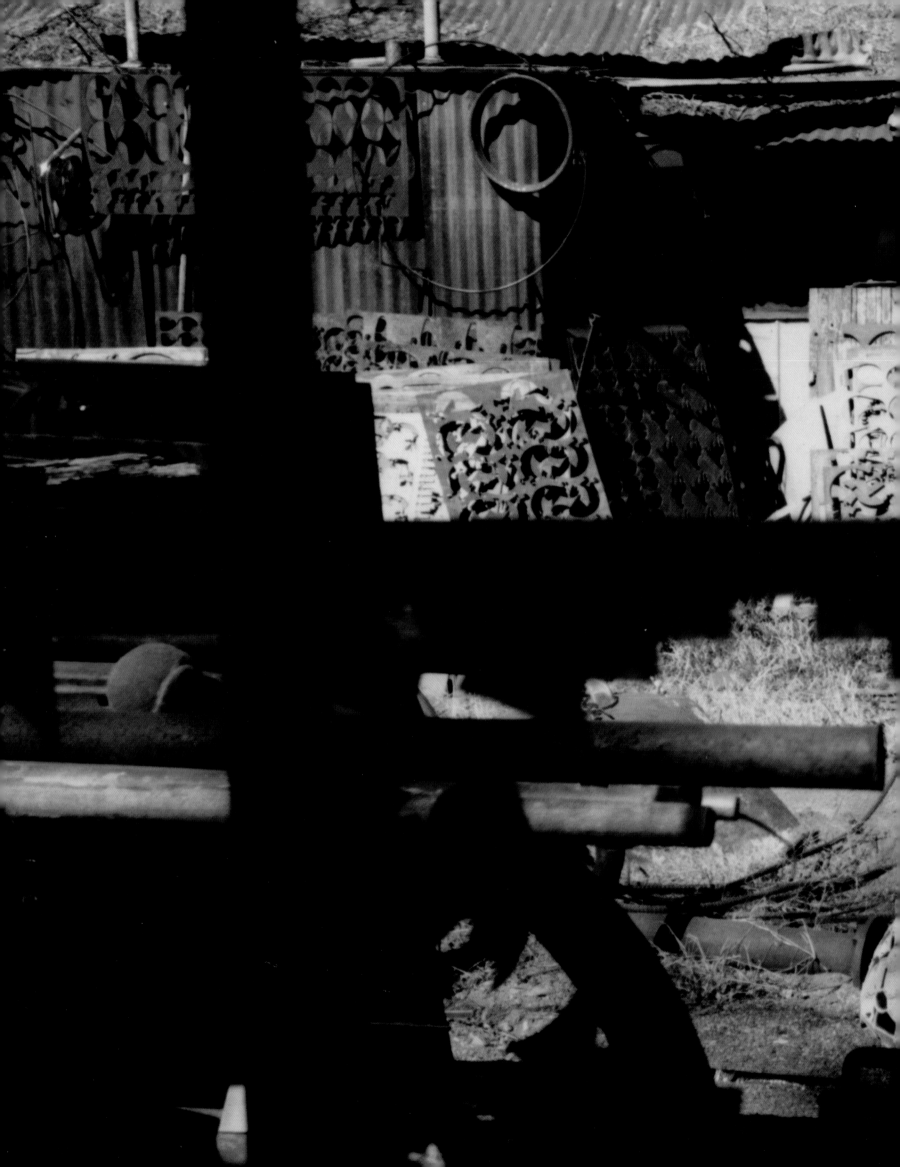

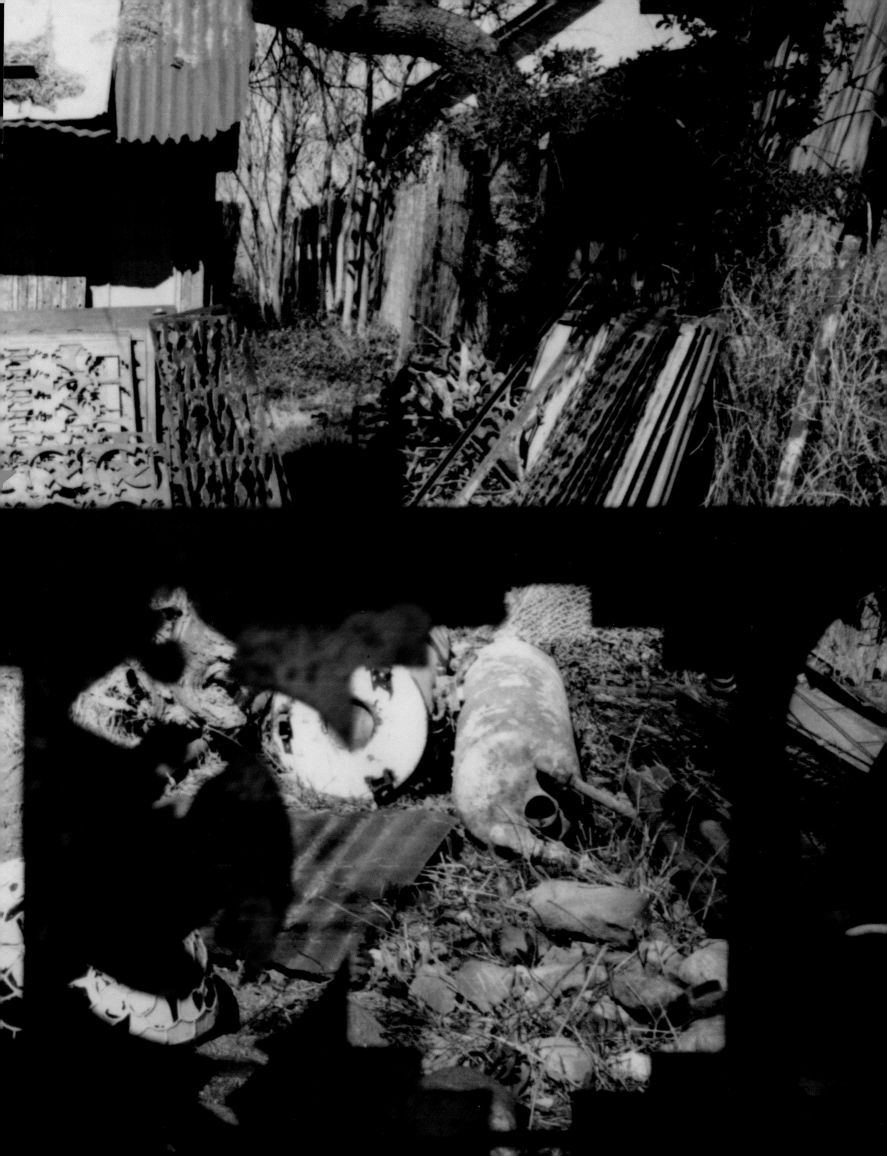

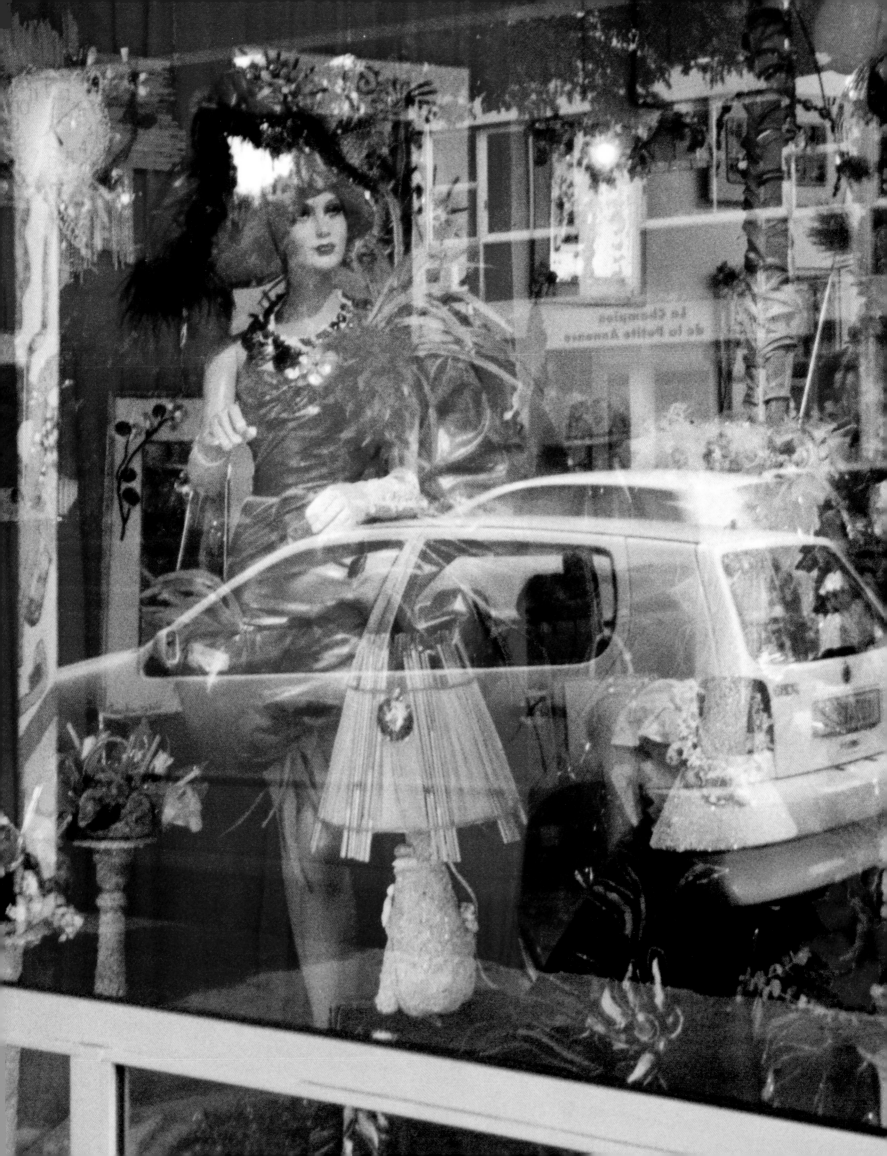

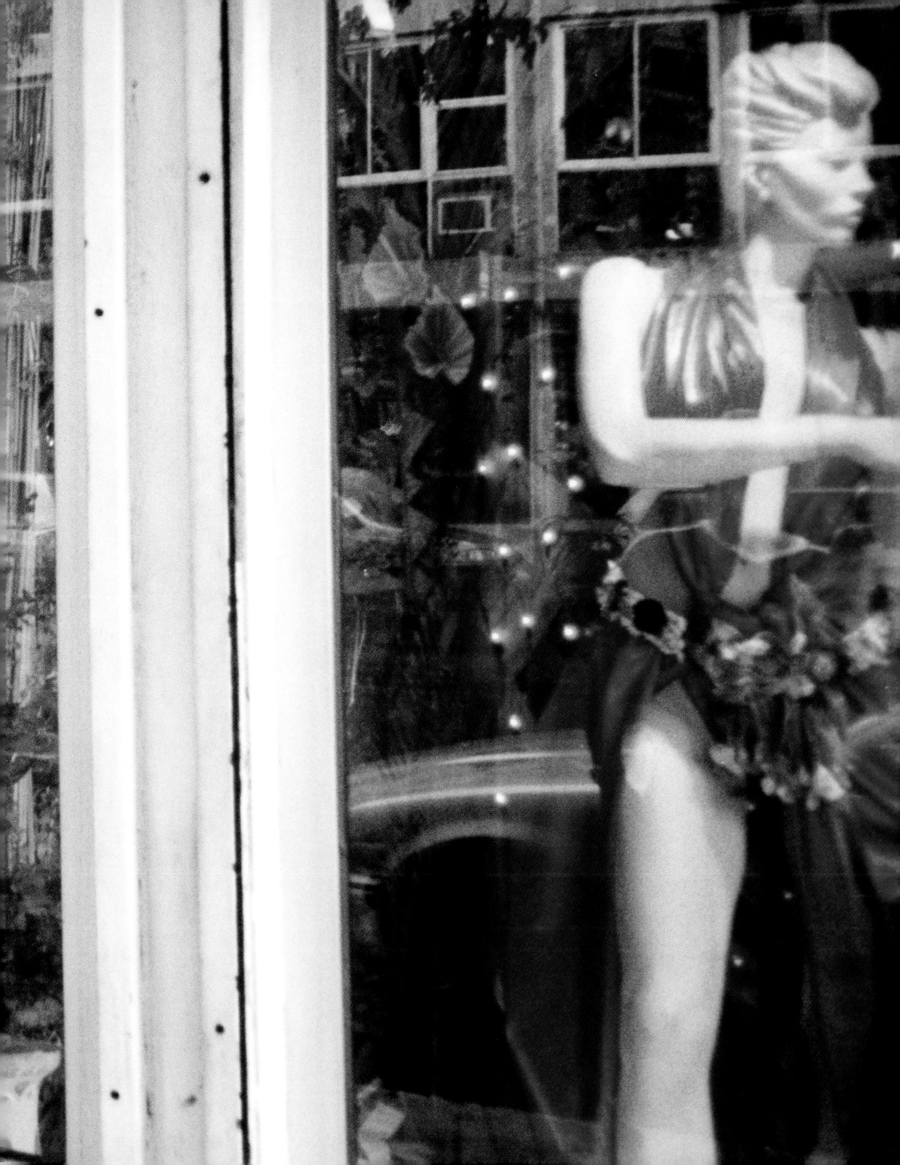

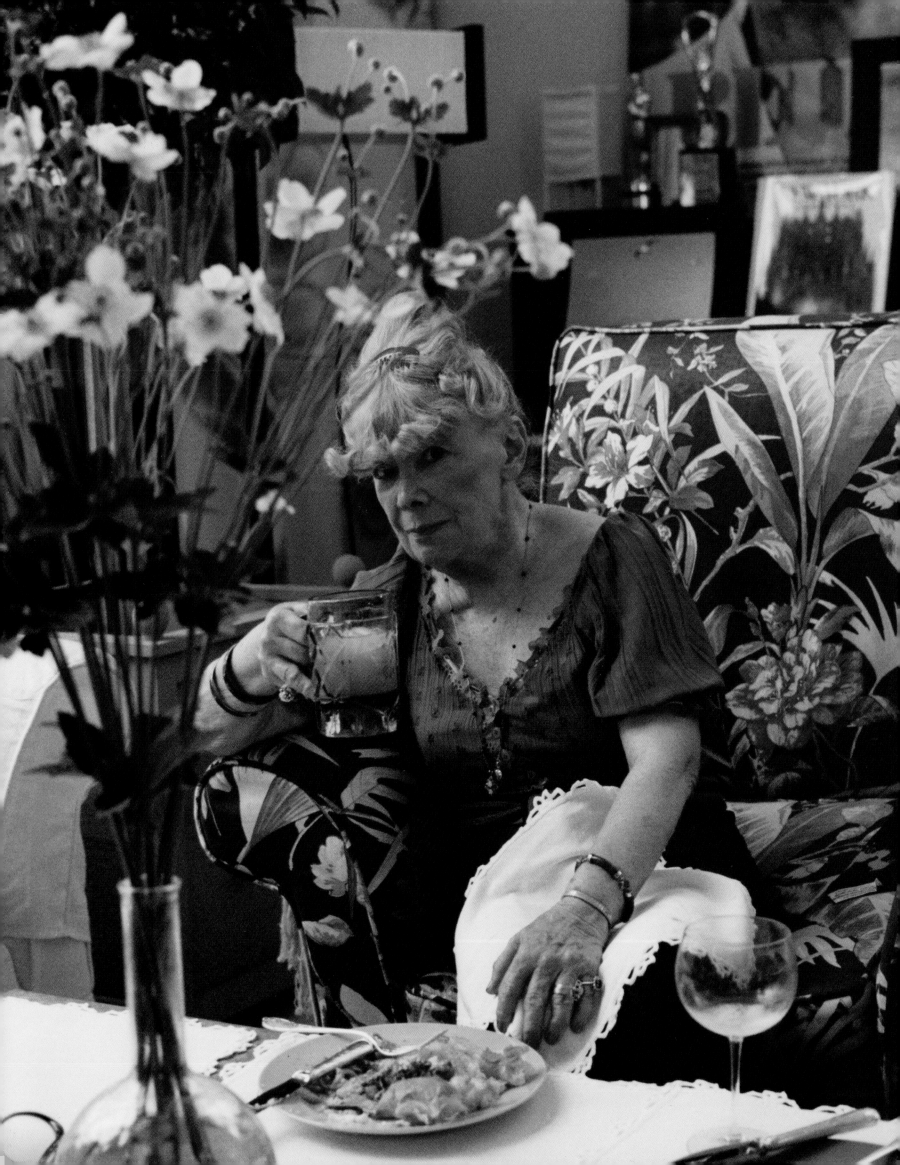

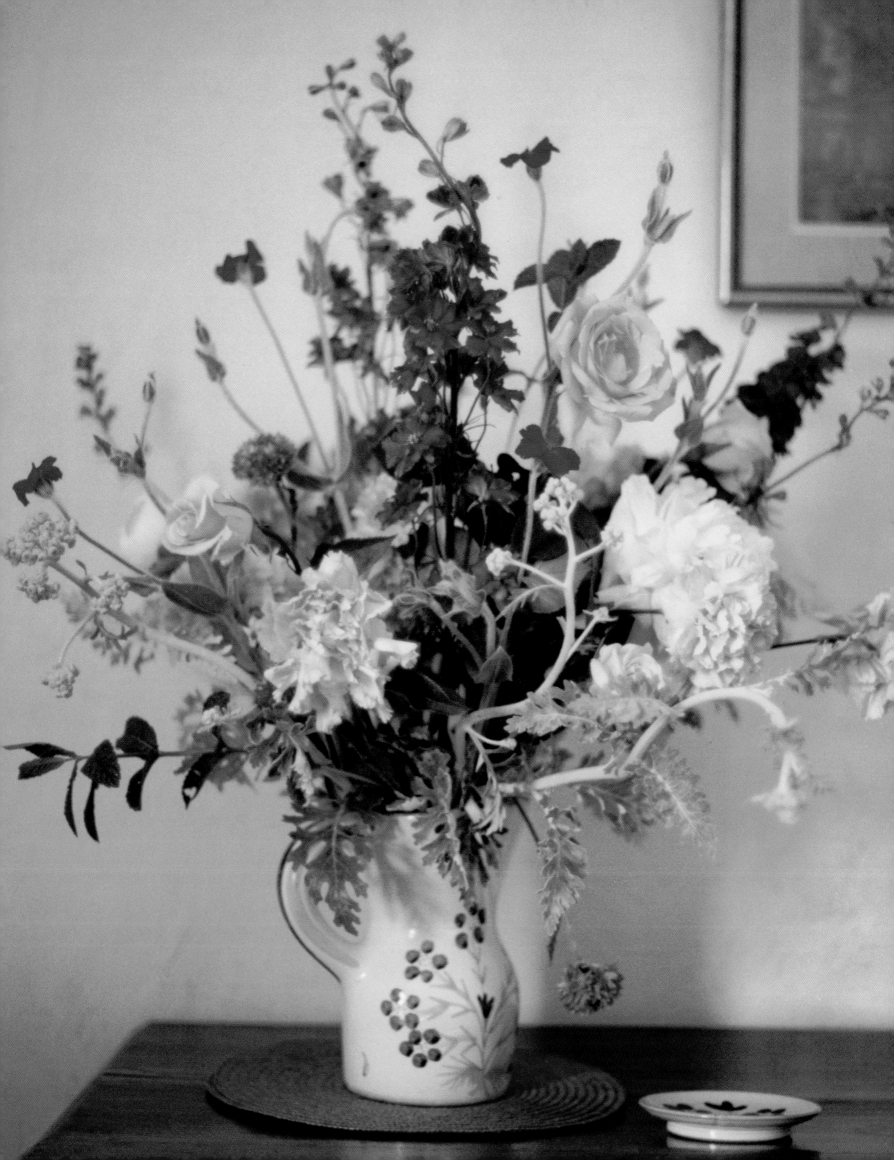

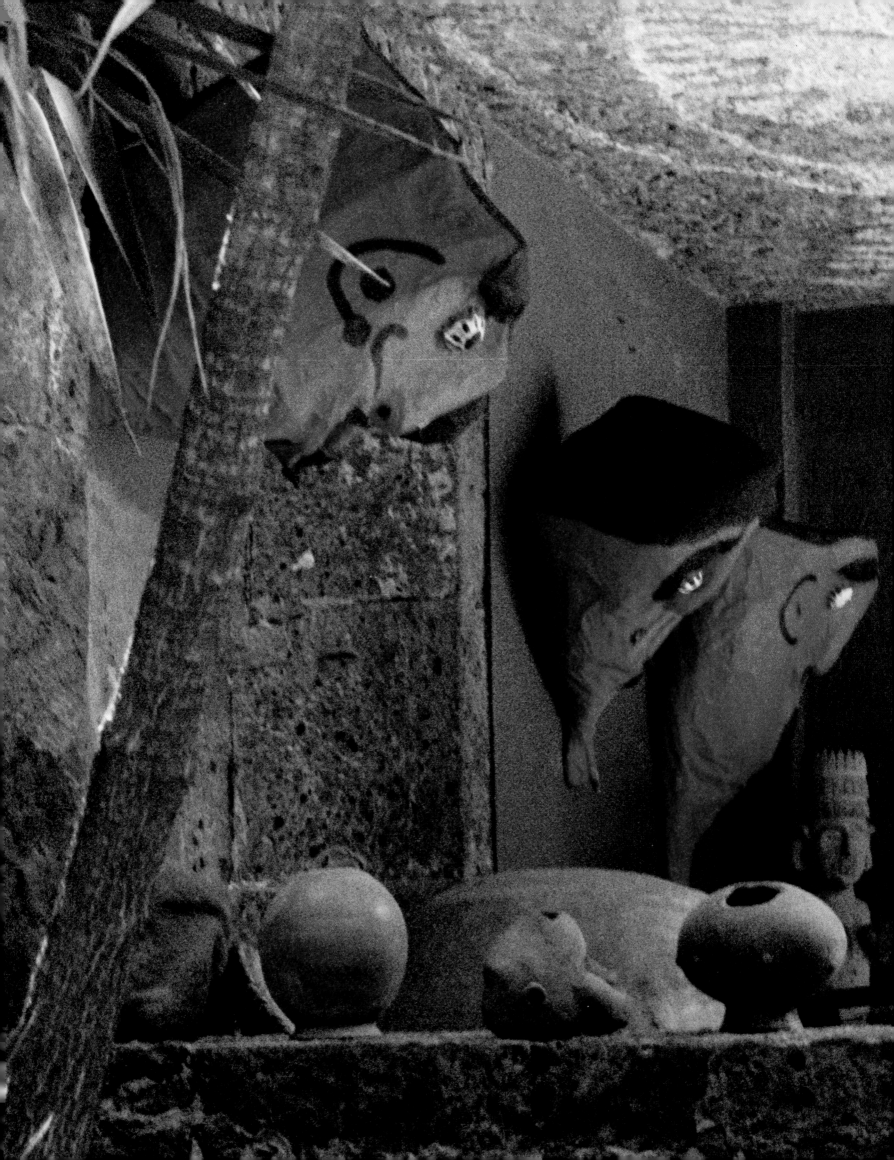

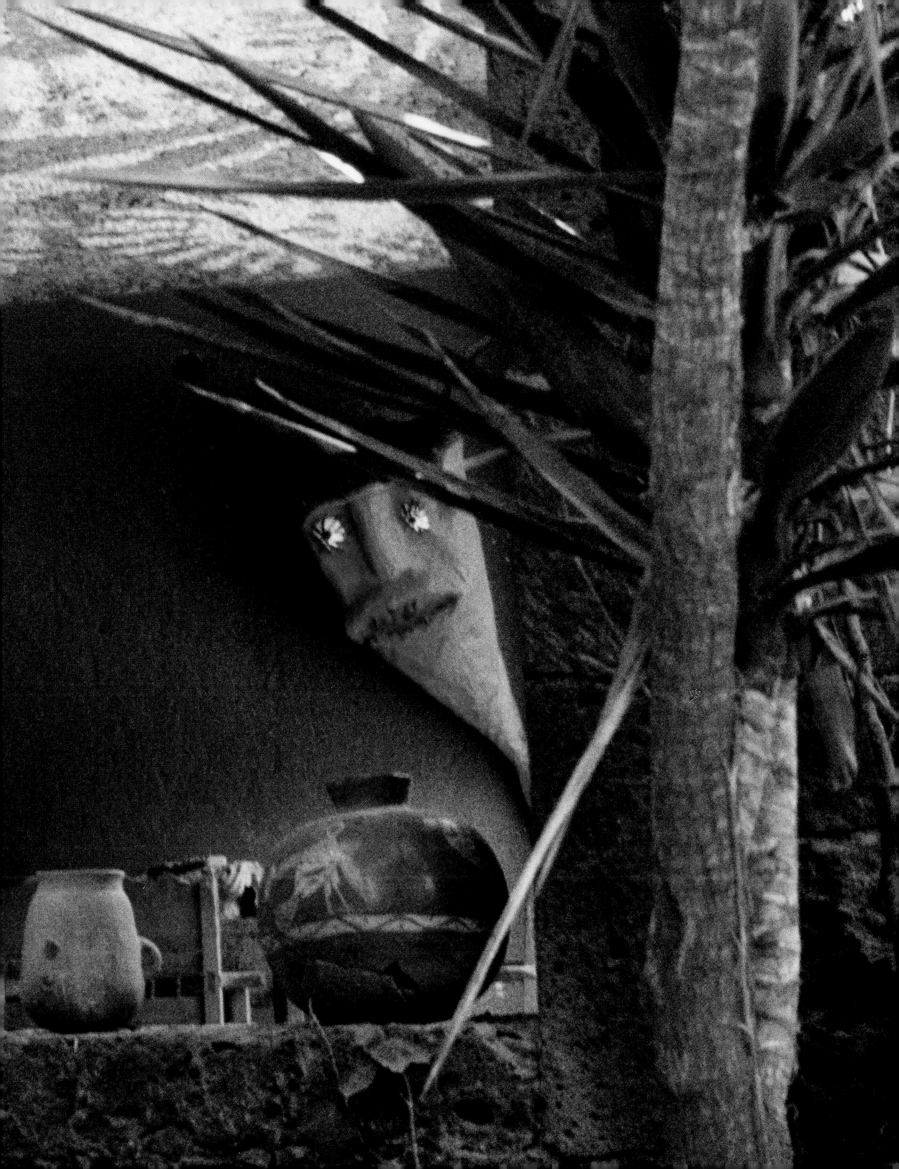

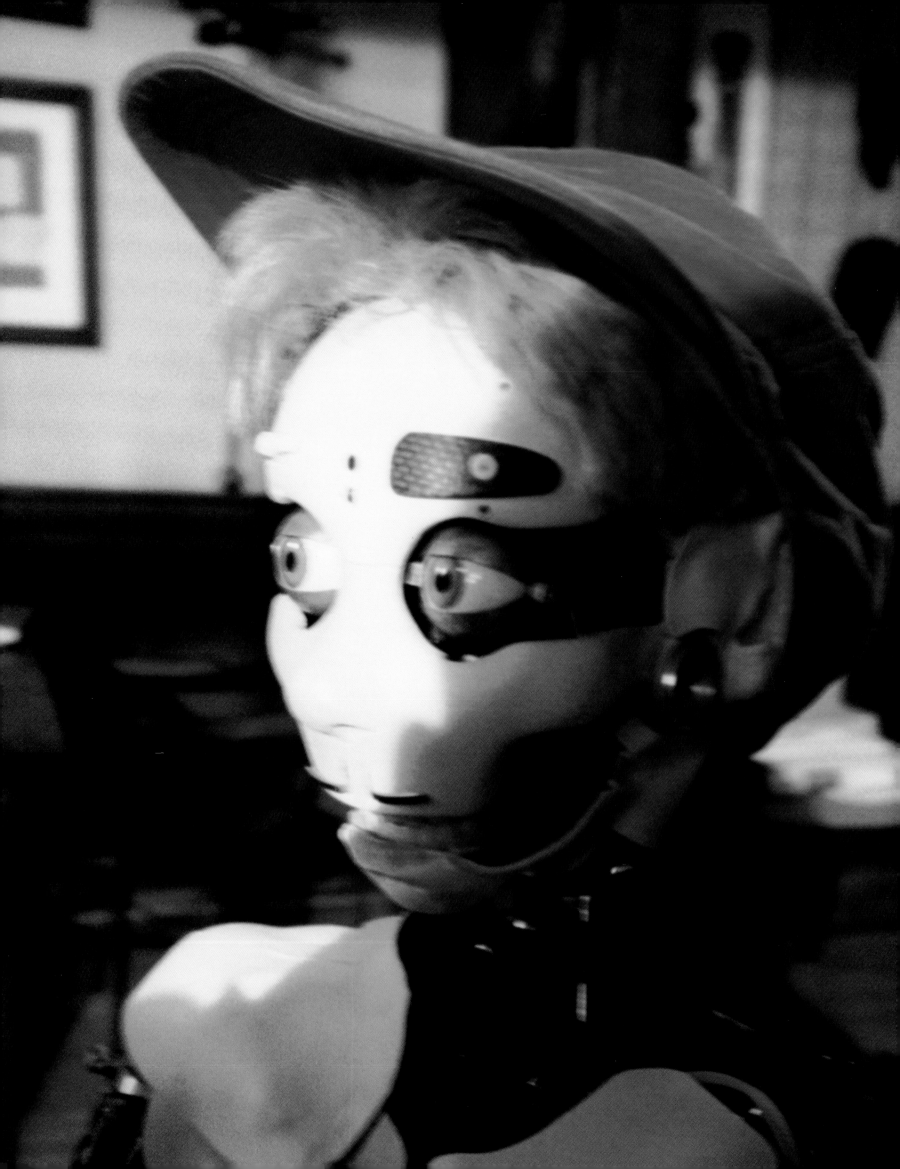

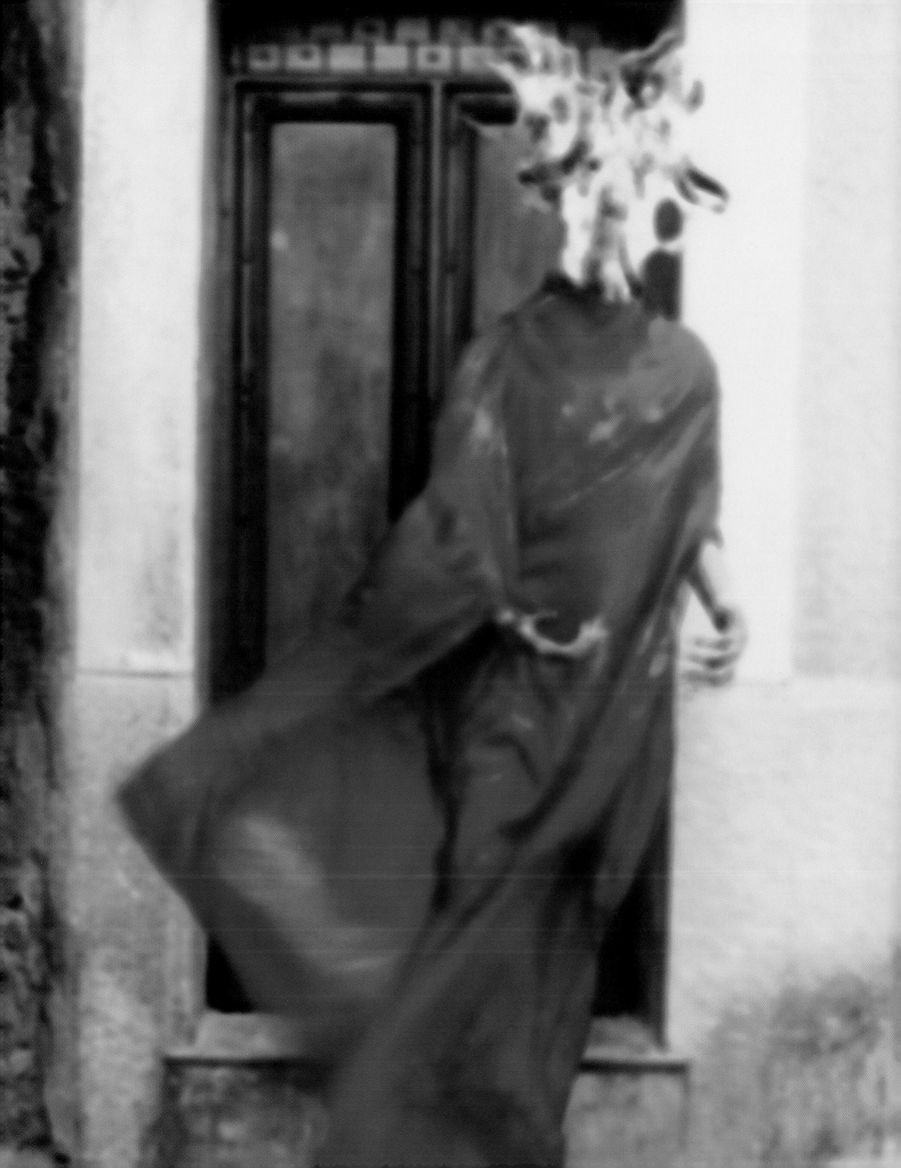

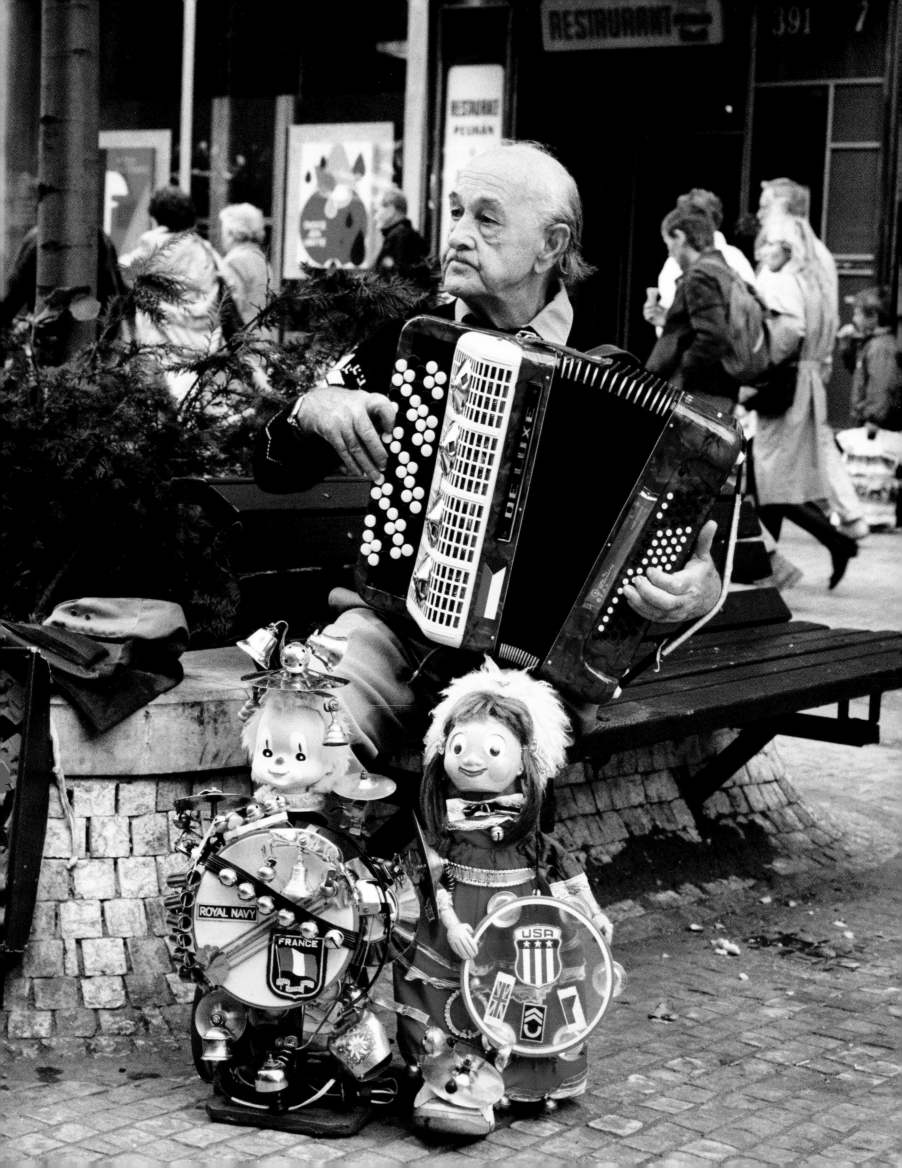

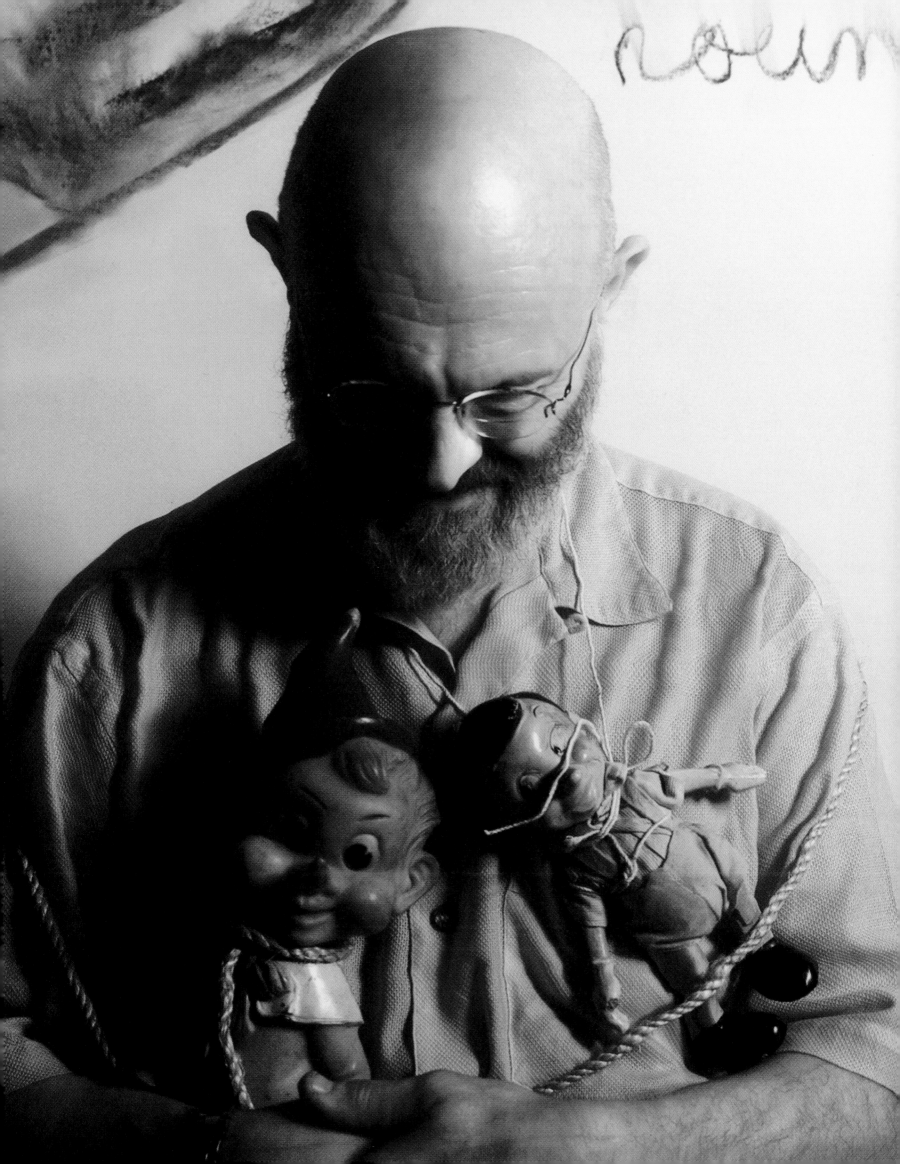

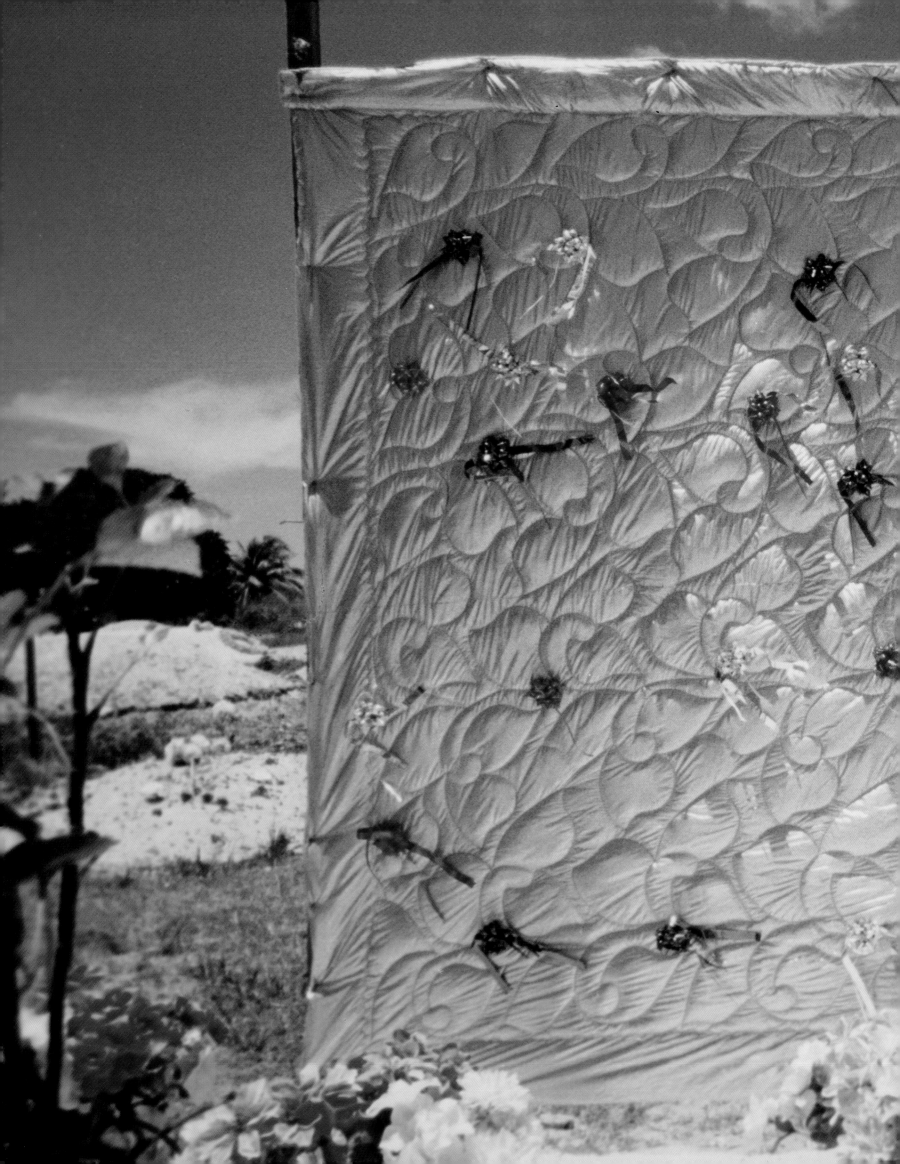

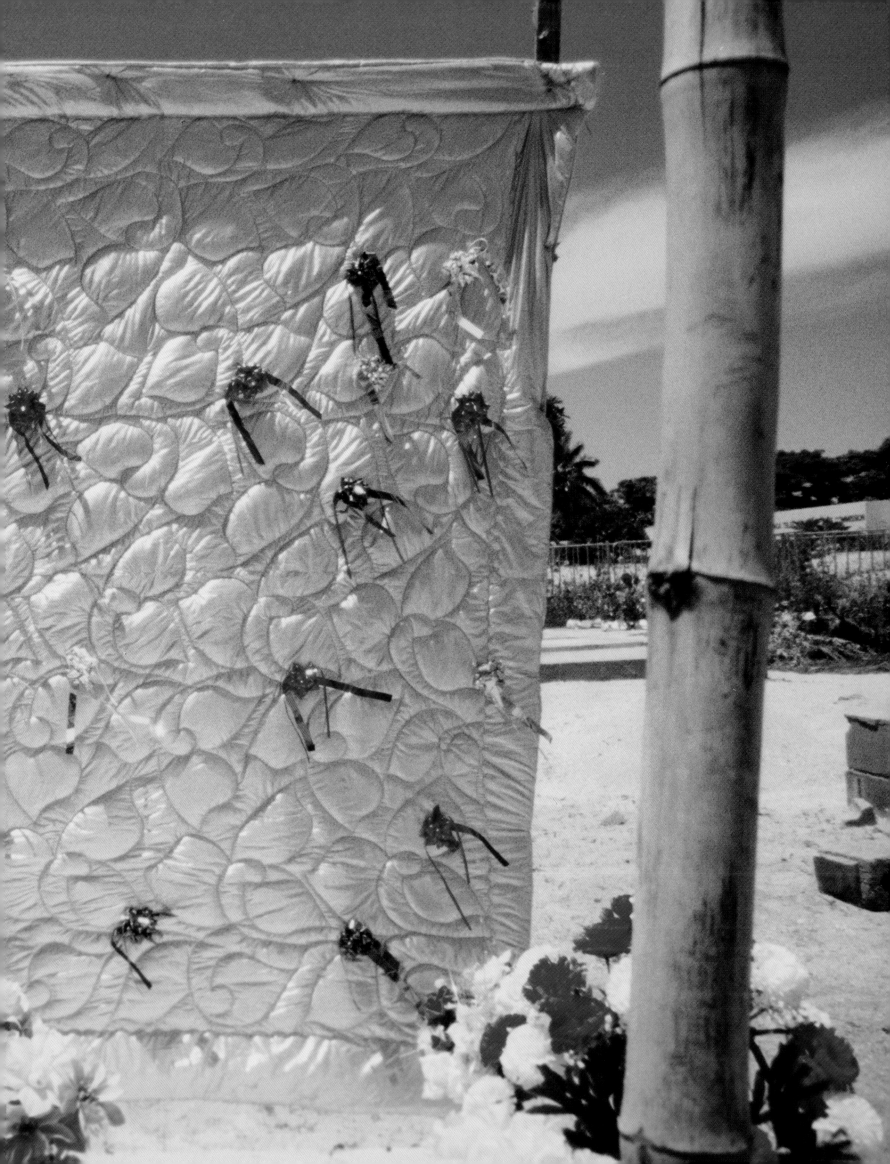

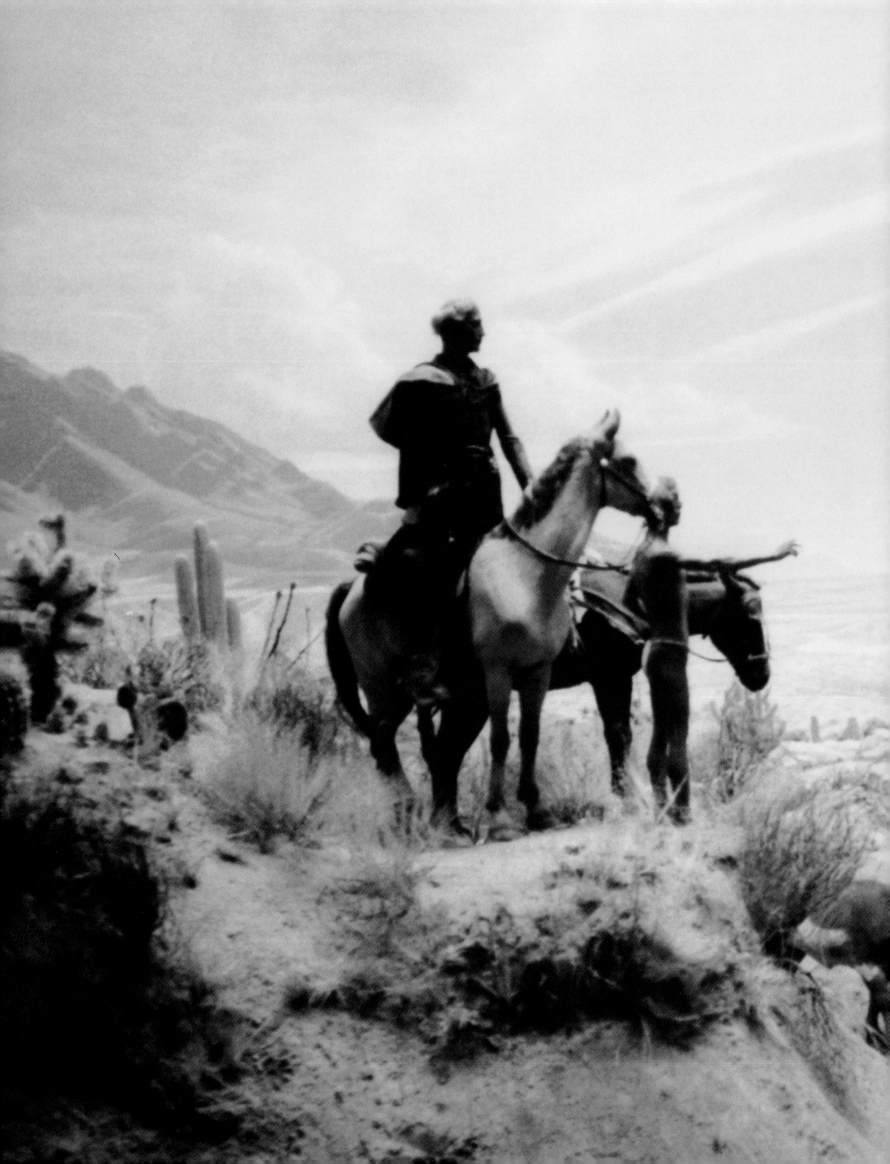

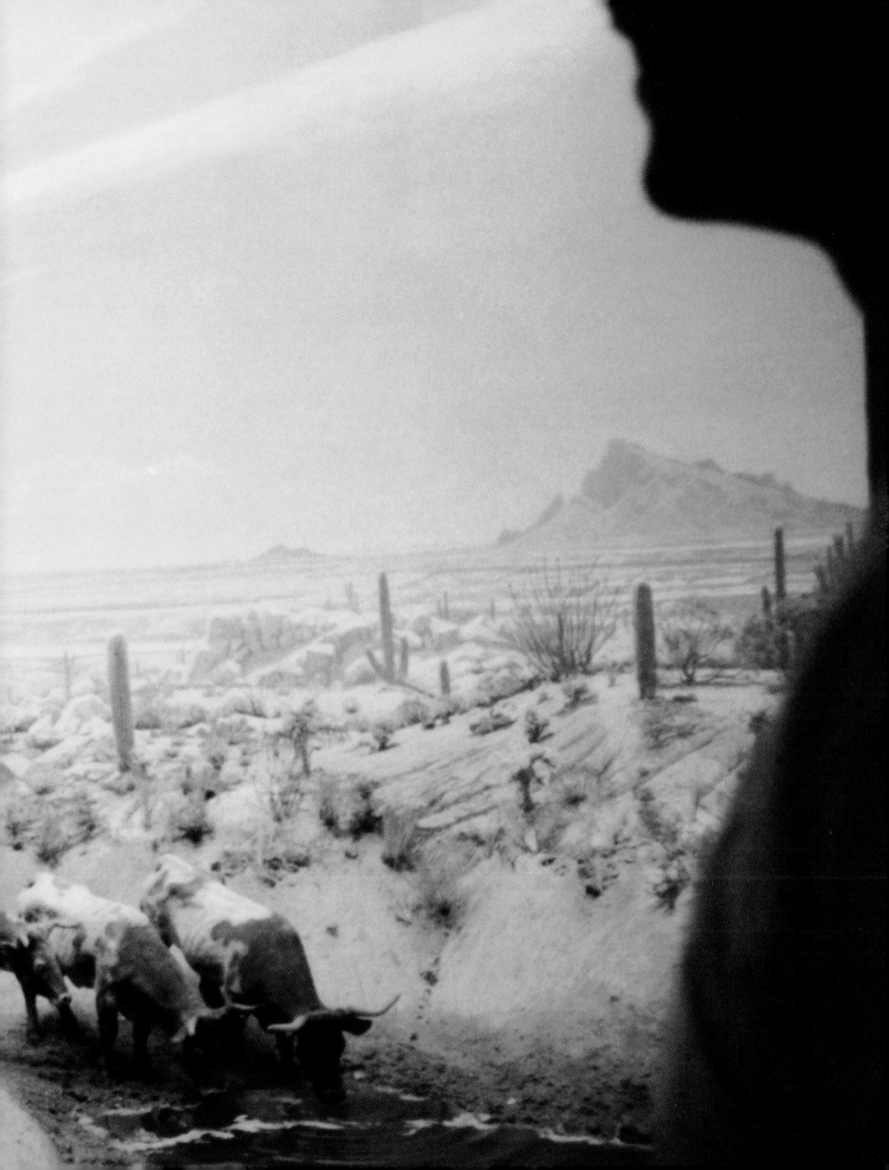

4 5 6 7

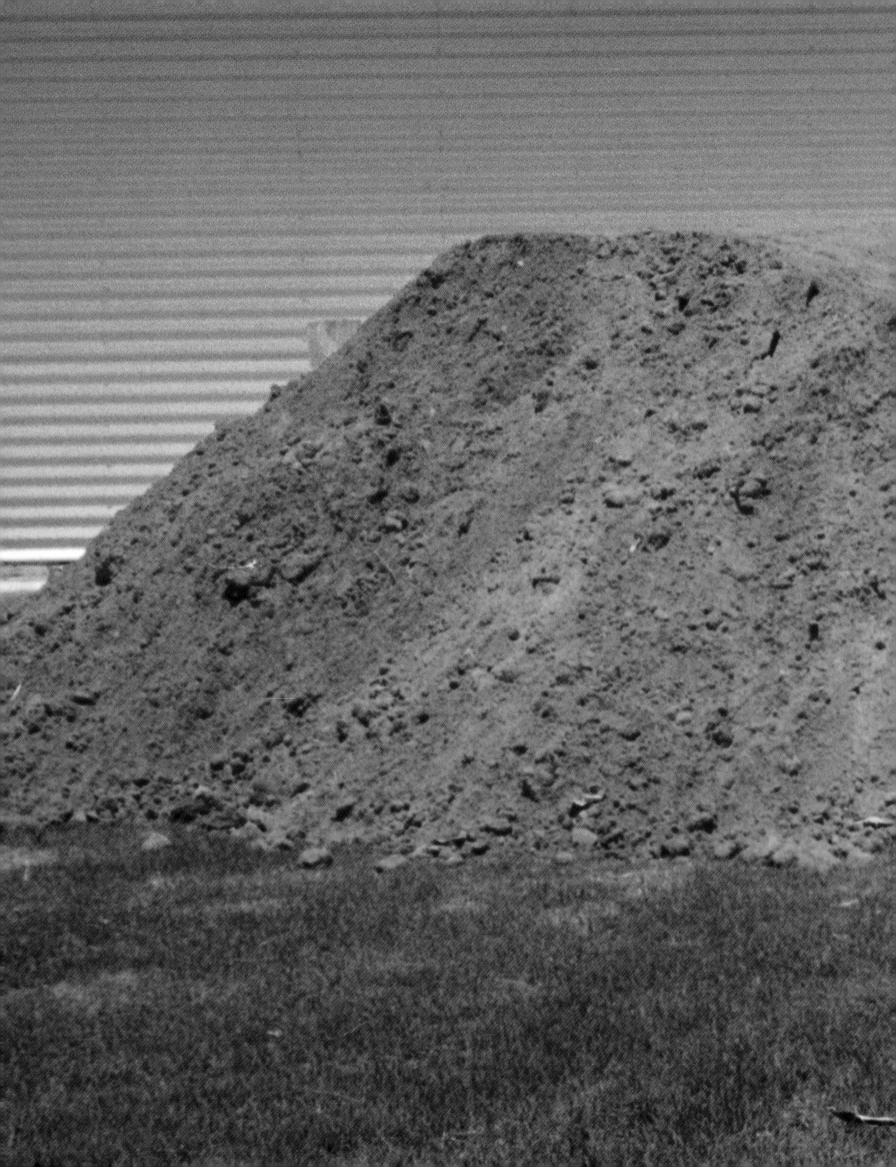

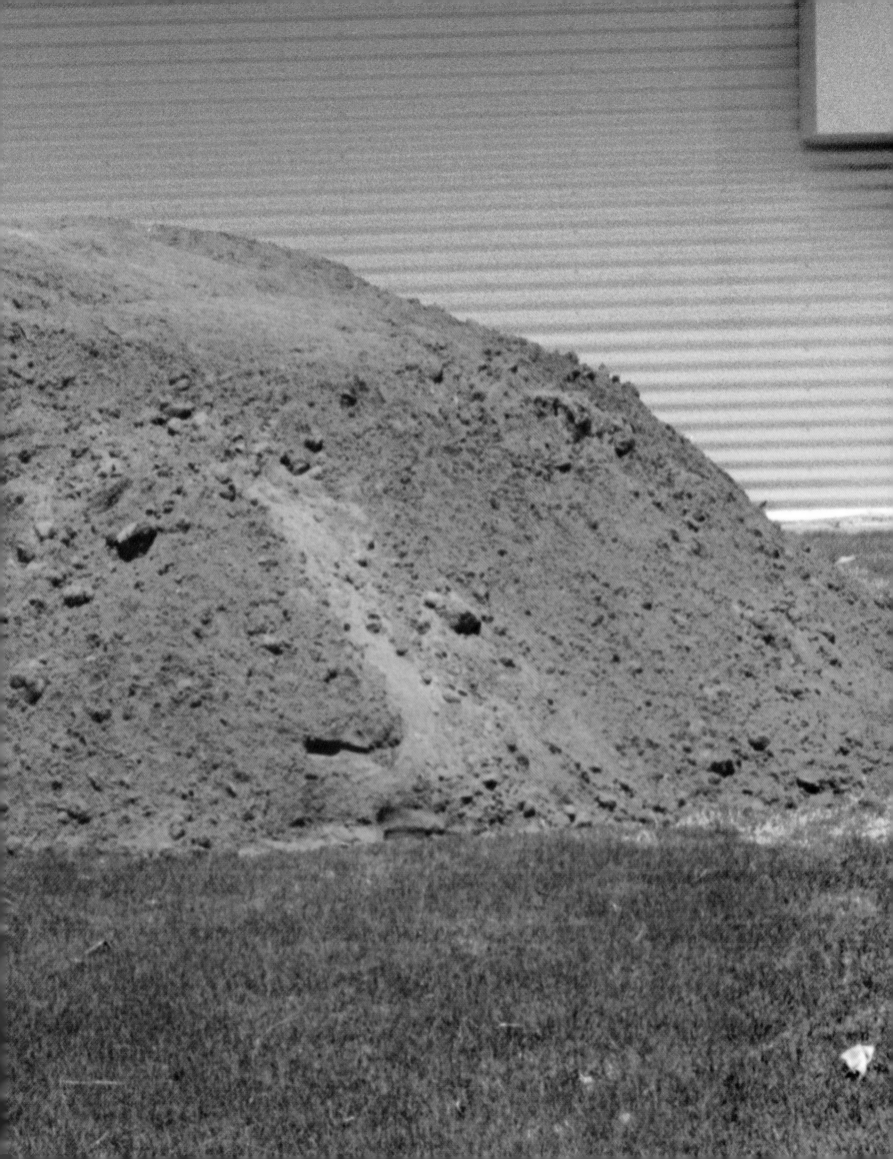

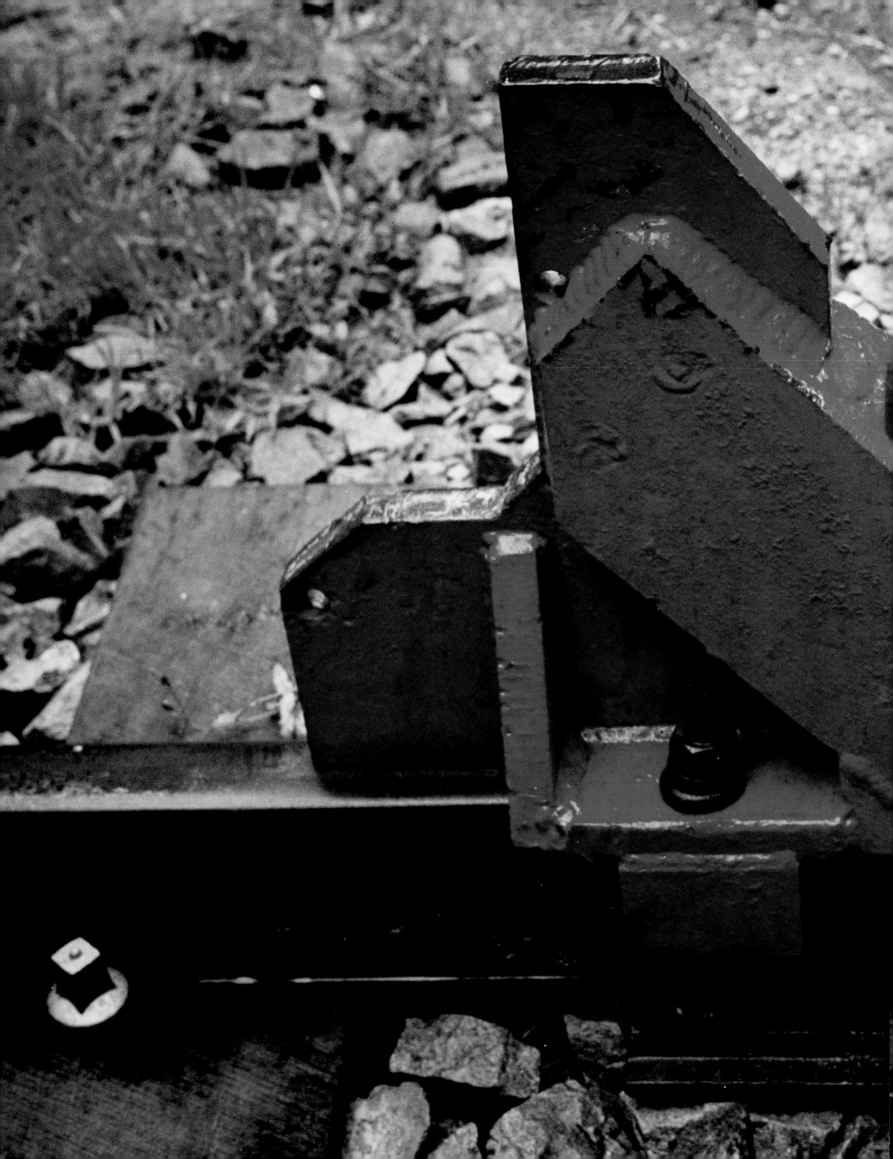

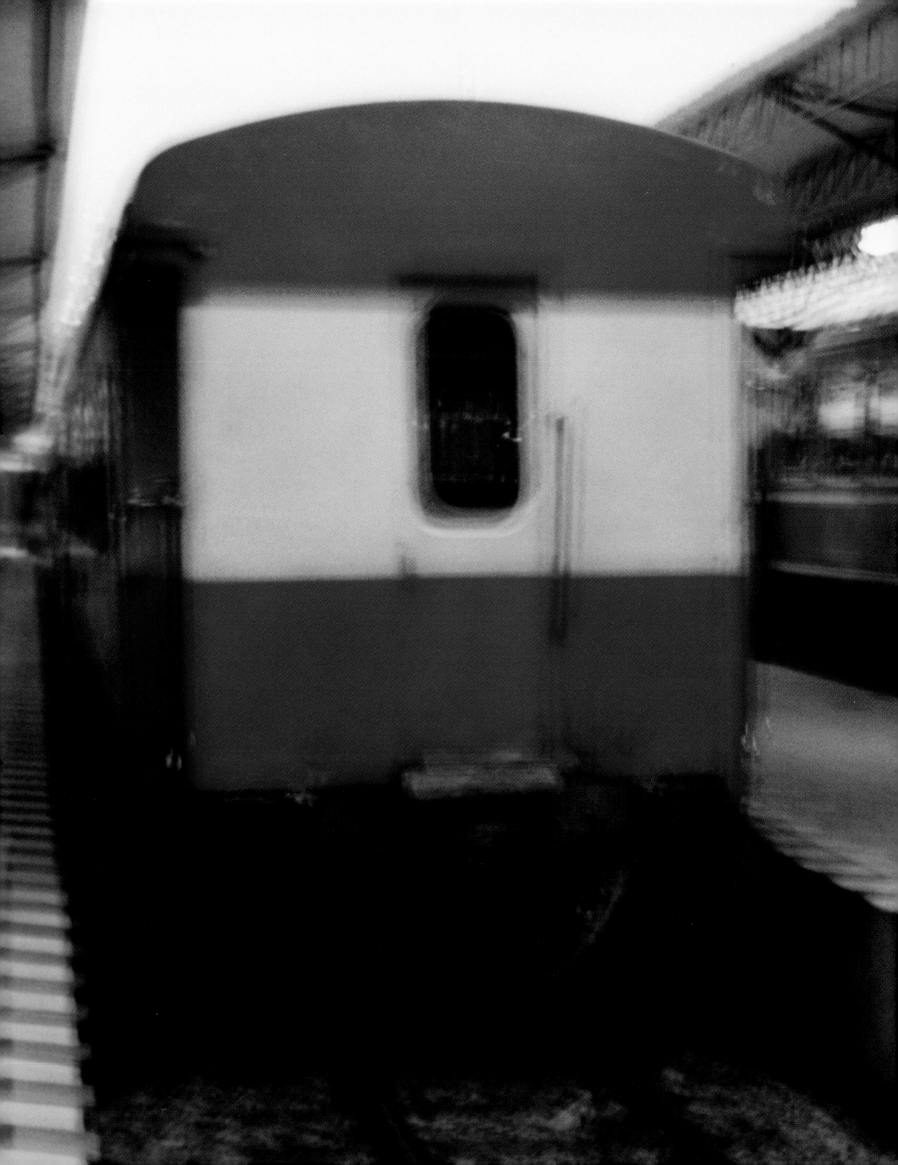

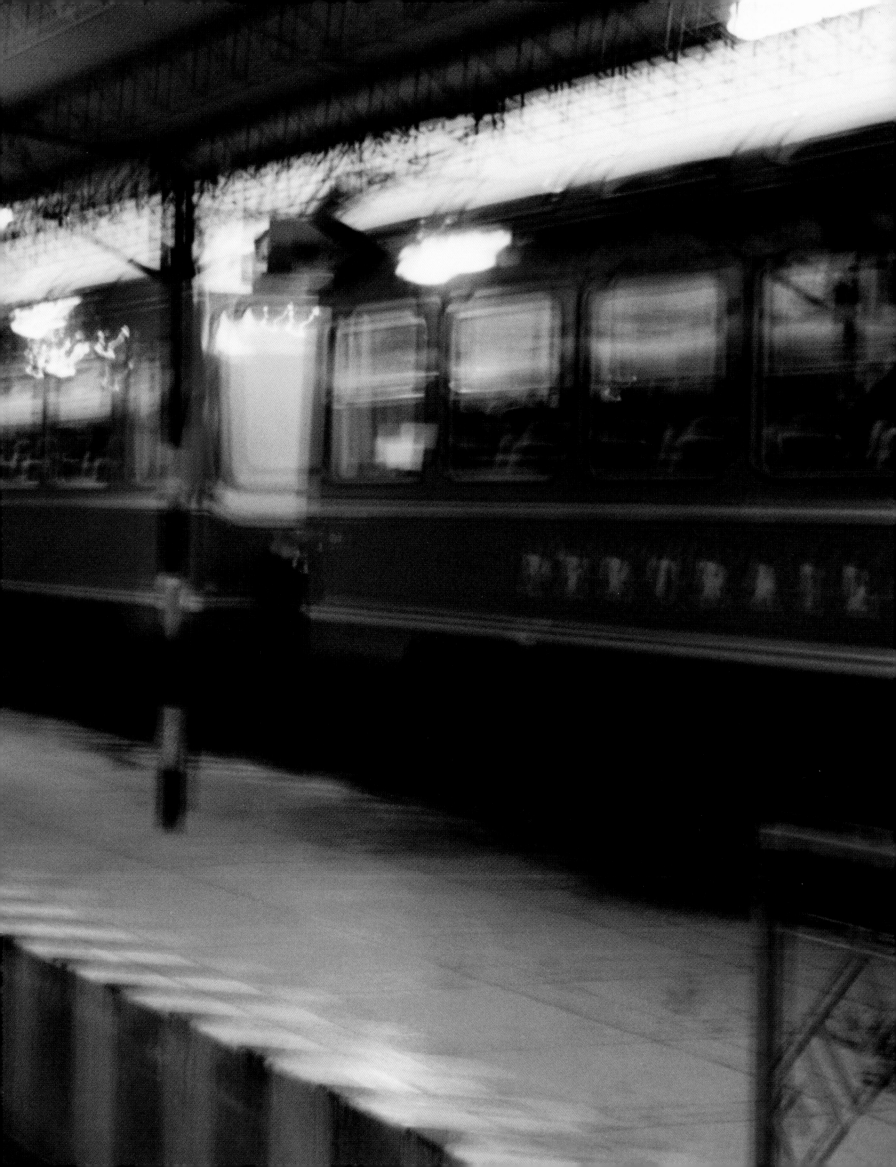

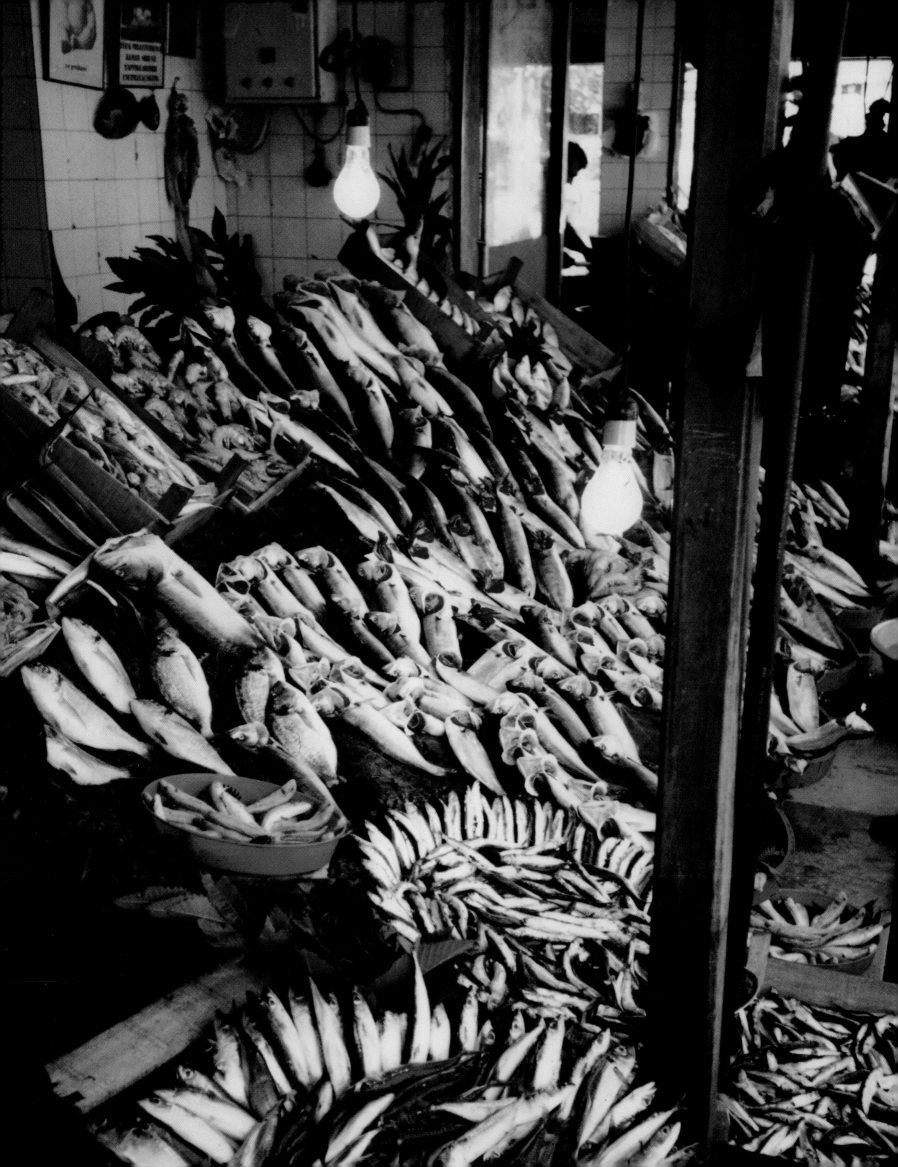

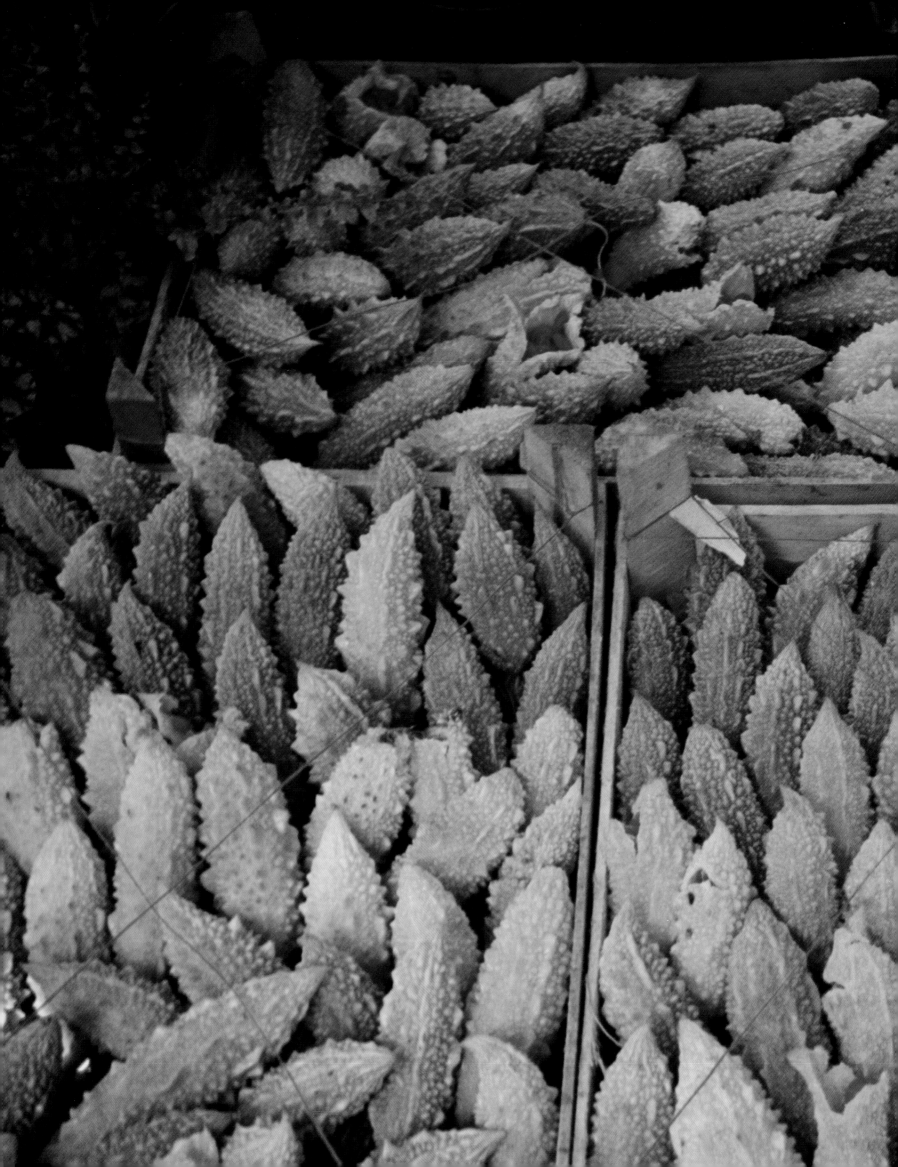

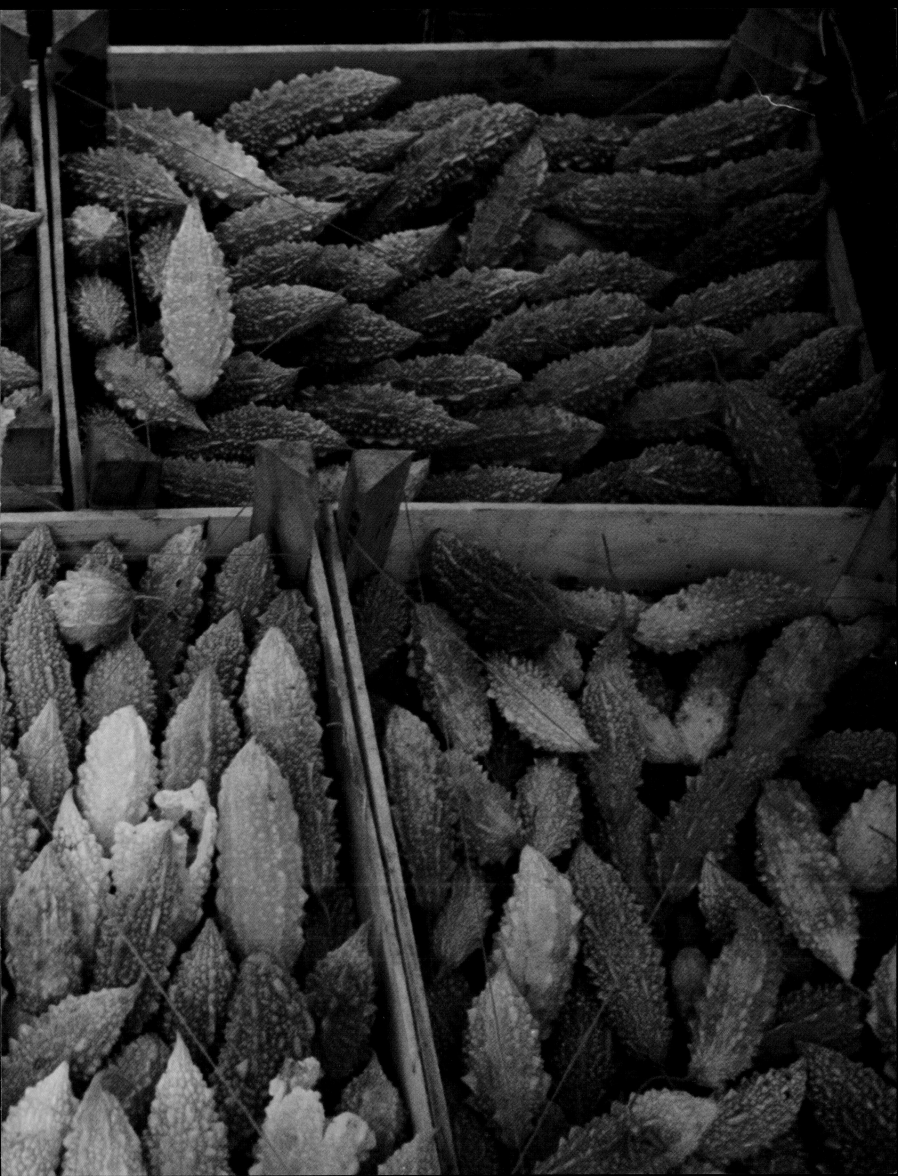

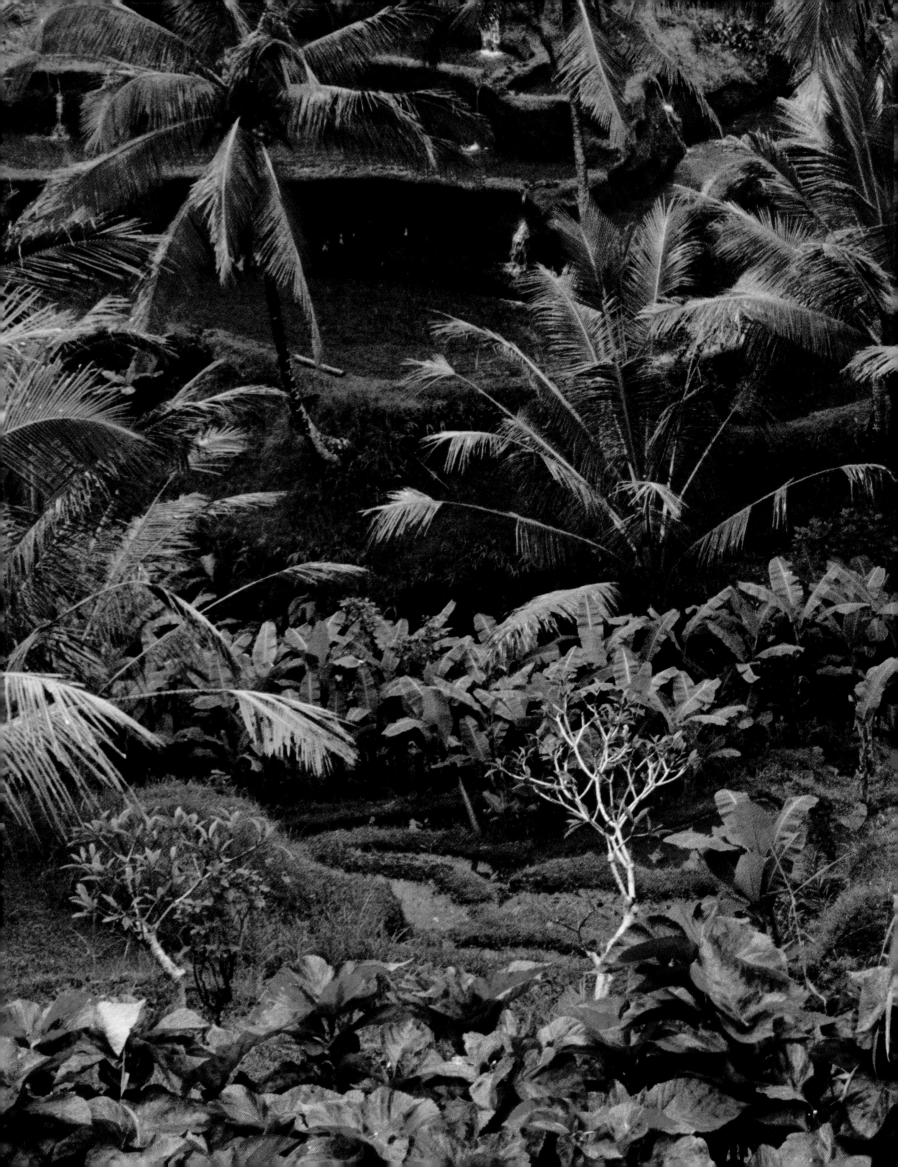

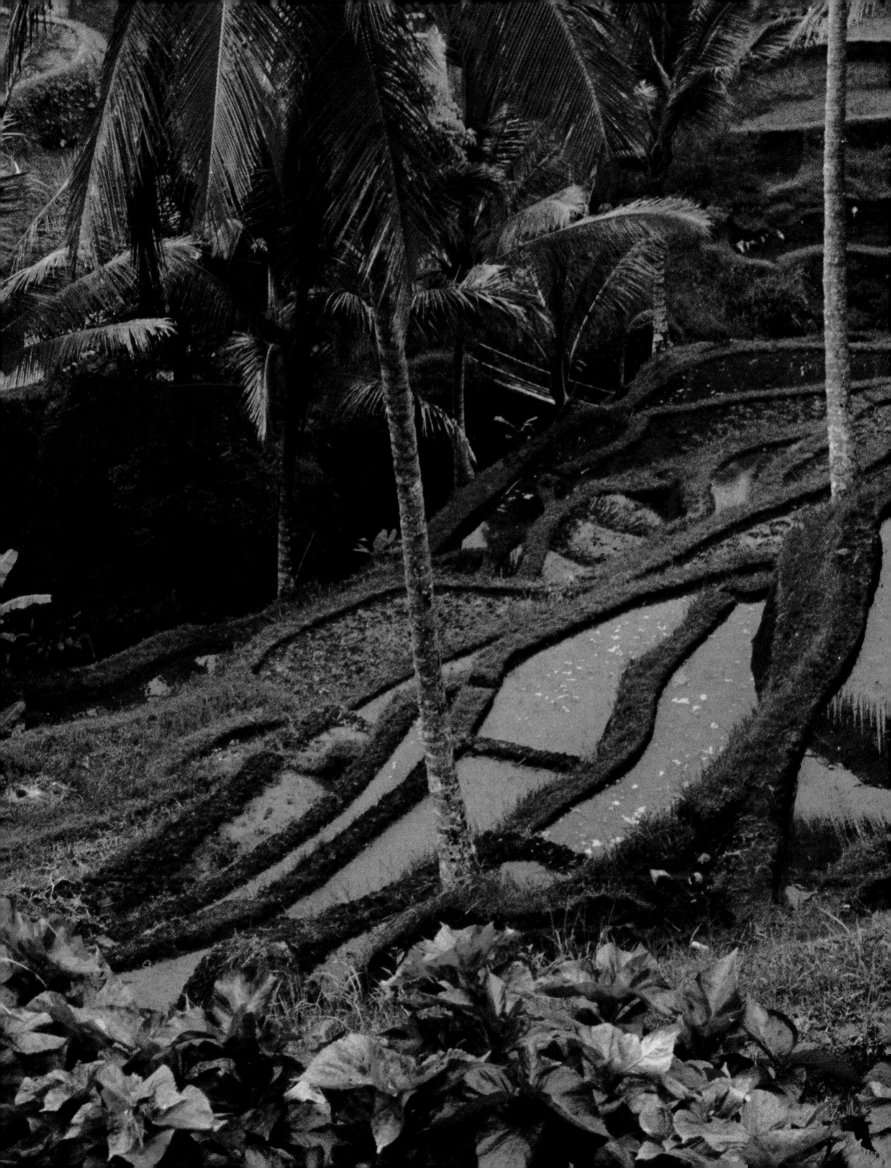

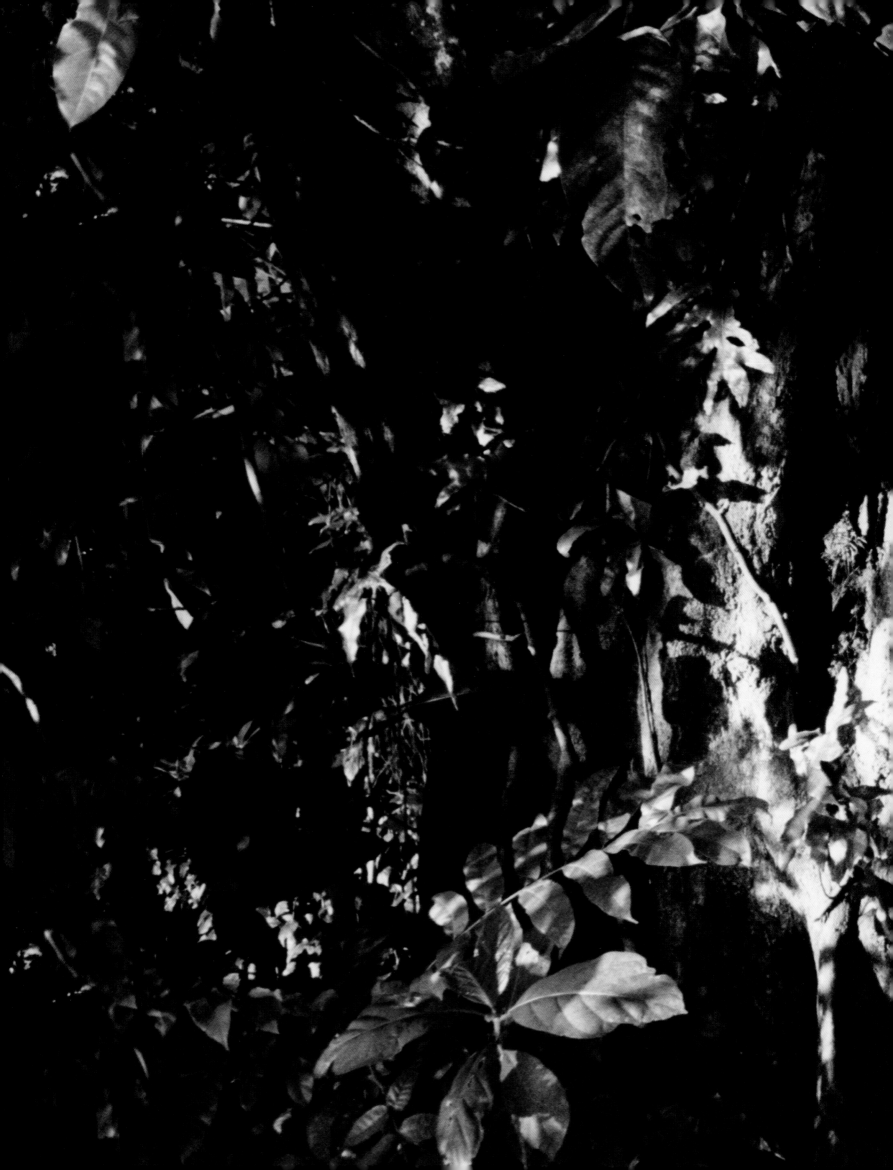

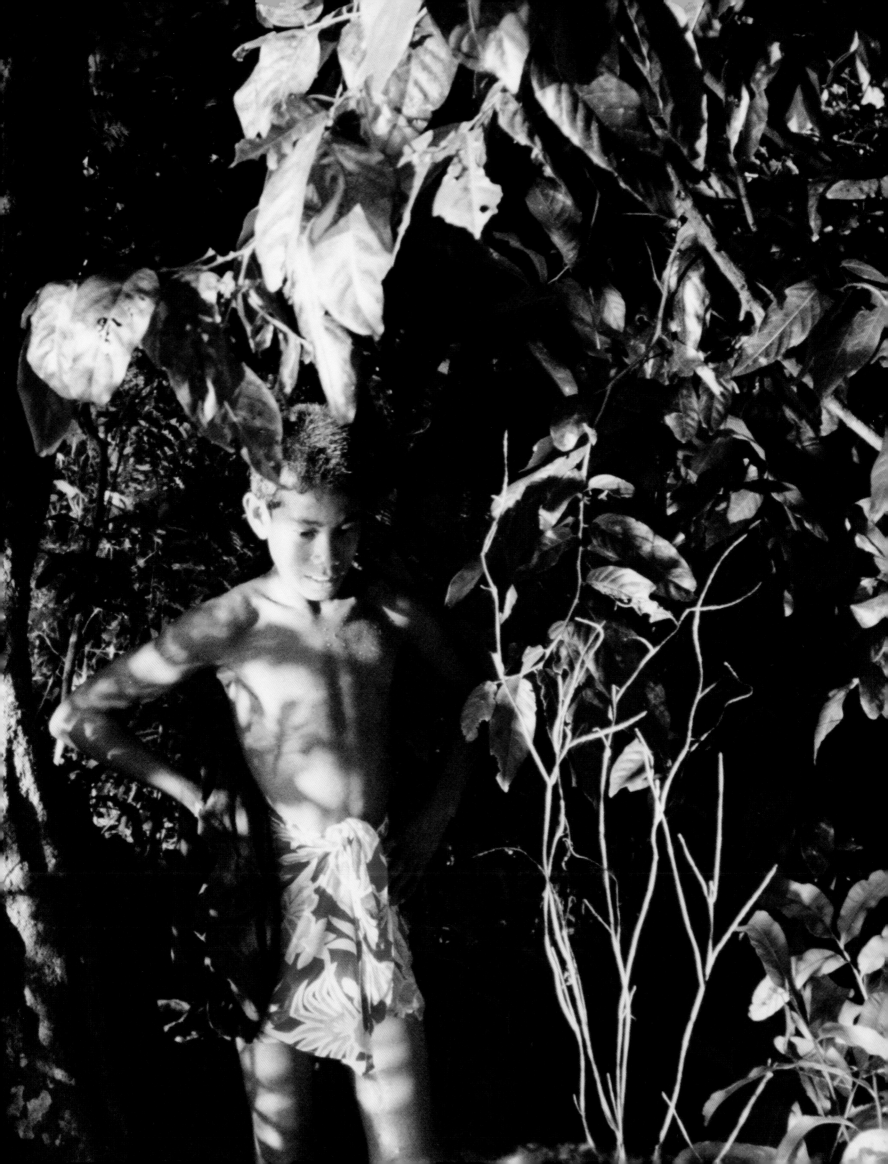

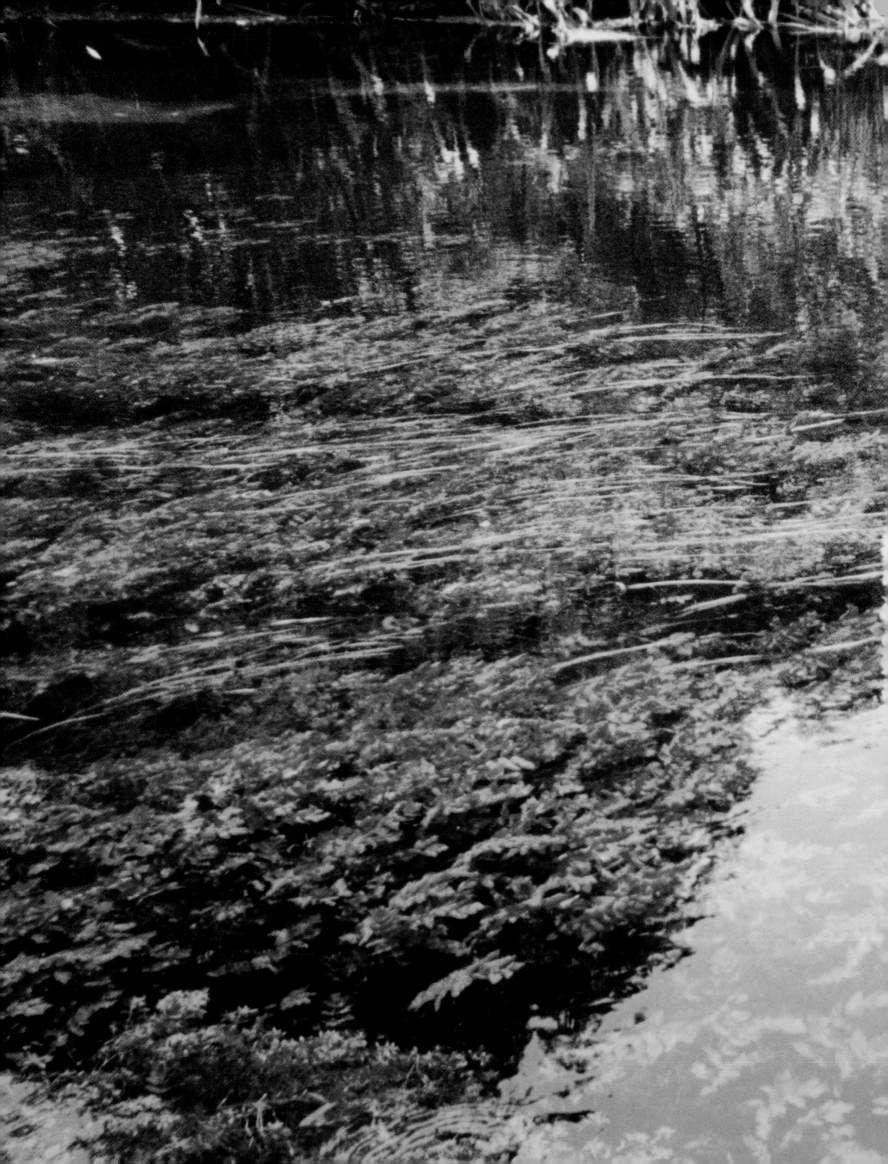

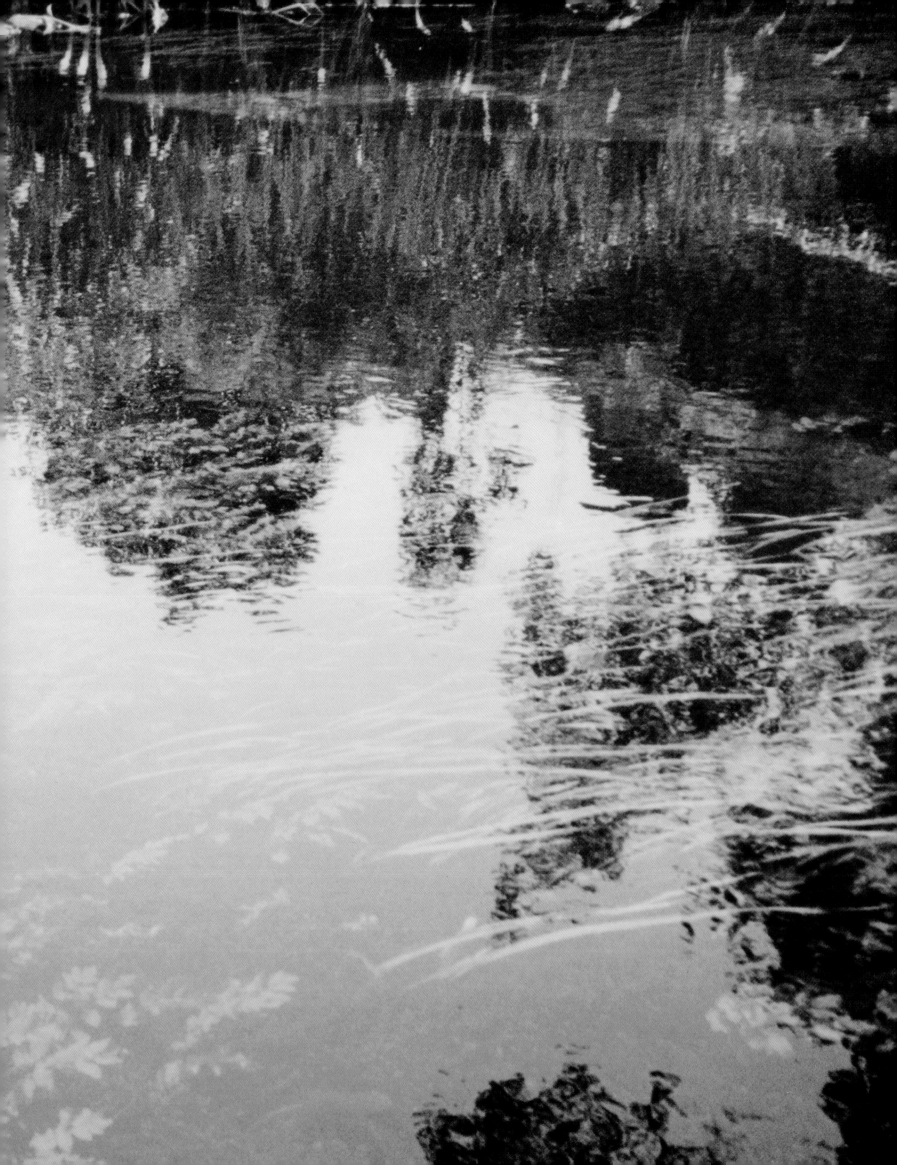

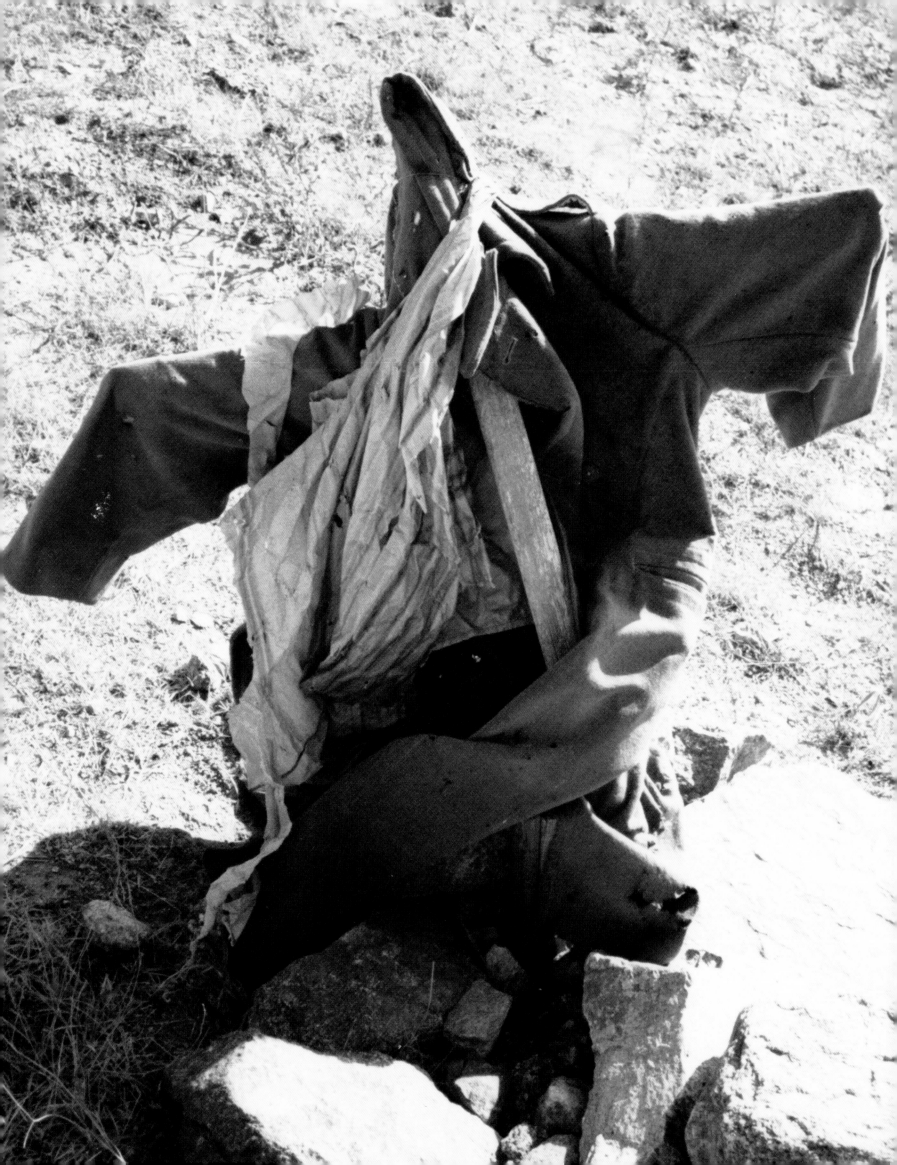

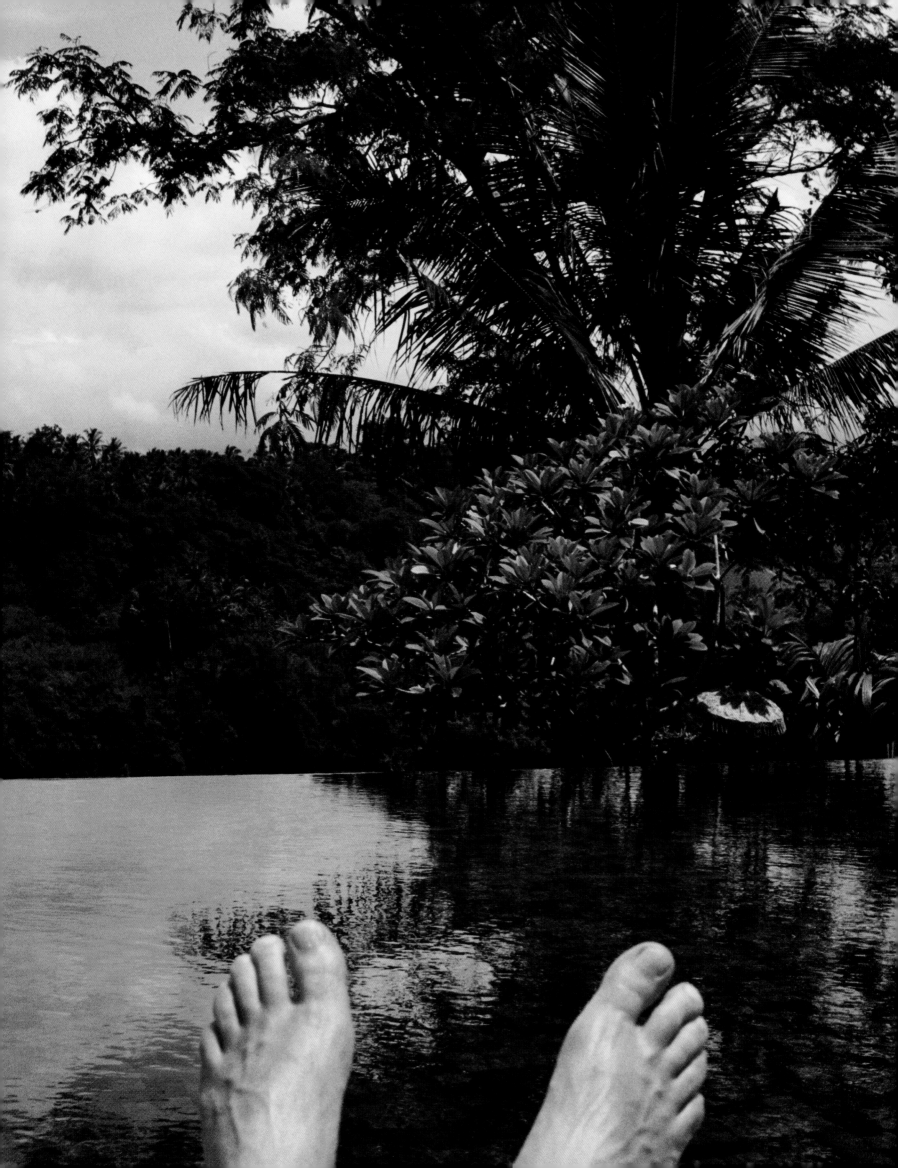

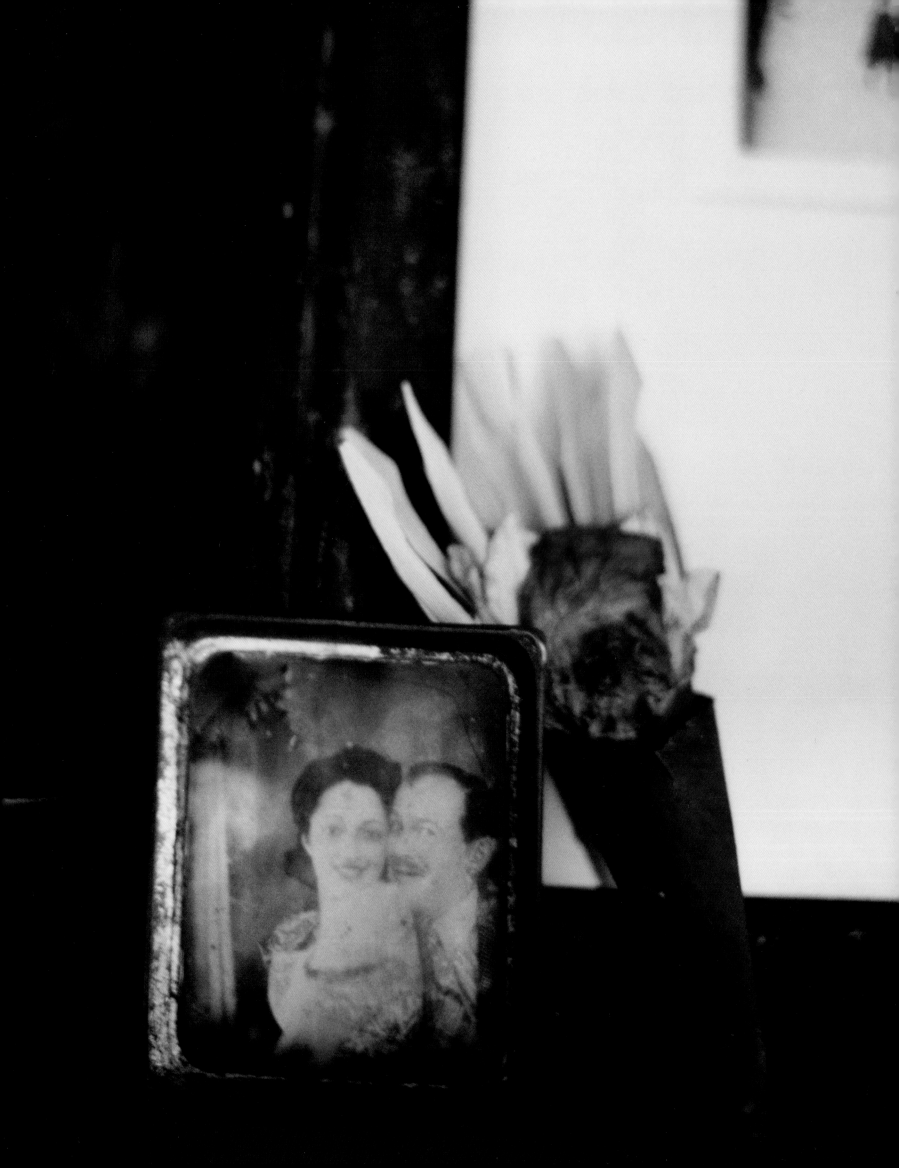

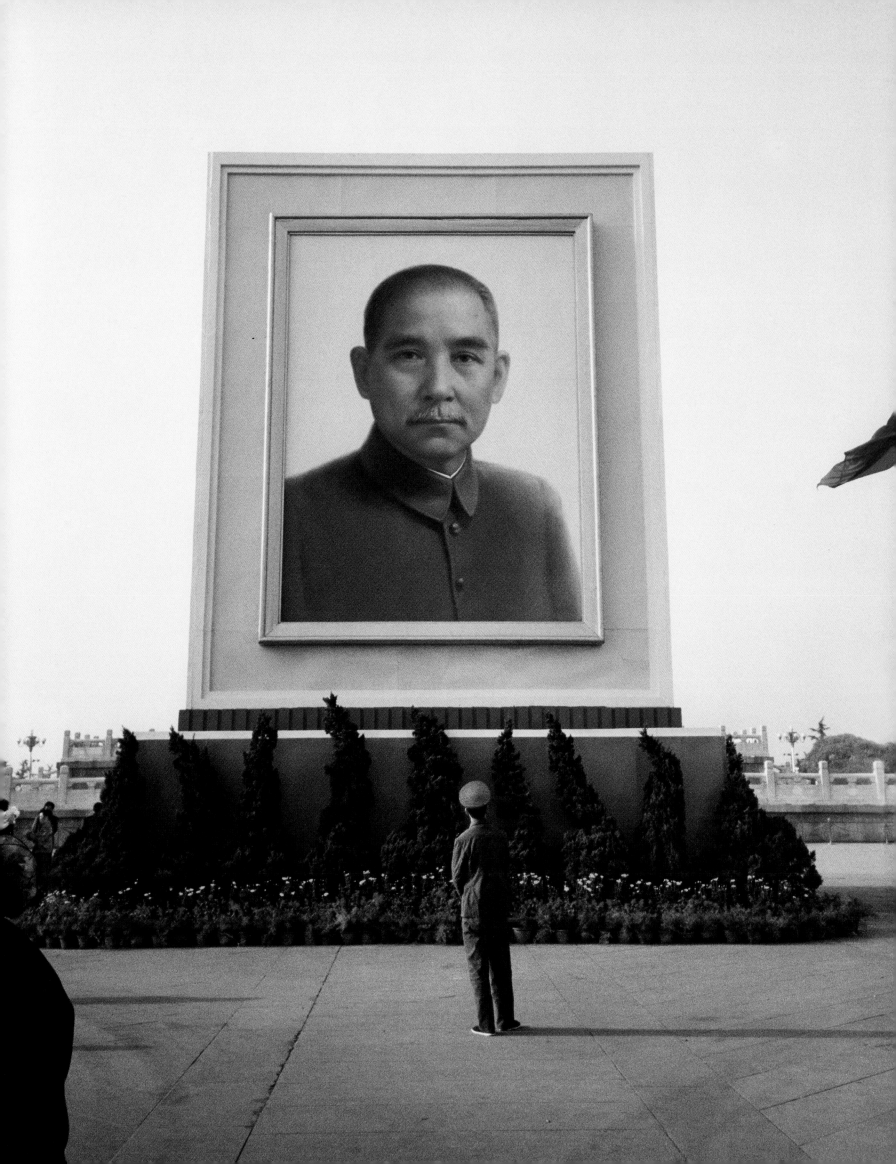

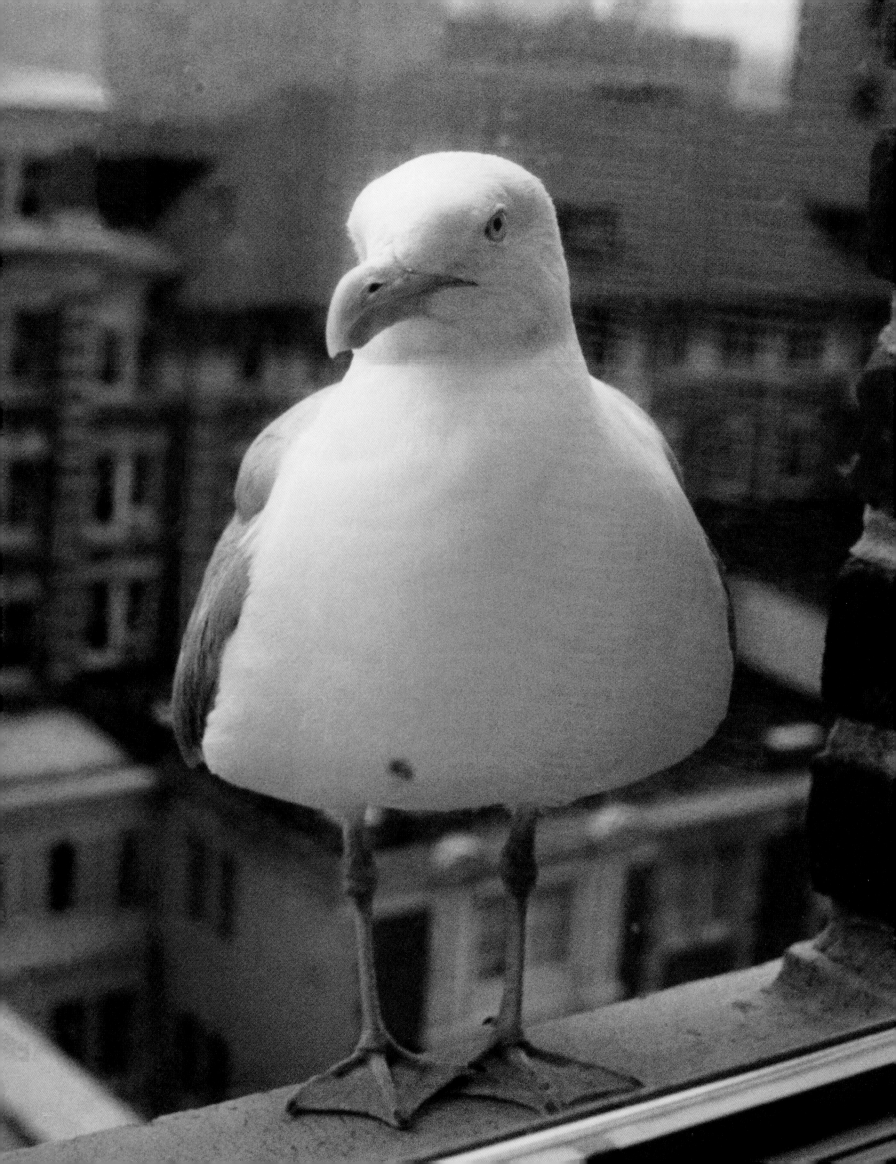

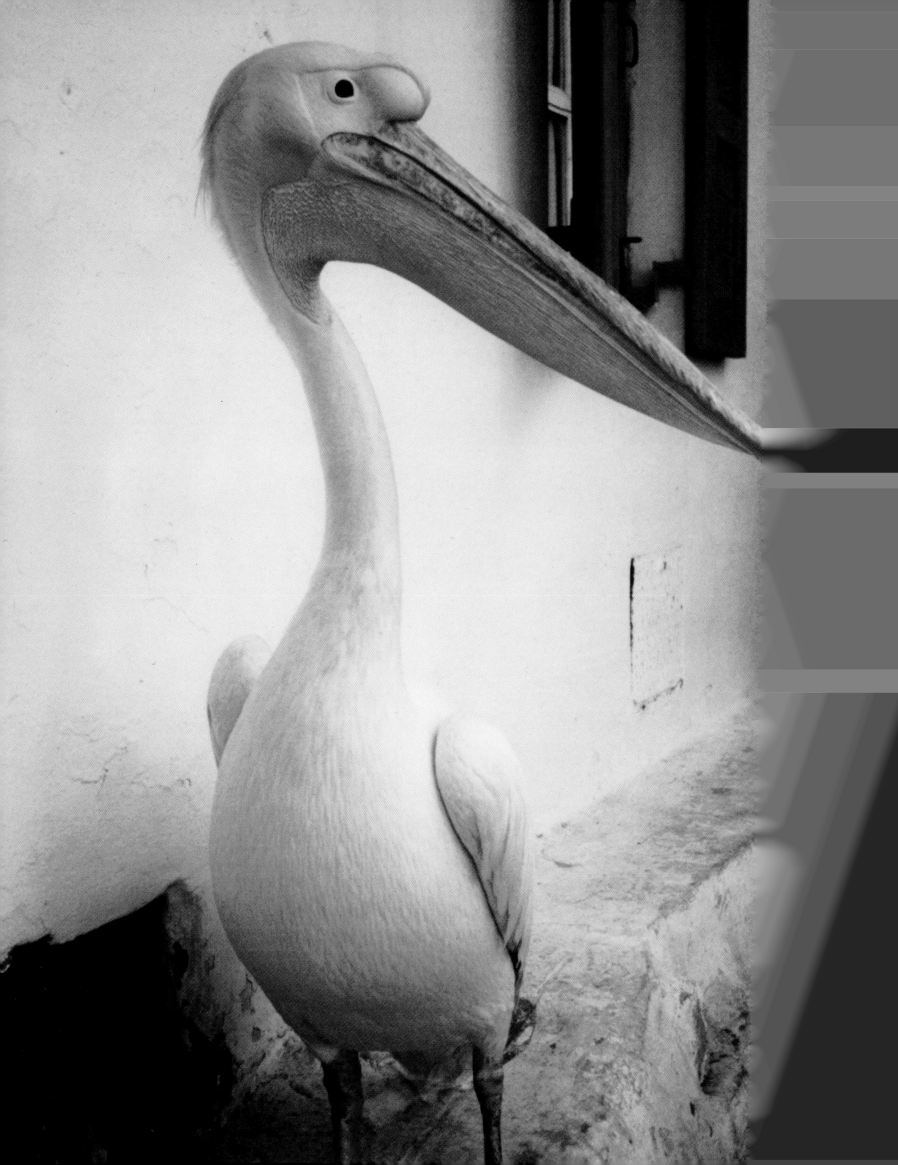

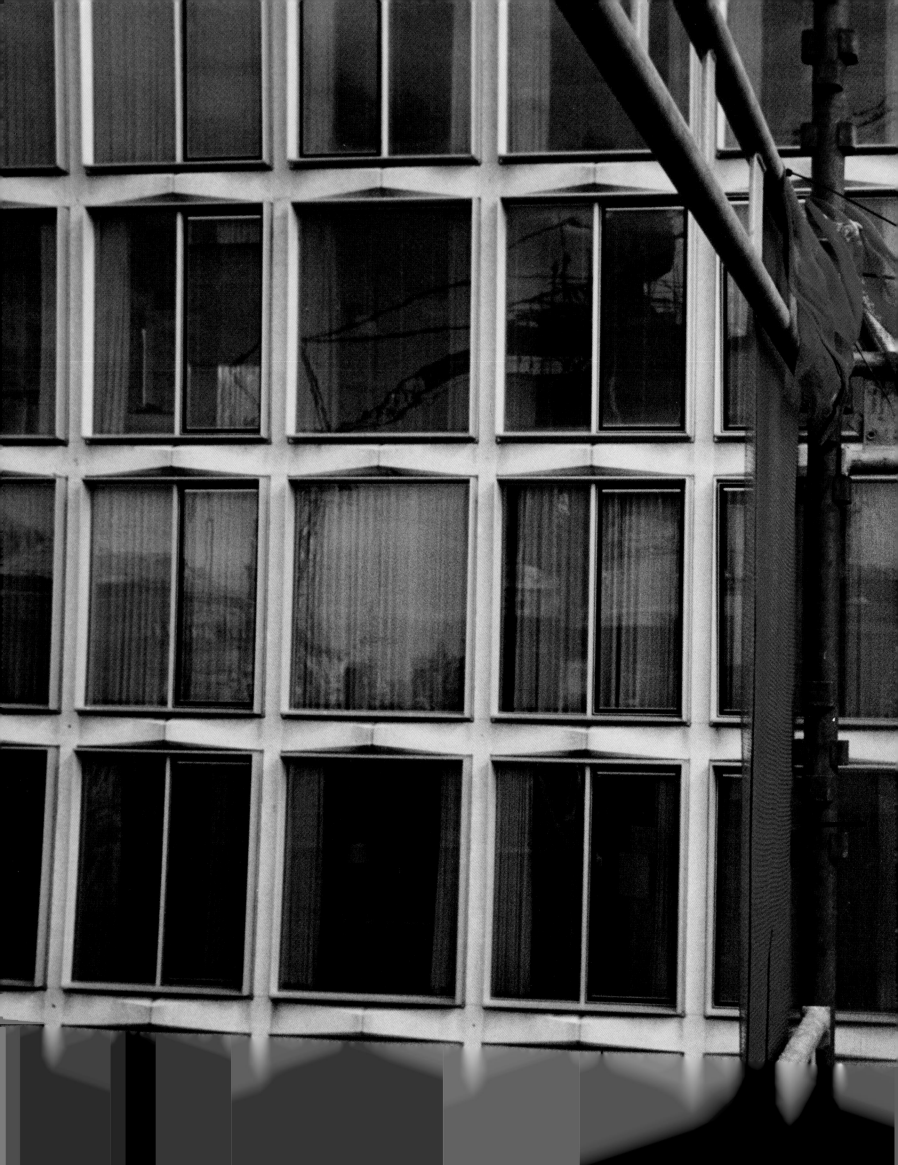

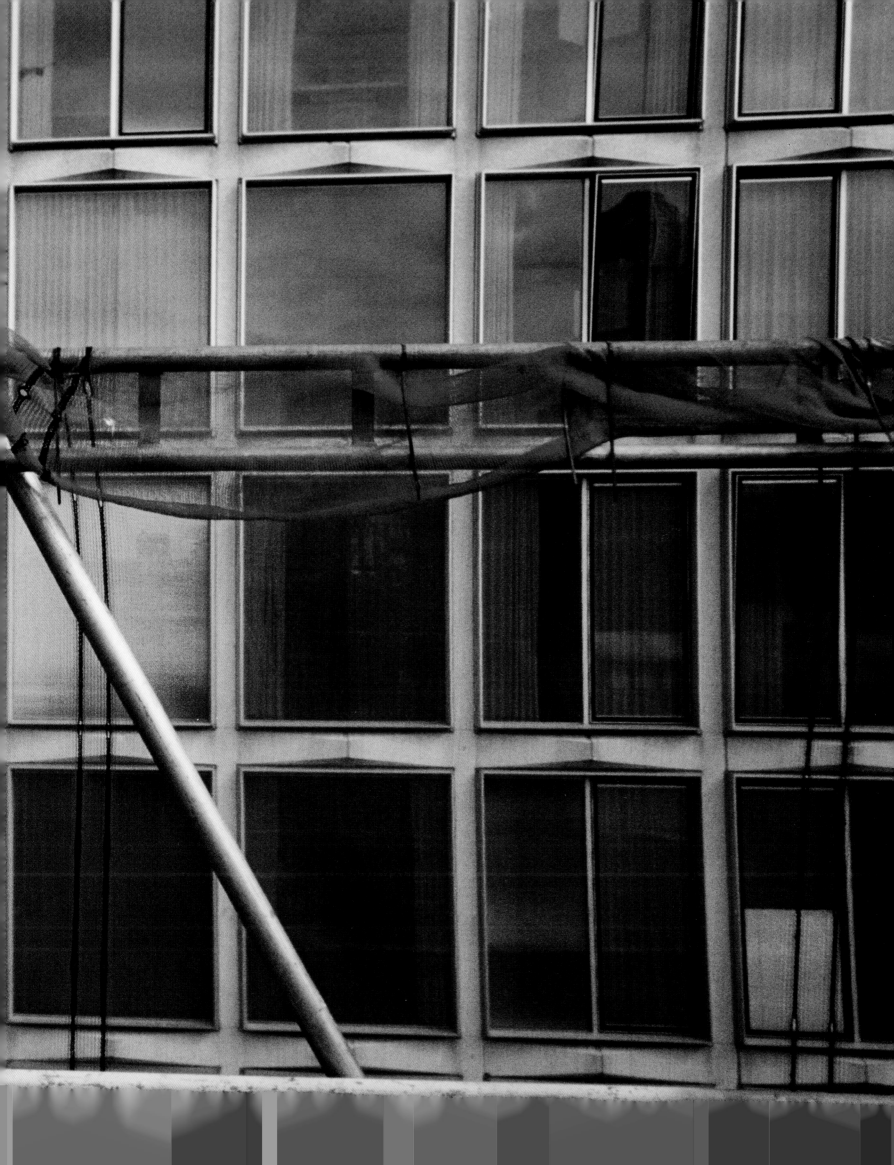

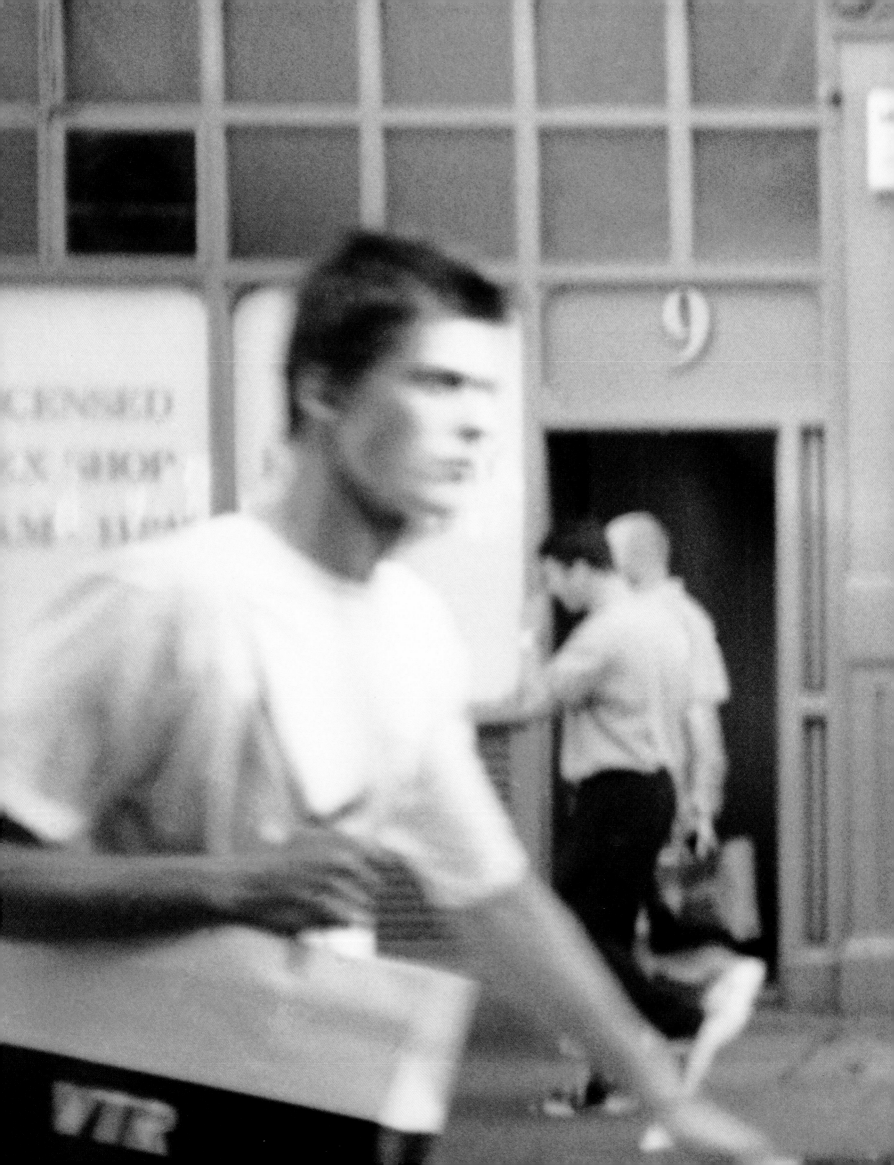

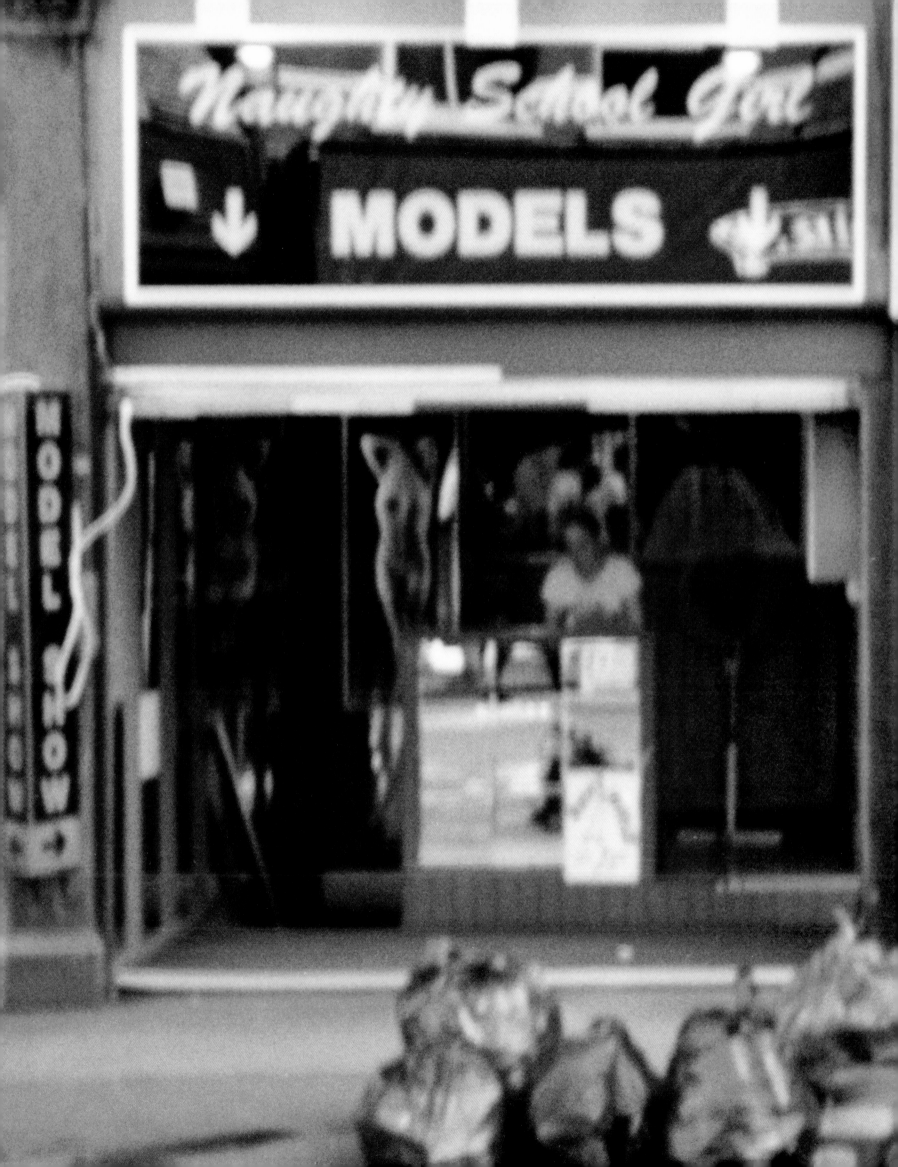

FINGERS

Ovc

VAFEL ŠTANGLIC

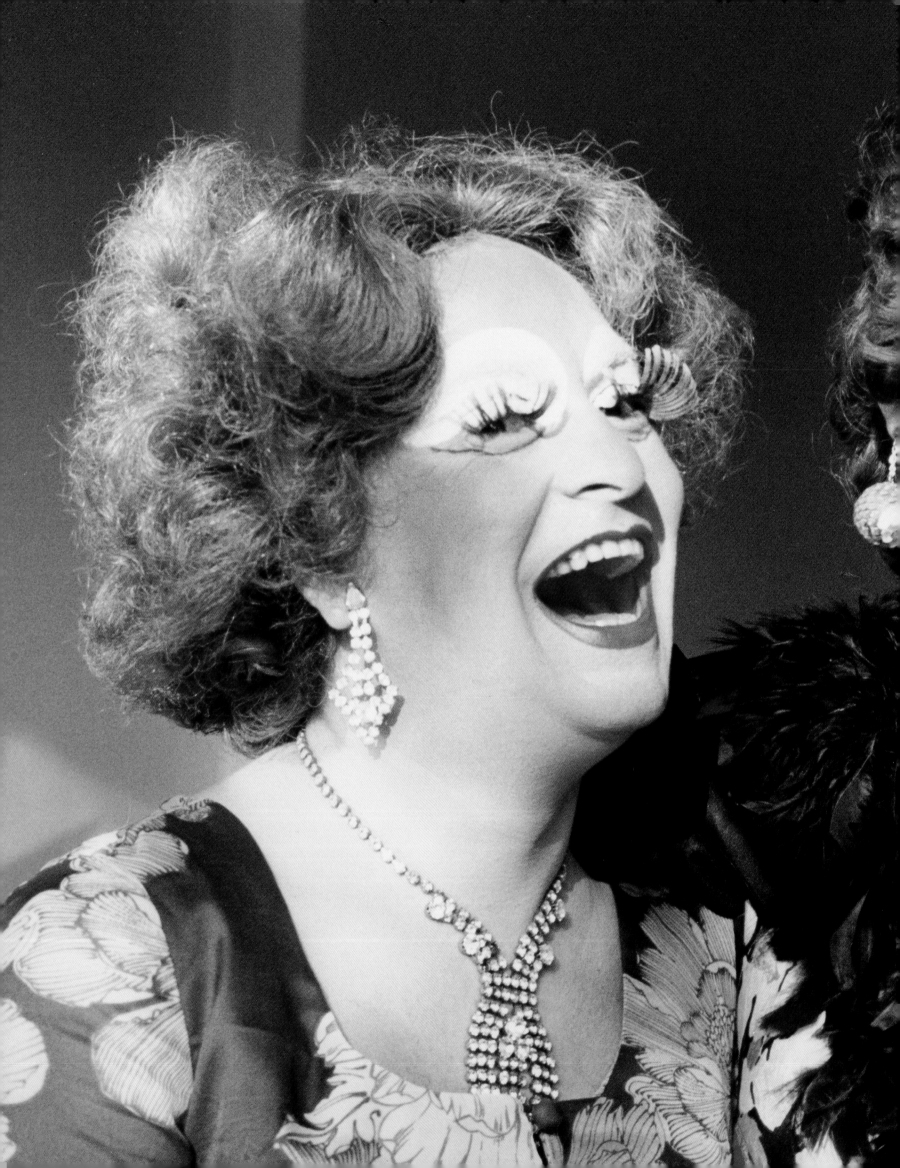

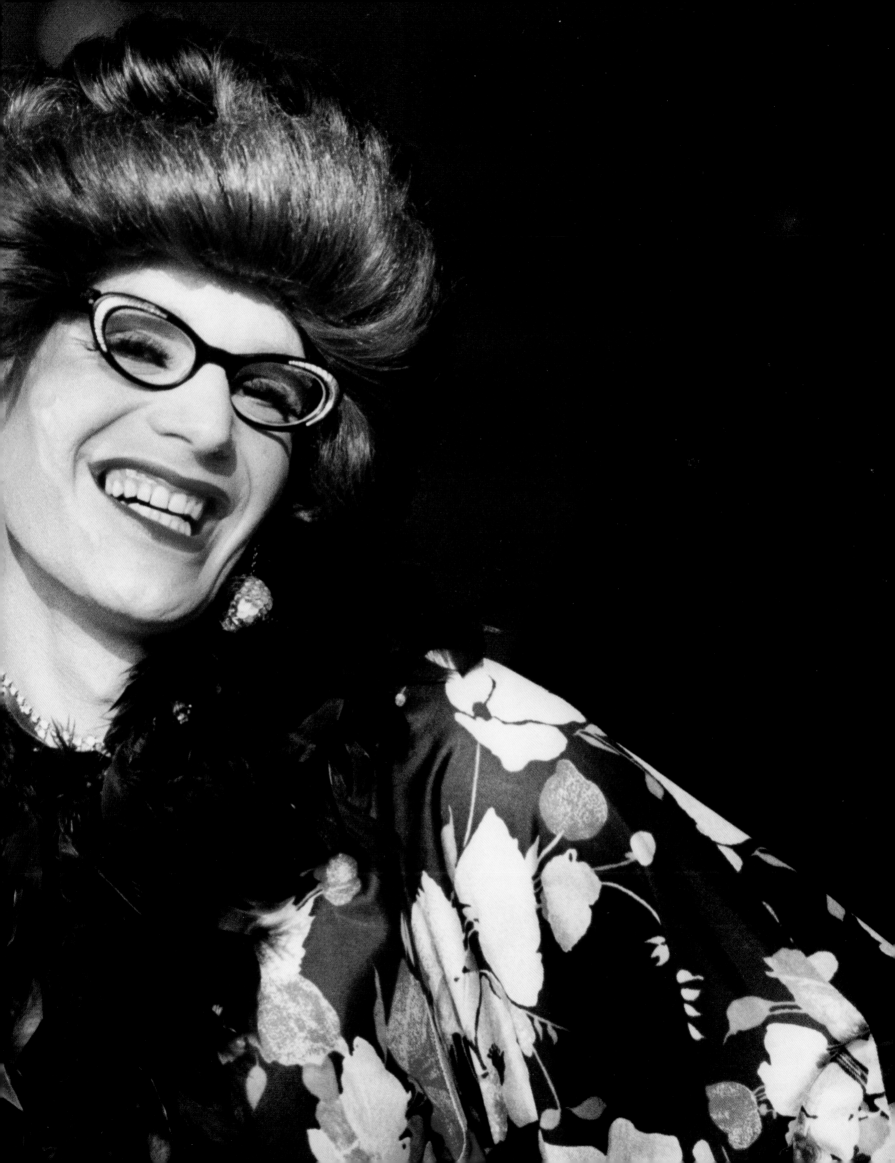

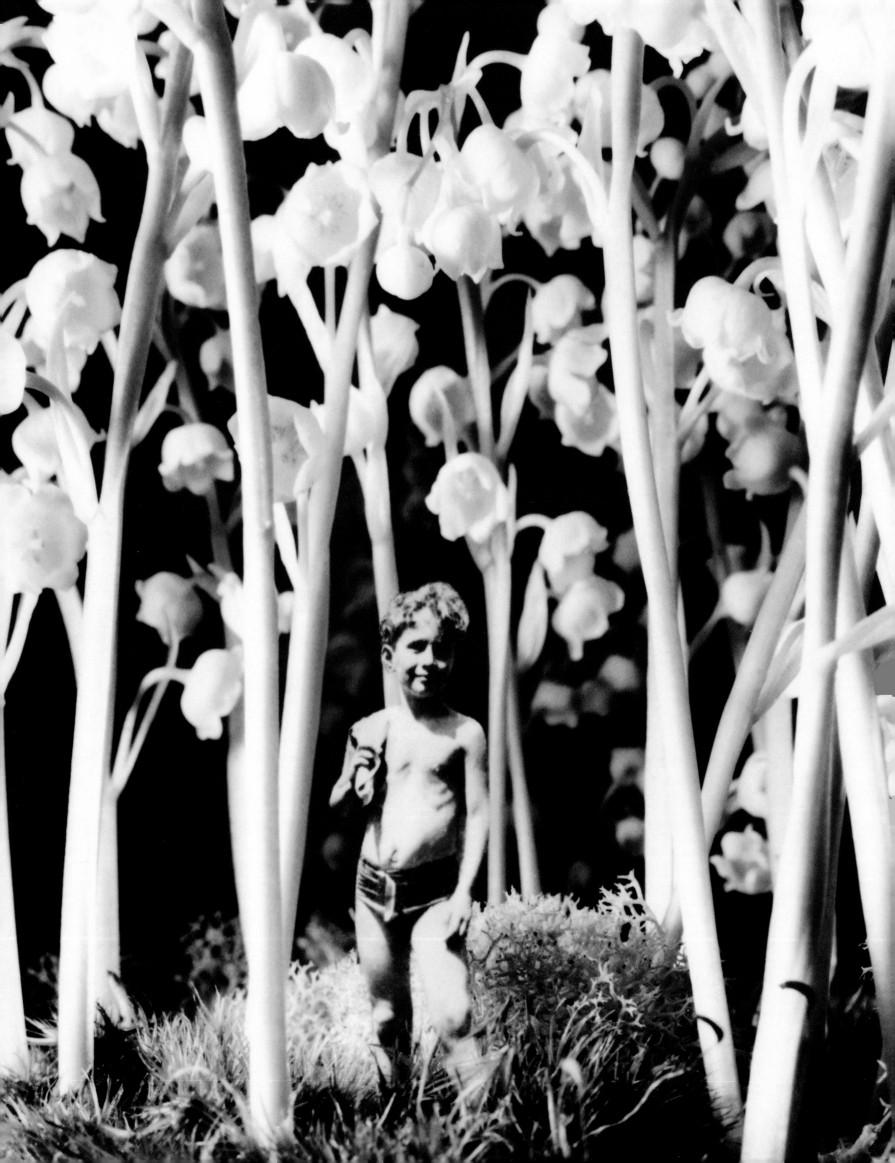

"We come across a cascade of light, and there is eternity." —Albert Camus, *Notebooks 1935–1942*

For as long as I can remember, I've loved taking photographs. It was always a complete and spontaneous pleasure for me. I never considered a tripod, zoom lens, or light meter. It was never work, only satisfaction. Looking...observing...recording...reflecting. Acts unspoiled by ambition, expectation, or competition. Being an actor, and in the public eye, this then, was a private act. Much of this book is about wonder... What is that...? How did that...? Is that real...? Is that...? Thus, picture taking for me often answers the question; it often solves the puzzle. The photographs were made over the past twenty-five years, mostly with my trusty Nikkormat, in the U.S., Europe, Asia, and in South and Central America. The most recent images were shot this past year (2002) at Machu Picchu. There, among the slippery stones of the fifteenth-century Incan ruin, I once again came across that "cascade of light." —**Joel Grey** New York City 2003

Acknowledgements

This project came together in a rather unexpected way. A couple of years ago when my daughter was about to give birth to her first child, I was going through photographs (mostly 4 x 5s) in boxes, shoeboxes to be precise, looking for her first baby pictures. In the midst of this, two artist friends stopped by and remarked on some of the non-baby images. They then encouraged me to do something with them—they sent me to a lab. Having never been to one professionally, I went with no particular goal except to try something new and to see what might be done with these images...see what might be within?...beneath...?

Prints, 8 x 10s, 11 x 14s, and 20 x 24s, quickly accumulated and piled up on my dining room table. The art director Sam Shahid stopped by one day, noticed them, and said, "It's a book." Six weeks later he called me into his office to see a mock-up reflecting his "take" on the work. Now, here we are, less than a year later. It's a book. I can't thank Sam enough for his original narrative vision and belief in "Pictures I Had to Take."

Other people who were enormously supportive, critical, and mentoring were the following: Diana Michener, Jim Dine, Duane Michals, Greg Gorman, June and Helmut Newton, Ross Bleckner, Jennifer Grey, James Grey, Jack Ceglic, Lyn Von Kersting, Cynthia O'Neal, Alice and Michael Arlen, Jean-Claude Huon, Walter Hubert, Hugh and Tiziana Hardy, Jean and David Halberstam, Andy Oates, Marilyn and Alan Bergman, Tommy Tune, Peter Glebo, Todd Ruff, Louise and Alan Schwartz, Robert Homma, Indira Wiegand, Joel Sternfeld, Michel Karman, David Fahey, Peter Magill, Mary Boone, Lyn Goldberg, Craig Cohen, Daniel Power, Gerhard Steidl, Roger de la Rosa, Anthony Accardi, Staley-Wise Gallery, and Bee Gilbert, who first initiated me into "nikkor-matdom" in London in 1972. I am also grateful to the late Violet Arase who was my most excellent assistant in the 70s and 80s and who must have known "something" then, as most of the negatives for the pictures were carefully saved by her and recently found when I needed them most. Lastly I want to thank my late father Mickey Katz for his humanity and my mother Grace for her unstoppable love of beauty.

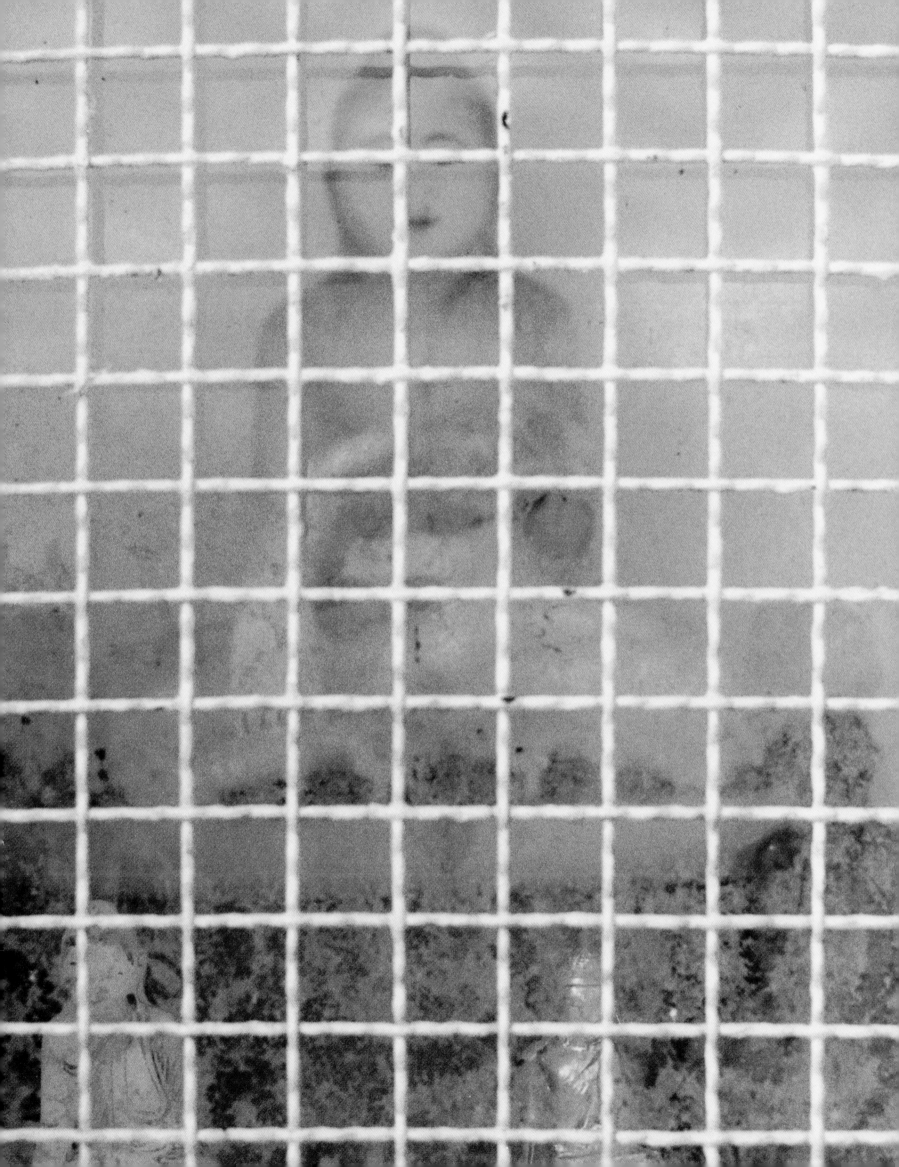

Prague, Czech Republic, 1989

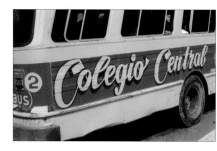

Zihuatanejo, Mexico, 1998

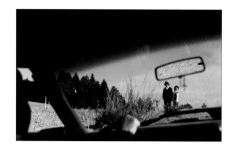

Mexico City, Mexico, 1985

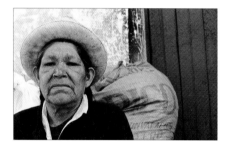

Cuzco, Peru, 2002

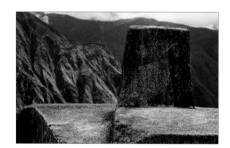

Machu Picchu, Peru, 2002

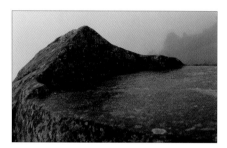

Machu Picchu, Peru, 2002

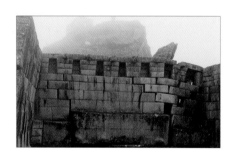

Machu Picchu, Peru, 2002

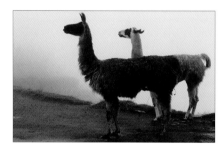

Machu Picchu, Peru, 2002

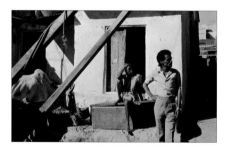

Jaipur, India, 1986

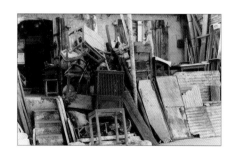

Jaipur, India, 1986

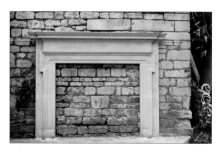

Bath, England, 1992

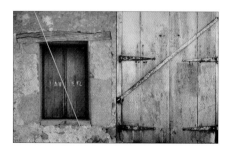

Tepoztlan, Mexico, 1985
Puerta Vallarta, Mexico, 1968

Puerta Vallarta, Mexico, 1968

Salmon River, Idaho, 1976

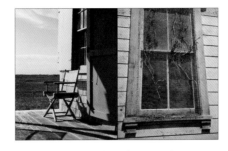

Nantucket, Massachusetts, 1985

Cambria, California, 1998

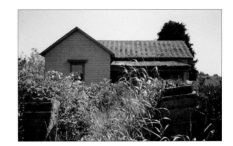

Cambria, California, 1998

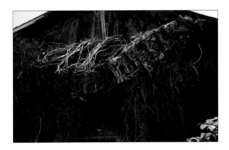

Cambria, California, 1998

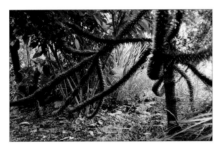

London, England, 1998

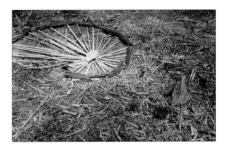

Melbourne, Australia, 1997

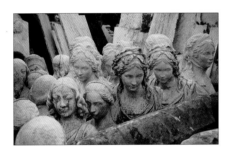

Bath, England, 1992

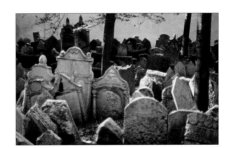

Prague, Czech Republic, 1989

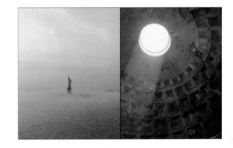

New York City, 1991

Rome, Italy, 1997

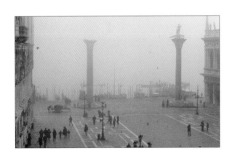

Venice, Italy, 1989

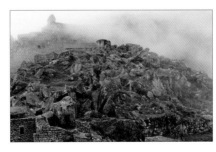

Machu Picchu, Peru, 2002

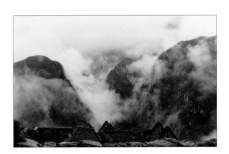

Machu Picchu, Peru, 2002

Dublin, Ireland, 1996

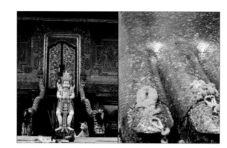

Ubud, Bali, 1999
Bangkok, Thailand, 1996

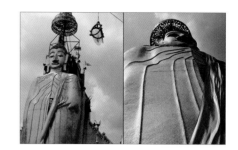

Bangkok, Thailand, 1996

Venice, Italy, 1989

Rome, Italy, 1999

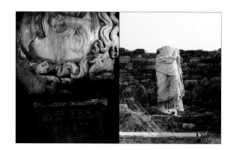

Istanbul, Turkey, 1994
Delos, Greece, 1987

Puerta Vallarta, Mexico, 1968

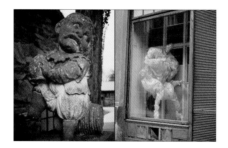

Wilmington, North Carolina, 1993
Prague, Czech Republic, 1989

New York City, 1986

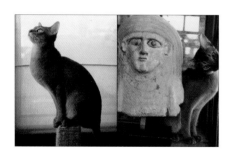

New York City, 1996

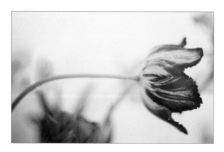

Hartford, Connecticut, 1992

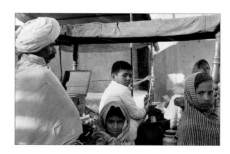

Jaipur, India, 1986

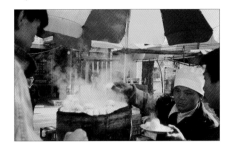

Beijing, China, 1992

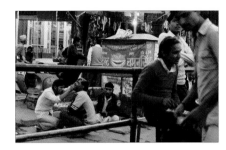

Jaipur, India, 1986

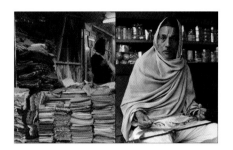

Jaipur, India, 1986

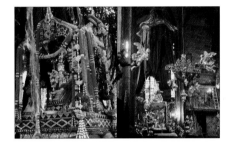

Ubud, Bali, 1999
Prague, Czech Republic, 1989

Coyoacan, Mexico, 1985

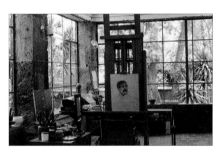

Coyoacan, Mexico, 1985

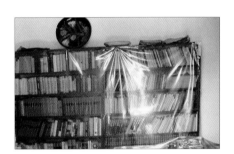

Coyoacan, Mexico, 1985

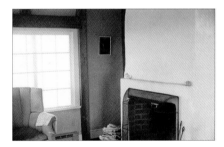

Nantucket, Massachusetts, 1985

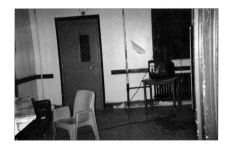

Rikers Island, New York City, 2003

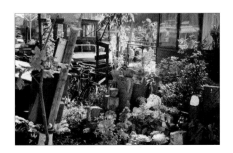

Amsterdam, Holland, 1989

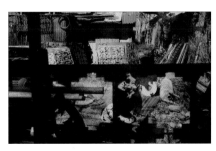

Nogales, Mexico, 1998

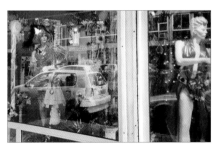

Papeete, Tahiti, 2000

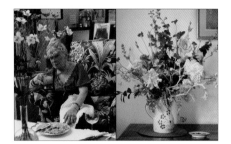

Brentwood, California, 1981
St. Paul de Vence, France, 1970

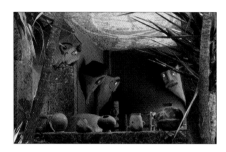

Coyoacan, Mexico, 1985

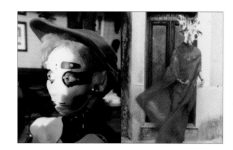

Vancouver, British Columbia, 1999
Venice, Italy, 1970

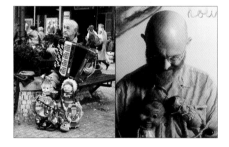

Prague, Czech Republic, 1989
Washington, D.C., 1999

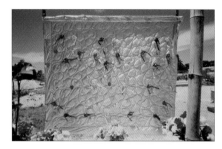

Samoa, 2000

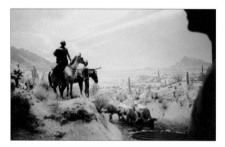

Tucson, Arizona, 1998

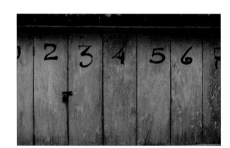

Ubud, Bali, 1999

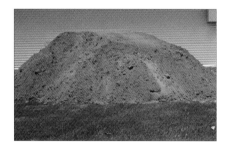

Broome, Australia, 1998

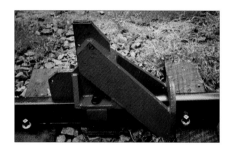

Aguas Calientes, Peru, 1998

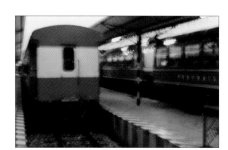

Aguas Calientes, Peru, 2002

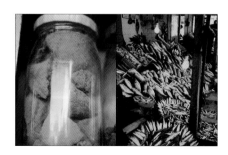

Marrakesh, Morocco, 1969
Istanbul, Turkey, 1994

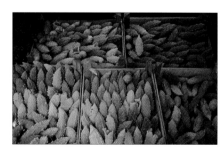

Istanbul, Turkey, 1994

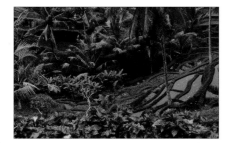

Ubud, Bali, 1999

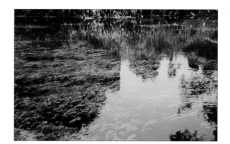

American Samoa, 2000

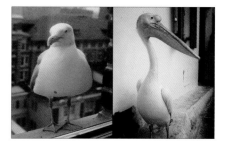

Ninfa, Italy, 1997

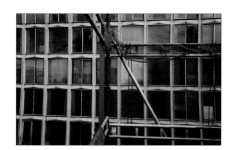

Mykonos, Greece, 1994
Ubud, Bali, 1999

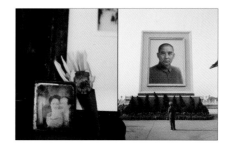

Los Angeles, California, 1999
Beijing, China, 1992

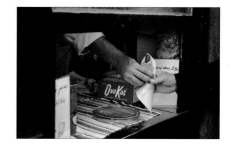

Atlantic City, New Jersey, 1978
Mykonos, Greece, 1994

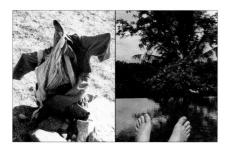

London, England, 2002

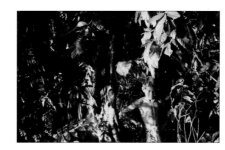

London, England, 1998

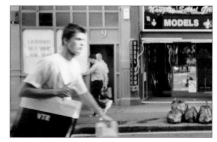

Prague, Czech Republic, 1989

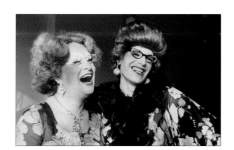

Amsterdam, Holland, 1989

New York City, 1996

Kyoto, Japan, 1992

Pictures I Had to Take

Published in the United States by powerHouse Books,
a division of powerHouse Cultural Entertainment, Inc.
180 Varick Street, Suite 1302, New York, NY 10014-4606
telephone 212 604 9074, fax 212 366 5247
e-mail: cabaret@powerHouseBooks.com
web site: www.powerHouseBooks.com

First Edition, 2003

Library of Congress Cataloging-in-Publication Data:

Grey, Joel, 1932-
 Pictures I had to take / photographs by Joel Grey ; introduction by Duane Michals. - - 1st ed.
 p. cm.
 ISBN 1 - 57687 - 168 - 1
 1. Photography, Artistic. 2. Grey, Joel 1932- I. Title

TR655. G74 2003
779'.092 - - dc21

 2002193021

Hardcover ISBN 1-57687-168-1

Separations, printing, and binding by Steidl, Göttingen

10 9 8 7 6 5 4 3 2 1

A complete catalog of powerHouse Books and Limited Editions is
available upon request; please call, write, and willkommen to our web site.

Printed and bound in Germany

Art Direction by Sam Shahid